6/96

Gainesville
Tallahassee
Tampa
Boca Raton
Pensacola
Orlando
Miami
Jacksonville

UNIVERSITY PRESS OF FLORIDA

ART

O F T H E **Florida Seminole and Miccosukee Indians**

Dorothy Downs

00 99 98 97 96 95 6 5 4 3 2 1

Library of Congress Cataloging-in-Publication Data
Downs, Dorothy, 1937–
Art of the Florida Seminole and Miccosukee Indians / Dorothy Downs.
p. cm.
Includes bibliographical references (p.) and index.
ISBN 0-8130-1335-6 (acid-free paper)
1. Seminole art—Florida. 2. Mikasuki art—Florida. I. Title.
E99.S28D69 1995
704'.03973—dc20 94-36021

The University Press of Florida is the scholarly publishing
agency for the State University System of Florida,
comprised of Florida A & M University, Florida Atlantic
University, Florida International University, Florida State
University, University of Central Florida, University of
Florida, University of North Florida, University of South
Florida, and University of West Florida.

University Press of Florida
15 Northwest 15th Street
Gainesville, FL 32611

To Maurice

I think our patchwork sets us apart from other tribes. I don't believe any other tribe in the U.S. has the patchwork like the Seminoles and Miccosukees. To me, it's everyday dress. Some of the younger people, they dress in jeans and wear little shirts, but they try to put some patchwork on themselves. To me, it identifies us. I am Indian. I am proud to be an Indian. **Virginia Poole, Miccosukee, 1989**

Contents

Illustrations

Plates (following page 142)

Acknowledgments

I wish to thank my many Indian friends who have allowed me into their homes and shared their life experiences. They made this book possible. I have enjoyed their wit and their love of a good laugh. I thank in particular Mary Frances Johns, Howard and Effie Osceola and their daughter Margaret Billie, Frances and Bill Osceola and their daughters Debbie Osceola and Tina Clay, William Buffalo Tiger and his sons, Lee and Stephen Tiger, Donna Frank, Annie and Linda Jim, as well as the many other artisans who talked to me about their work. Pat Diamond, secretary to the chairman of the Seminoles, was always a cheerful contact whenever I needed to know "who to talk to" in the tribe. Rhodes Davis shares my interest in the Miccosukee people and I thank him for his support of the book.

This project developed over many years of research and writing. Joyce Herold, the curator of the Denver Museum of Natural History, introduced me to the extensive collection of Seminole artifacts in the Crane Collection that launched me on this study. Since then, several colleagues have generously taken the time to read all or parts of this manuscript and advise me in my work: Marcilene Wittmer, associate professor of art history, University of Miami; Richard Conn, the chief curator of the Denver Art Museum; Harry A. Kersey, Jr., of Florida Atlantic University; Mallory McCane O'Connor, the director of the Thomas Center Gallery in Gainesville, Florida; Janet Berlo, professor of art history at the University of Missouri, St. Louis; Kate Duncan, professor of art history at Arizona State University, Tempe; Ruth Phillips, associate professor of art history, Carleton University, Ottawa; Carol Damian, associate professor of art history, Florida International University; Bob Carr, Dade County archaeologist; Charles Randall Daniels, anthropologist and director of the Musko-

gee Museum; and Petey Cox. In addition, Ellen Edelen shared her editorial expertise and provided untold encouragement.

Many librarians and museum curators have opened their collections to me or provided numerous photographs, although, to my regret, I am unable to use all this wealth of material. I would especially like to thank Rebecca Smith and Dawn Hugh, librarians at the Charlton Tebeau Research Center, Historical Museum of Southern Florida, Miami; and Esperanza Varona, John McMinn, and the late Helen Purdy of Special Collections, Otto Richter Library, University of Miami. The map and drawings were patiently done by Rowena Luna and Allen Welker.

I would also like to thank my mother, Mary Kathryn Rieder, and my sons, Craig and Gary Downs, for their unflagging support.

Eye-dazzling colors dance in the early morning Florida sunlight. An Indian woman in a long skirt glides through her camp to begin a new day of work in her sewing chickee. Wisps of smoke drift lazily from the cooking fire, where a large black pot simmers. Lush bromeliads hang from cypress trees in pools of dark water. The huge alligator stirs and grunts in his pen.

A scene of days gone by? No. As recent as today. The woman turns on her television set and begins sewing on her large commercial sewing machine. A jumble of bolts of brightly colored cloth, large spools of thread and rickrack surround her. Soon the whir of the machine fills the air. The serenity of her environment stands in sharp contrast to the bustle of the cities nearby. Outsiders, such as the people who live in those cities, are often fascinated by Seminole and Miccosukee patchwork clothing, but they generally know very little about the world of the Indian women who spend long hours at their sewing machines patiently creating those rainbows of design.

Boldly patterned skirts and jackets have now become so synonymous with Seminole and Miccosukee Indians that patchwork fabric is thought by many to be their only art form. Few people realize that some modern artisans also make fine baskets, still prized by collectors. Their ancestors were skilled at fingerweaving, beadwork, and silverwork, in addition to making simple pottery, carved wooden effigies, and canoes—although, sadly, most of those skills have been lost for many generations. They also designed the chickee, an open-sided structure well suited to the muggy southern climate. All of these accomplishments, moreover, were but a

tiny ripple in the deep pool of an ancient cultural, religious, and artistic heritage.

The common ancestors of the people we know today as Seminoles and Miccosukees have not always lived in Florida. As the elders say, "We're not from here," which is true. Some of their forebears lived in other regions of the Southeast and were participants in the rich artistic and ceremonial traditions of the Mississippi Culture period, dating broadly from 1000 to 1700 A.D. We know from figures etched on shells, from drawings, and from other descriptions during the period that a distinctive style of costume has always been an important aspect of Southeastern Indian culture. People traded far and wide to acquire exotic items. Southeastern Indians are now considered part of a wider group of Indians, those of the Eastern Woodlands of North America—a region that spans the whole of eastern Canada and the United States, extending west to the Great Lakes and south to Oklahoma, Louisiana, and Florida.

But when Europeans first encountered the native inhabitants of the North American continent, Indian tribes both in the North and the Southeast were suddenly confronted not only with a newly abundant supply of goods but with dramatic opportunities for cultural exchange, given their accessible location to ports of entry for European ships. They were also vulnerable to the diseases introduced by white men.

Most of the indigenous Florida Indians who greeted explorers were annihilated by 1710, their large tribes decimated not only by diseases but also by slave raids and battles among themselves. Many simply fled the area, with the result that Florida was virtually deserted by the early eighteenth century. Diverse groups from Georgia and Alabama, known collectively as Creek Indians, then began to inhabit the abandoned Florida territories, and they became the ancestors of the modern Seminole and Miccosukee people. They were subsequently joined by runaway African slaves, who in all likelihood influenced the Indian culture.

Europeans introduced the appealing ready-made products of a budding industrial age. Commercially manufactured glass beads, wool or cotton cloth, tailored shirts or coats, metal cooking pots, and tools quickly re-

placed the handmade items that had been so time-consuming to produce. As the Indians became more acquisitive, they increased the amount of time they spent engaged in hunting and preparing hides to trade for the new goods. Some traditional arts and crafts were consequently lost, but on the whole the introduction of new materials and techniques was put to good use by these innovative people to create fresh modes of expression that served the community on aesthetic, symbolic, and religious levels. Not only were novel materials readily adapted to existing techniques and designs but the Indian artisans also learned accompanying technical skills and new design elements from European and possibly African sources. Only the most persistent designs from the elaborate iconography of the Southeastern cultural complex were retained in their original form, and even these were used in new ways. Designs such as the clustered diamonds representing the diamondback rattlesnake, for example, which can be found on prehistoric southeastern pottery and in nineteenth-century beadwork, now appear in twentieth-century patchwork patterns.

Discussion of beadwork and patchwork as art is bound to raise the age-old question "What is art?" In a broad definition, "Art is considered to be those products which man has created as a result of the application of his knowledge and skills according to the canons of taste held as artistic by his culture" (Dark 1967, 132). In accordance with this definition, a craft is defined as a specialized skill or art. Cultures in which the Western arts of painting and sculpture are unknown often employ other "rich visual systems of great aesthetic power" (Forge 1973, xviii). For example, cultures that are naturally nomadic or have otherwise been forced into a fugitive existence often find their aesthetic expression in body decoration or personal adornment. The Seminoles and Miccosukees exemplify this trait. For them, art and daily life are inseparable.

Approximately two thousand Seminole and five hundred Miccosukee Indians now live in Florida (see map). They are divided by language, location, and political preference and are considered Seminole or Miccosukee depending on the tribe with which they are registered. The Hollywood (formerly the Dania), Big Cypress, and Brighton groups formed a

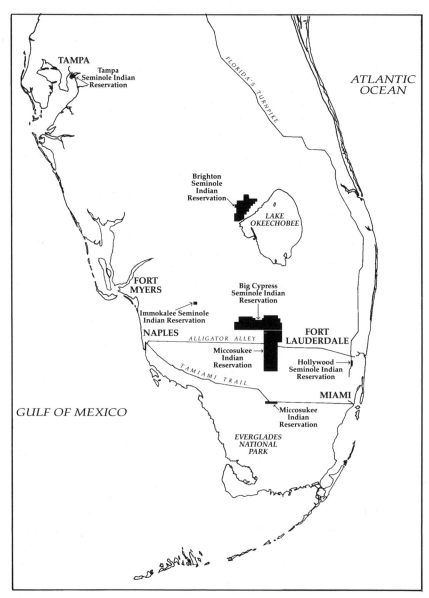

TAMPA
Tampa Seminole Indian Reservation

FLORIDA'S TURNPIKE

ATLANTIC OCEAN

Brighton Seminole Indian Reservation

LAKE OKEECHOBEE

FORT MYERS

Immokalee Seminole Indian Reservation

Big Cypress Seminole Indian Reservation

NAPLES

ALLIGATOR ALLEY

FORT LAUDERDALE

Miccosukee Indian Reservation

Hollywood Seminole Indian Reservation

TAMIAMI TRAIL

MIAMI

GULF OF MEXICO

Miccosukee Indian Reservation

EVERGLADES NATIONAL PARK

Seminole and Miccosukee reservations, 1994. Map drawn by Rowena Luna.

constituted body known as the Seminole Tribe of Florida in 1957, with tribal headquarters on the Hollywood Reservation. Smaller Seminole reservations were later established at Immokalee and Tampa.

The Miccosukee Tribe of Indians of Florida was recognized in 1962. A small piece of land on the edge of the vast expanse of the Everglades along the Tamiami Trail, a scenic forty-mile drive from Miami, was set aside as the Miccosukee Reservation. A few Miccosukee-speaking families living along the Tamiami Trail did not, however, agree with some of the concessions the group made in order to receive tribal recognition from the United States government. They did not join either tribe, choosing instead to remain independent, and consider themselves "Miccosukee-speaking Seminoles."

The word *Miccosukee* has been both spelled and used in various ways over the years and thus needs some clarification. The spelling "Mikasuki" was originally used to designate not only the name but the language of some of the bands of Indian people who had settled in Florida. By around the turn of the twentieth century, non-Indians typically referred to all of the Indians living in south Florida as Seminoles and to the language that most of them spoke as "Mikasuki." But after the Seminole and Miccosukee tribes formally incorporated, linguists decided to eliminate this confusion between people and language by using the spelling "Miccosukee" to designate the people who belonged to that specific tribe as well as their language—which they share with most of the Seminoles.

Miccosukee is the language spoken by people living along the Tamiami Trail, on the Miccosukee Reservation, and on the Seminole reservations at Hollywood, Big Cypress, Immokalee, and Tampa, whereas the people living on the Brighton Seminole Reservation near Lake Okeechobee primarily speak the Muskogee or Creek language. A few people, either by marriage or choice, have moved to a reservation where the other language is spoken and have learned the language of their new home. Either Miccosukee and English or Muskogee and English are taught in tribal school programs, which are bilingual.

Today, a number of ties—language, clan organizations, an oral tradition

of storytelling, religion, art—continue to bind these people together. The Seminoles and Miccosukees have expressed fears that they will "lose everything" if their children no longer know how to speak their native language, and they have struggled to preserve other aspects of their culture as well. Clan and kinship continue to play a major role in the social organization of this matrilineal society. Ancient religious beliefs still survive, and herbal medicine is still practiced. Above all, arts and crafts, inspired by tradition as well as by new elements that have entered the environment, continue to be the center of the Seminole and Miccosukee way of life.

Totemic clan names, such as Panther, Bird, and Otter, reaffirm the people's belief about their alliance with a particular first ancestor or their ties to the supernatural, as in the Wind clan. According to stories and myths, animals and plants talked to and guided the people in early times. Both clan and other animals often appear as heroes or trickster figures in the moralistic stories of an oral tradition that provides continuity to the culture and inspiration for designs. For example, the patchwork designs called "crawdad," "turtle," and "lightning" are vague reminders of the great myths or stories of the past. These stories, which continue to be passed on by the elders, remind the people of their interrelatedness with all of nature.

Clans also determine household arrangements. Although the primary structure is the nuclear family of father, mother, and children, most families continue the tradition of living in matrilocal camps, where the women are all related and of the same clan. The family camp is essentially owned by the oldest woman, the matriarch. Women may appear shy and retiring to outsiders, but this is deceiving. The role of women is both secure and significant in a matrilineal society, even though men usually assume the positions of political leadership. The clan camp includes residences for unmarried sons and married daughters and their families. Marriages used to be arranged, with clan members selecting an appropriate partner from another clan. Today, partners always continue to be selected from another clan, but men and women can now make their own choice of a mate. Nonetheless, a husband's primary loyalty is always to his clan camp, his mother's camp. Responsibility for disciplining and instructing children

falls not on the father but on maternal uncles, along with other clan
members.

Seminole and Miccosukee religion centers around the teachings of Breathmaker, who gave them this "pointed land" known as Florida and taught them how to live on it with their fellow creatures. Ties with Breathmaker and spiritual medicine are restored every year at the Green Corn Dance ceremonials, which feature a sacred fire and medicine bundles. Held at three isolated locations, this is now the only annual religious event. The Green Corn Dance is, however, but one of the many ancient Southeastern rituals that used to be performed annually on dates determined by the medicine men. It is a time of renewal, new beginnings, and unification.

Herbal medicine is another ongoing tradition that is essential to the well-being of the people. Granted, non-Indian medical doctors are consulted for serious illnesses, but many feel that some diseases are best treated by the men and women who continue practicing the ancient art of herbal medicine. Medicine doctors know the location of the necessary plants and are familiar with preparation methods and the specific songs that activate healing of mind and body. Together, ceremonialism, medicine, and storytelling have served an important role in unifying the society, as well as affording a source for design inspiration.

Artistic traditions are most often practiced by women. Men are considered the providers and have thus always been responsible for meeting the basic economic needs of the family. But women made the clothing, in the course of which they created the beadwork decoration that was a primary form of artistic expression during the chaotic nineteenth century. They also revived and improved basket-making skills and developed the new art form of patchwork in the twentieth century. Indeed, their most powerful artistic expression today is found in these patchwork patterns. The designs created by women on the bead-embroidered shoulder bags of the nineteenth century and on twentieth-century patchwork clothing are, moreover, recognized as high levels of artistic accomplishment. In addition, Seminole and Miccosukee arts and crafts include what can be considered men's work—silverwork, chickee building, and woodwork.

In spite of their tragic history of social upheaval and geographic reloca-
tion—the result of three devastating wars—the Seminoles and Miccosu-
kees have shown amazing resilience and have established a legacy of
continuity against what might seem impossible odds. Their unique style
of dress, together with the other arts and crafts they have developed over
time, reflect this continuity, as well as their capacity for adaptation and
innovation.

Seminole and Miccosukee acculturation and innovation are best under-
stood by considering the impact of historical forces and social change on
these people. Many books and articles are available that deal with the
history of the indigenous Indian people of Florida. Detailed accounts of
the political, social, and cultural upheaval these people experienced, along
with relevant dates and statistics, can be found in such sources. Here,
history will serve primarily as a guidepost or reference point. Certain
times, places, events, and participants had a special influence on the
development of modern Seminoles and Miccosukees—and the art of the
people provides visual landmarks along the way.

This survey of Florida Seminole and Miccosukee Indian arts and crafts
accordingly focuses on the influence of such drastic cultural changes on
material selection, technical skills, and design elements. It considers the
native traditions from which the Seminole and Miccosukee arts and crafts
derived, describes the enticing new materials and exciting ideas introduced
by European and possibly African sources, and examines the innovative
ways in which these were adapted to Indian use. Changes in the primary
art form—costume or dress and accessories—are traced through the years,
from the earliest contact with Europeans to the present day. Many of the
contemporary women who make patchwork, baskets, and dolls share
their feelings about their work.

Many distinguished artists and critics have recognized the beauty in
tribal arts. A major exhibition recognizing the influence of tribal arts
on modern art was organized by the Museum of Modern Art in 1984,
accompanied by a two-volume catalog (Rubin 1984). A striking color
photograph of Pablo Picasso wearing a Seminole patchwork jacket at a
bullfight on the Côte d'Azur graces the cover of the book *Understanding*

Picasso (Porzio and Valsecchi 1973). The innovative new combinations of colors and designs worn in competitions and sold by Seminoles and Miccosukees at crowded tribal fairs are eagerly bought by art collectors and admirers of ethnic dress.

The determination of Seminole and Miccosukee Indian people to defend their language, cultural identity, and artistic traditions against a series of cultural threats is an inspiration to Indian and non-Indian alike, and in this the role of art has proved crucial. These people were able to maintain their strength and dignity because of their perseverance—their courage to create during a long history of economic and social reversals. Their ability to survive as an ethnic group and their modern artistic achievements suggest that art not only sustained them in the past but today identifies them as a gifted and unique group of people. Lessons in both courage and creativity can thus be learned from the Seminole and Miccosukee Indians and their arts and crafts.

How do people without a written history recount their past? They must rely on word-of-mouth accounts such as stories told by the elders. These oral accounts refer to a mythological time very different from the concept of time familiar to us from the written historical documentation of European cultures. Like other North American Indian groups, the Indians of Florida now wonder whether they will be able to fit the pieces of the mythological puzzle together as they search for information about their beginnings. Even supplemented by modern anthropological or archaeological research and historical accounts, the picture remains far from complete.

It has been shown that changes in dress go hand-in-hand with historical developments and social transformation (Weiner and Schneider, eds., 1989). One very effective way to track the evolution of modern Seminole and Miccosukee Indians from their ancient ancestors is thus to trace changes in their dress styles, especially because their major form of artistic expression has long been found in clothing or costume. Study of their material culture can reveal the impact on Seminole and Miccosukee social customs and values that resulted from their contact with Europeans and acceptance of commercially made products. It also indicates that the increased amount of time they spent in the business of the deerskin trade in order to acquire the enticing new goods introduced by Europeans diminished the time available for production of native arts and crafts. On a more positive note, it also reveals the people's tenacious ability to improvise, innovate, and create new but suitable modes of artistic expression. These changes will be demonstrated both by written accounts and visually. Historical drawings afford us information about the dress of the

native people at the time of first European contact. Later changes in clothing styles are additionally documented by paintings, photographs, and surviving artifacts.

The First Floridians

According to a story told by one tribal elder, the ancestors of the Seminole and Miccosukee Indians migrated long distances over the course of many generations—a story that archaeological evidence supports. Once in the Southeast they encountered and to some extent participated in the customs of the ceremonial complex of the Mississippi Culture period (1000–1700 A.D.). The Southeastern Indians of this period had established comparable though not as elaborate centers and cultures as those in Mesoamerica. Excavations have revealed that the Mississippian sites stretched from Oklahoma to Florida and from the Gulf of Mexico to the Great Lakes. Religious-political-ceremonial centers with large surrounding communities were ruled by chiefs from atop platform mounds.

Priests, warriors, ball players, and other notable members of the society wearing elaborate costumes are depicted on surviving artifacts. Fantastic feathered serpents and half-animal/half-man transformation figures such as bird-men or members of the deer clan are incised or embossed on shell, stone, bone, and metal (Wilson 1985). Ceremonial regalia were made from materials procured through trade over great distances, and ritual paraphernalia were decorated with a rich iconography of symbols recognized throughout the Southeast. Surviving examples of copper ceremonial objects such as circular gorgets with pierced designs and hair ornaments or plates with embossed decoration from the Southeastern ceremonial complex are also evidence that the people were skilled at metalworking techniques long before the arrival of Europeans. Copper came from the distant Great Lakes region and would have been considered an exotic trade good.

There are many unanswered questions about the origins of the aboriginal Indian groups of Florida and about precisely when the groups migrated into the area. Archaeological evidence suggests that the indigenous people

had already experienced a breakdown in their social, religious, and political order that had in turn led to further rivalries and in-group fighting as the new bands moved into the region from approximately 1300 to 1500 A.D. Ceremonial centers began to lose contact with one another and were later abandoned entirely. To make matters worse, late-fifteenth-century and sixteenth-century European explorers introduced diseases that drastically reduced Indian population, leaving it more vulnerable still to unrest.

When European explorers first arrived, Florida was inhabited by diverse Indian groups (see, for example, Milanich and Proctor, eds., 1978). The earliest documented contact occurred in 1513, when the expedition of Juan Ponce de León was met by hostile Indians on Florida's northeast coast near present-day Saint Augustine. He called the land La Florida, because it was discovered at Easter, known in Spanish as *Pascua Florida* (Milanich and Milbrath, eds., 1989, 3). At that time, settlements of the Timucuan Indians stretched from what is today Cape Canaveral north to Georgia and westward to the Aucilla River and included the Alachua area near present-day Gainesville. In 1539 Hernando de Soto landed on the west coast at Tampa Bay and established his camp at Ocita, near the mouth of the Little Manatee River, before moving north into the fertile lands of the Apalachee (Hudson, DePratter, and Smith 1989, 85).

The southern part of the Florida peninsula was inhabited by nonagricultural people. On the west coast, Calusa groups were settled south of Tampa Bay, and, on the east coast, Tequesta villages were located south of Pompano Beach, north of which were three Jeaga villages near the Jupiter Inlet. The related Ais lived yet farther north on the east coast in the Indian River area from Cape Canaveral to the St. Lucie River and inland some twenty to thirty miles.

A few of the indigenous people who first greeted Europeans in Florida were described, drawn, or painted by artists who accompanied early expeditions. Around 1545 Escalante Fontaneda survived the wreck of the Spanish ship on which he was serving off the Florida Keys. In his memoirs he described his native Calusa captors and the surrounding Indian people he encountered, writing of the subjects of the cacique Carlos that "the men go naked, and the women in a shawl made of a kind of palm-leaf,

split and woven" (in True, ed., 1973, 28). Men in neighboring groups wore breechcloths of hide or woven palm, and women only covered themselves below the waist. Other Spanish accounts refer to the woven mantles, tuniclike garments worn by the Apalachee in the north.

Dramatic forms of body decoration, such as painting or tattooing, and the ornaments of shell and feather worn by the Indians excited the imagination of European artists. During his visit to Florida in 1564–65 the French artist Jacques Le Moyne depicted the activities of the Timucuan men, women, and children who lived on the northeast coast in the vicinity of Fort Caroline and the St. Johns River. Theodore de Bry made a series of engravings based on Le Moyne's work, and John White's drawings of the Timucuans were influenced by Le Moyne and other sources. The Timucuan Indians, a vigorous people with firm, muscular bodies, were portrayed as they went about their daily life and rituals in what appeared to be an ideal climate. Their scant clothing, made of vegetal fibers or fur, seemed to be worn primarily to conceal their genitals or to provide what little warmth was needed. These accounts, drawings, and paintings thus establish that at the time of early European contact Florida Indian people wore only minimal covering made of natural materials—skins and woven plant fibers. For ornamentation they used shell, stone, bone, or native copper, in addition to which the Spanish introduced small amounts of silver (Goggin 1940, 25). The Calusas made beads, pendants, and other ornaments from Spanish silver coins or other salvaged silver, but we do not know if they applied previously known metalworking skills or were taught new techniques by the Spanish (Johnson 1976, 93).

Unfortunately, most of the indigenous people and their idyllic lifestyle had vanished by 1710. The large population of the northern Florida Indian groups was decimated by epidemics of smallpox, tuberculosis, measles, and other diseases introduced by Europeans and the African slave trade. The Indians had little or no immunity to foreign viruses, and mass or multiple burials are sad evidence of the devastation caused by epidemics (Hudson, DePratter, and Smith 1989, 78). Slavery claimed other natives. Spanish Jesuit missions were first established in 1565, followed by Franciscan missions located from coast to coast by 1700—and Indians were often

forced to work for these missions as slaves. Others were captured to work on plantations or were shipped to Caribbean islands, where many perished. In addition, the Europeans encouraged the rivalries and slaving raids that were common between Indian groups. Colonel James Moore and fifty Carolinians, for example, led one thousand Indian mercenaries on a catastrophic raid against the Apalachee in 1703–4 (Smith and Gottlob 1978, 9). Few Indian houses remained in Florida after that, and most of the stragglers simply fled the area.

The Eighteenth Century

The art and culture of the Indian people we know today as the Seminoles and Miccosukees were most directly shaped by events in the eighteenth and nineteenth centuries. During the former, British colonization accelerated in North America from Canada as far south as Georgia, when it was increasingly recognized that the colonies provided both raw materials and new markets for products, since the native Indians willingly traded furs for European goods. Furthermore, land was needed to grow cotton and other crops for the manufacture of linen and cotton cloth, a burgeoning cottage industry.

Then, at midcentury, a technological breakthrough in cotton textile production ushered in the industrial revolution (Schneider 1989, 180–81). Flax for linen can be grown in temperate climates, but cotton must be grown in a more tropical climate such as that of southeastern North America. As the demand for it increased, colonists turned to this region to establish plantations for growing cotton, as well as other crops such as tobacco. Along with the plantation system came the need for hardy slaves, who were primarily imported from Africa.

The native people in Georgia and Alabama whom Europeans labeled "Creek Indians" are the ancestors of the Seminoles and Miccosukees. The term originated in the late seventeenth century when British Carolinians applied the name Ocheese Creek Indians to people living in towns along an important Indian trade route called the Ocheese Creek, now known as the Ocmulgee River (Sturtevant 1971, 97–98). The name was shortened

to Creek Indians to cover the surrounding Indian bands, but the term poorly captured the variety of tribal and linguistic groups it covered.

Muskogean was the dominant language in the Southeast, although Yuchean, Iroquoian, and Algonquian languages were also spoken. The many distinct languages and dialects of Muskogean include five closely related groups: Choctaw-Chickasaw, Apalachee, Alabama-Koasati, Miccosukee-Hitchiti, and Muskogee-Seminole (Hudson 1976, 23). At first the term *Creek Indians* referred to people living in eastern Muskogee-speaking towns, but, by 1710, the term had been extended to all Muskogee and associated Hitchiti towns. Soon *Lower Creeks* was applied to eastern Indian towns on the Chattahoochee River in Georgia and *Upper Creeks* to Indian towns above the forks of the Alabama River on its tributaries, the Coosa and Tallapoosa, in Alabama.

Bands of Creek Indians gradually extended their hunting grounds into the Florida territory and began to occupy the fertile regions abandoned by the original inhabitants. As there were no official boundaries between these territories, they were free to roam at will and their crossing was of little consequence. In addition, hoping to buffer the expanding influence of the British, the Spanish sent emissaries to encourage Lower Creeks to resettle the deserted western lands of the Apalachee. As a result, several new Indian towns had been established in the region by 1727.

The Spanish first called these Florida Creek, Yuchi, and other Indian settlers *cimarrón*, which has variously been translated as "wild" or "unruly," a term that present-day Seminole and Miccosukee people find both confusing and derogatory, protesting that their ancestors were neither. The definition of the term as given in contemporary Spanish dictionaries includes "runaway slave or maroon," which probably referred primarily to the runaway slaves who had begun to settle nearby. (There are no reliable estimates of the Indian population in Florida in the 1700s, but the black to white ratio was approximately two to one.) *Cimarrón* became *simalóni* in the Muskogee language, which does not recognize the *r* sound, and that term was later rendered "Seminole" by the British.

General James Oglethorpe arrived in the Southeast near present-day Savannah in 1732, with English settlers he had recruited for the Trustees

for Establishing the Colony of Georgia in America. The first of Oglethorpe's groups to establish a colony consisted of debtors or "worthy poor." He wrote to the trustees that he was well received by Tomochichi, the chief of a small band of Lower Creeks who identified themselves as "Yama-craw," and his wife, Senauki, plus some twenty followers and the shaman of the tribe, who danced around him (Britt and Hawes 1976, 184–85). Oglethorpe entertained the party afterward in his tent and made presents of clothing, thereby continuing the British policy of distributing gifts of clothing and cloth to Indian leaders, which had been used successfully with Indian groups to the north. Tomochichi and Oglethorpe became close friends.

Oglethorpe called a meeting with the Creeks for May 1733, in response to which nearly one hundred Indians and their chiefs, representing the eight tribes of the Lower Creek nation, assembled in Savannah. Dressed in their finest traditional garb, the Indians negotiated with Oglethorpe through interpreters and worked out a treaty of cooperation and land usage. Gifts were exchanged after the treaty was signed. Oglethorpe was presented with eight bundles of skins, one from each of the tribes. Each Indian leader was given a coat trimmed in lace, a hat, and a shirt. Other gifts included linen and coarse cloth for clothing (Spaulding 1977, 78).

Tomochichi, Senauki, his nephew Tooanahowi, and five other Indians joined Oglethorpe when he returned to England in 1734. The object was to impress the Indians as much as possible with the magnificence of Britain. They were entertained lavishly and "were bedecked in new robes at the expense of the Trustees, such as their ancestors were stranger to" (Britt and Hawes 1976, 192). A mezzotint was made of Tomochichi and his nephew, and, to commemorate their meeting with the trustees, a group portrait of the Indians in their native dress was painted by court artist William Verelst. But the Creeks were not the first group of Indians to visit London and be painted by Verelst. He had previously painted portraits of four Iroquois chiefs in Indian and English dress who had been presented to the court of Queen Anne in 1710. They too had been paraded around London and given the title of "Indian Kings" (see "A Survey of Prints in the William and Mary Parlor, South Wing," Winterthur Mu-

seum). Four mezzotints based on the Verelst paintings were made by John Simon, and about two hundred prints were shipped to America and distributed among Indian leaders. A group portrait was also made of a delegation of Cherokees who visited London in 1730.

An inscription on the mezzotint portrait of Tomochichi and Tooanahowi described the latter as the "son to the Mico of the Etchitas" (fig. 1.1). (The Etchitas later became known as the Hitchitis, a pre-Seminole linguistic group.) Both are bare-chested in this portrait, although Tomochichi's chest is decorated with a bold linear design. They wear fur ties at the neck, and Tooanahowi holds an eagle. Tomochichi presented George II with some eagle feathers and gave the following address, translated into English by Major Pidgeon, who traveled with them: "These are the feathers of the Eagle which is the swiftest of birds and who flieth all around our Nation. These feathers are a sign of power in our land and have been carried from town to town there; and we have carried them over to leave with you, O Great King, as a sign of everlasting peace" (Britt and Hawes 1976, 193).

The group portrait of the Creeks in particular gives us an accurate look at the Indian dress of the period and the minor changes that were beginning to take place. The men wear fur robes over their bare chests and ties or beaded collars around their necks, and they have feathers behind their ears. One warrior has a strap with a design of arrows on it looped around his neck. Their legs are bare of all but their garters and moccasins. These muscular, fur-clad Indians make a striking contrast with the paunchy and bewigged trustees. Senauki is outfitted in a colorful cloth dress more stylish than modest with its scooped neck, though it is impossible to distinguish whether it is a one- or two-piece dress, while Tooanahowi is dressed in a "Blue Boy" outfit, the appropriate clothing of a wealthy English boy of the period.

Tomochichi and his party embarked on their return to Georgia on October 31, 1734. They sailed aboard the ship *Prince of Wales* with a group of persecuted German Protestants, Salzburgers, who had also been recruited by the trustees. The Salzburgers settled the town of Ebenezer and described the Creeks who lived nearby:

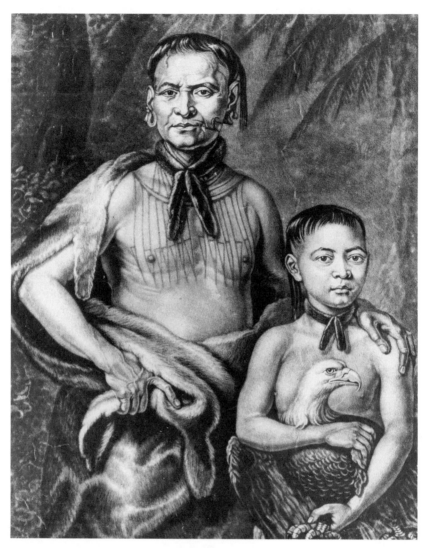

Fig. 1.1. *Tomo Chachi Mico or King of Yamacraw and Tooanahowi, his Nephew, Son to the Mico of the Etchitas,* from a mezzotint by John Faber after a painting by William Verelst, 1734. This portrait of Tomo Chachi (customarily spelled Tomochichi) shows the body decoration and fur dress of Creeks at time of their early contact with Europeans. Photograph courtesy of the National Anthropological Archives, Smithsonian Institution. Neg. no. 1129-A.

They paint their faces with various colors, especially black shaded with red
. . . . They always go bareheaded, all of them have short black hair which
they trim somewhat at the crown. To dress up they put small white feathers
in their hair and behind their ears, which they consider a symbol of bravery,
and they also tie up their short hair with a red band. Most men and women
have stripes painted on their necks, faces and bodies. Around their necks
they wear coral, and on their ears they have rings or as stated, colored
feathers. To get such finery, and also to obtain knives, etc., they trade game
which they have killed. They have no beards, and if they should grow any
they pull it out. Instead of trousers, which they consider indecent, they cover
themselves with a short cloth. Occasionally they cover their bodies with a
deerskin or a woolen blanket. When they go to hunt, they wear very loose
woolen gaiters which reach from their feet up to the loin. These protect them
from the rattle snake, which cannot bite through thick woolen cloth. Their
shoes are cut from deerskin and laced on the foot. (Urlsperger 1968, 143)

This revealing account, along with the group portrait, confirms that the
style of Indian men's dress was relatively unchanged at this point, even
though European woolen blankets and cloth had been adopted into Indian
wardrobes. Unfortunately, the Salzburgers gave no information about
women's dress.

Oglethorpe and the trustees then turned to the Scottish Highlands to
recruit more colonists. Forty-five families consisting of approximately
170 men, women, and children, drawn from the McIntosh, McGillivray,
McQueen, and other groups of the clan Chattan confederation in the
Inverness region, arrived at Savannah in January 1736 and were well
received by the Indians living in the region. Oglethorpe referred to the
Highlanders and Indians often in his letters to the trustees, writing in
February 1736, "The Highlandsmen have these three weeks had quiet
possession of the Altamaha, and agree very well with the Indians." That
same year he also commented that "the Indians and the Highlanders have
behaved with great courage, fidelity and affection and the Englishmen
that came with me are not far behind them" (*Collections of the Georgia
Historical Society*, 1873, 12, 28).

The Indians and Highlanders were understandably compatible, for the two groups shared many common social customs and attitudes. Both were tribal and organized into clans, although Highland clans were patrilineal and the Indian clans were matrilineal. Both had close ties with nature, consulted oracles, and believed that supernatural spirits and "little people" inhabited the woods. Comparable rituals included dancing, sacred fires, and harvest ceremonies, in addition to which they shared a love of the dramatic in speech and action. Both groups were avid warriors, relished a good fight, and revered virility. Highland men matched the Indian ideal of courage and manliness. Highlanders also wore their native dress in the American wilderness—which must have delighted the Indians, who were great admirers of distinctive costume. Oglethorpe wrote to the trustees that the Highlanders "present a most manly appearance with their belted plaids, broadswords, targets and firearms" (*Collections of the Georgia Historical Society,* 1873, 15) and, on one visit, wore Highland dress as a compliment to them (Britt and Hawes 1976, 201). Beyond that, however, the fierce Highland warriors and Indian men also shared a preference for skirtlike clothing, refusing to wear trousers because they considered them unmanly. Convenience and freedom of movement were other reasons why these men preferred short skirts. The short flap of a breechcloth had always been an essential article of aboriginal Southeastern Indian men's dress, and the basic element of Highland garb was somewhat similar to the Indian breechcloth (as opposed to the skirt style of kilt known today). It consisted of a wool plaid cloth secured around the waist by a belt. This cloth, some sixteen feet long, hung in flaps at the front and back that reached almost to the knees. The remainder of the piece in the back could be looped over the shoulder and held with a brooch, tucked in, or used as a cloak. Intricate plaid designs identified the owner's clan or regiment, and many patterns were sold at the trustees' store in Savannah (Ivers 1974, 164).

The rest of the costume consisted of a shirt, which was like those given to the Indians in great number, a waistcoat, and a jacket, along with bonnet, stockings and garters, sporran or pouch, and shoes. Emblems or crests of silver known as "amorial bearings" or heraldic devices that

indicated the individual's clan membership were worn on the bonnet, belt, and pouch. Stockings were formed of tartan that was cut, shaped, and stitched. Garters were made from a yard-long strip of cloth, which was wrapped around the stockings below the knee and knotted on the outside of each leg. Shoes, called *mo casan* in Gaelic, were made of a single piece of soft hide and were excellent for running (Dunbar 1962, 164).

Writing in 1744, Edward Kimber described the Creeks who joined Oglethorpe on a punitive raid against the Spanish at Saint Augustine in 1743 as having large robust bodies painted red or black. The hair around their foreheads and temples was plucked out or shaved. The men wore European shirts—obviously a new addition to the Indian wardrobe. Skins or blankets were tied or loosely cast over their shoulders. Their breechcloths were worn "before and behind, to cover their privities, of red or blue Bays, hanging by a girdle of the same." (The cloth Kimber calls "Bays" referred to European baize, a material similar to felt.) "Boots"—probably leggings also of baize—were worn with what, according to Kimber, the Indians called "morgissons," slip-on shoes made of deer or buffalo skin. Kimber also noted that the Indians who went to London in 1734 with Oglethorpe could be distinguished from the other Indians by their style of dress (Kimber 1976, 16). This strong preference for skirtlike dress with the dash of Highland flair continued: Creek, and later Seminole, men never adopted trousers or the overall look of the dress of the other European men—English, Spanish, French, or German—who were on the southern frontier.

Some of the Indian men who had fought side by side with Oglethorpe, the Highlanders, and the English against the Spanish remained in Florida, while others returned later with their families to settle on the lands deserted by the original inhabitants. After their regiments disbanded, many of the Highland men became Indian traders, traveling far and wide through the entire Eastern Woodlands region. More Highlanders fled to the American frontier following the Jacobite Rebellion of 1745, and many of them also became traders. By 1750, Indian trade in the Creek nation was thus virtually monopolized by members of the clans of the Chattan confedera-

tion. Although many Englishmen and other Europeans also engaged in trading, more licenses bore Scottish names such as McGillivray, McIntosh, and McQueen.

It was considered a great privilege to have a European trader settle in or near an Indian town. Indian women found the traders desirable because they provided trade goods to distribute to their families. Most of the white female colonists were either too young or already married, so there were few white women to compete for a trader's affection. Indian women were described as quite appealing, and traders often married those from the most powerful clans. These generally proved to be beneficial liaisons for all parties.

In addition to considerable cultural exchange, many children bearing British surnames (whether English, Scottish or Irish) resulted from those unions. According to Indian marriage customs, the mother and children remained with their matrilineal clan if a couple split up or the man simply left. Creek law further required that a white man who had had children by an Indian wife must leave all his property with the children for their support should he depart from the Creek nation (Waring 1960, 21). It has been estimated that there were "400 children so begotten from British-Indian unions in the Georgia colony alone, and being left and brought up by their mothers," who spoke both an Indian language and some English (McPherson 1962, 272–73). Numerous Indian men with British surnames assumed leadership roles through matrilineage, but the tendency of those men to align with whites often caused them serious difficulties with nativistic Indians, who tended to be loyal to the tribe.

Considerable change in their material culture resulted from the Indians' continued contact with whites. As the Indians became more acquisitive, they needed more hides for trade—and the process of preparing the hides was both time-consuming and unpleasant. Hunting was the men's major role, and they skinned their kill and dressed the hides in a preliminary way. It was the women's responsiblity, however, to cure the skins. They set the skins out to dry, removed all remaining flesh, and soaked them in water for two or three days. Then the skins were wrung out and hung over logs to dry. The hair was painstakingly scraped off each hide with

a sharpened tool. Next, the skin was softened by soaking it in a container filled with water and pulverized deer brains, following which the women pounded it for further softening. Holes were punched in the skin, and then the hide was stretched on a frame, dried, and later smoked. Finally, it was ready for trade or to be made into clothing or other items for personal use. Sinew and a bone awl had to be used for sewing before thread and steel needles were introduced. Not surprisingly, European manufactured goods were quickly adopted in preference to goods that required such laborious efforts to produce. At the start, the Indians were simply presented with gifts of clothing or cloth from their new neighbors. But the acceptance of European commercial cloth and other goods brought an acceptance of capitalist values as well.

At the same time, with the arrival of Christian colonists in the Southeast certain changes in the native style of dress took place, probably dictated by modesty, especially among the women, who began wearing cloth skirts and bodices. Resourceful Indian seamstresses soon began making adapatations of European styles for their own and family use, using the new commercial fabrics as well as the traditional hides. As the Indians began to use the new materials in novel ways, costume thus became the primary means of artistic expression for Creek and Seminole people, gradually displacing other arts and crafts. Moreover, even though the Indian mode of dress was initially influenced by European clothing, changing styles increasingly reflected the Indians' own ingenuity. Certain elements already present in Indian dress were reinforced by European styles.

Physical evidence is scant, but objects excavated from Indian sites of the period and European lists of items given or traded to the Indians are indicative of the extent of increasing Creek and Seminole dependence on European goods. For one thing, the number of durable trade items, such as beads and metal or ceramic objects, that accompanied individuals to the grave suggests not only that those objects had become part of daily life but that they were considered of value to the deceased. The lists of merchandise traded or given as presents to the Indians are indicative of the amount of clothing or cloth that came into Indian hands. The first

known British reference to the Seminoles appears in the Colonial Office Papers dating to 1765. According to these records, British presents to the Indians in Florida for the Congress at Picolata in that year included 201 ready-made white plain shirts, 138 checked shirts, and 54 ruffled shirts, plus certain items probably reserved for the most important men: eleven gold-edged hats, suits of clothing, and three greatcoats. Among the cloth and sewing notions listed are 9 pieces of printed calicoes, 12 pieces of colored cotton, 50 pieces of stroud, 2,000 needles, 20 pounds of thread, and 16 gross of gartering (Covington 1960, 72; Shaw 1931, 166–67). Obviously, a considerable amount of sewing was going on in Indian households.

The most significant articles accepted by the Indians in trade were shirts and cotton cloth. Shirts with a half-front opening were the favorite items among Indian men and were given or traded in the greatest quantities. Indian women were attracted to the new cotton calico and checkered cloth, which they used to copy shirts from European styles (designated by the term *plain shirt*) for their men. Cotton cloth was well suited to the warm climate of the Southeast, and the women also used it to make their skirts and bodices. But woolen baize or stroud cloth was also popular. The Indians used stroud—a coarse woolen cloth manufactured at Stroud in Gloucestershire, England—for blankets, as well as for certain articles of clothing such as breechcloths and leggings. Later, it was additionally employed as the base fabric for bead-embroidered belts or straps and pouches.

The British also distributed silver items to Indian leaders to mark the signing of agreements. Impressive crescent silver gorgets, like those worn by British officers, were given to flatter Indian leaders. Likewise, traders in the Southeast either traded silver ornaments or gave them to the Indians when the situation required gifts in exchange for favors. European silver-smiths worked among the Creeks, Seminoles, and other Indian groups in the late eighteenth century.

In increasing numbers, diverse bands of Creek Indians from Georgia and Alabama began resettling the uninhabited regions of northern Florida as the frontier became crowded with colonists during the eighteenth

century. Miccosukees settled near present-day Tallahassee while other groups settled near what is now Gainesville. They built new communities of log cabin dwellings, raised crops and cattle, and prospered. The naturalist William Bartram's *Travels*, first published in 1791, is the best source of information on the southeastern Indians of this period (Bartram 1955). Chief Cowkeeper and his warriors, originally Oconee Creeks who had joined Oglethorpe in the 1740–43 raids on Saint Augustine, established a town called Cuscowilla in the Alachua region. When Bartram visited Cuscowilla in 1774, he described it as a Seminole town. Settlers from other Creek towns moved into the eastern regions of Florida nearby.

During the period when the British controlled Florida, from 1763 to 1783, these Creeks-turned-Seminoles had attained a high level of comfort. They were primarily pro-British and generally out of touch with the other Creeks. Commenting on the Seminole way of life, Bartram observed that the Seminoles enjoyed a "superabundance of the necessaries and conveniences of life, with the security of person and property, the two great concerns of mankind. The hides of deer, bears, tigers and wolves, together with honey, wax and other productions of the country, purchase their cloathing, equipage, and domestic untensils from the whites. . . . No cruel enemy to dread; nothing to give them disquietude, but the gradual encroachments of the white people" (1955, 182). As Bartram noted, though, in spite of having adopted the domestic utensils used by whites, Indian women "make all their pottery or earthenware, moccasins, spin and weave the curious belts and diadems for the men, fabricate lace, fringe, embroider and decorate their apparel" (1955, 401).

Bartram also described the Seminole style of dress. According to him, the dress of Chief Cowkeeper was extremely simple and his head was "trimmed and ornamented in the true Creek mode" (1955, 164). He said of men's dress:

> The clothing of their body is very simple and frugal. Sometimes a ruffled shirt of fine linen, next the skin, and a flap which covers their lower parts; this garment somewhat resembles the ancient Roman breeches, or the kilt of the Highlanders; it usually consists of a piece of blue cloth, about eighteen

inches wide; this they pass between their thighs, and both ends being taken up and drawn through a belt round their waist, the ends fall down, one before, and the other behind, not quite to the knee; this flap is usually plaited and indented at the ends, and ornamented with beads, tinsel lace, &c. . . . The shirt hangs loose about the waist, like a frock, or split down before, resembling a gown, and is sometimes wrapped close, and the waist encircled by a curious belt or sash. (1955, 393–94)

Bartram also tells us that some Indians wore a cotton calico coat with a full-front opening, known by the term *long shirt*, that was copied after European greatcoat or frock styles. A large mantle, typically red or blue and made of the finest cloth they could purchase, or a short cloak fashioned from fur or feathers was used for covering or warmth. Jewelry included arm bands or bracelets and large crescent gorgets suspended around the neck. Cloth boots, which reached from the ankle to the calf, were ornamented with beads and other decoration. Soft deerskin moccasins worn on their feet were also "curiously ornamented according to fancy" (1955, 394). There was a lingering influence from the mission period among Yamassee Indian slave residents of Cuscowilla, who had formerly been Spanish slaves. These slaves were described as better dressed than Cowkeeper. Although they attended him in fear, the slaves were free to marry among the other Indians. Their children were considered free and equal in every respect, and only the parents remained slaves as long as they lived.

Another Seminole chief, named Mico Chlucco the Long Warrior, was depicted in the frontispiece to Bartram's *Travels* (fig. 1.2). He is wearing a plain open-neck shirt with a fur robe, and his hair is plucked in the traditional style. But according to Bartram, other Seminole men shaved most of their head, leaving only a crest in front and ornamented hair on the back of the neck. "A very curious diadem or band, about four inches broad and ingeniously wrought or woven, and curiously decorated with stones, beads, wampum, porcupine quills, &c., encircles their temples; the front peak of it being embellished with a high waving plume, of crane or heron feathers" (1955, 394). Their elongated ears were pierced and decorated with silver or white heron feathers.

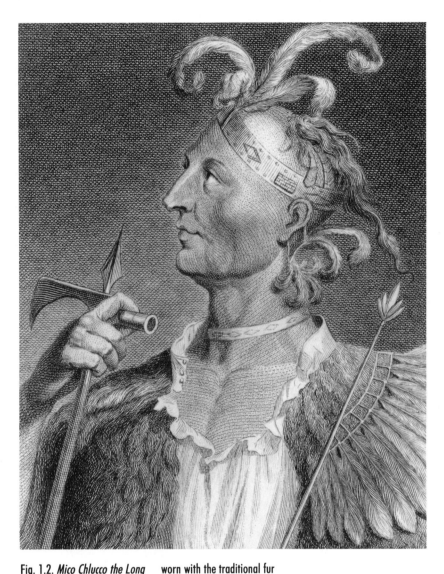

Fig. 1.2. *Mico Chlucco the Long Warrior, or King of the Siminoles,* from William Bartram's *Travels* (1791). Note the addition of a trade shirt worn with the traditional fur robe. Photograph courtesy of the Beinecke Rare Book and Manuscript Library, Yale University, New Haven.

In addition, body decoration was popular among the men, who painted their heads, necks, and breasts with vermillion. When they were a young age, their breasts and the muscular parts of their bodies were tattooed with scrolls, flowers, figures of animals, stars, crescents, or the sun. Bartram also mentions the gaudy outfits worn by young Creek and Seminole men. This flamboyant costume, which was designed to identify brave Indian warriors and impress others with their daring, reflected the atmosphere of change on a wild new frontier.

Bartram observed that Seminole girls were found to be "by no means destitute of charms to please the rougher sex: the white traders are fully sensible how greatly it is to their advantage to gain their affection and friendship in matters of trade and commerce" (1955, 170). Describing women's dress, he said:

> The dress of females is somewhat different from that of the men: their flap or petticoat is made after a different manner, is larger and longer, reaching almost to the middle of the leg, and is put on differently; they have no shirt or shift, but a little short waistcoat, usually made of calico, printed linen, or fine cloth, decorated with lace, beads, &c. They never wear boots or stockings, but their buskins reach to the middle of the leg. They never cut their hair, but plait it in wreaths, which are turned up, and fastened on the crown, with a silver broach, forming a wreathed top-knot, decorated with an incredible quantity of silk ribbands, of various colors, which stream down on every side, almost to the ground. They never paint, except those of a particular class, when disposed to grant certain favors to the other sex. . . . The mantle . . . [is worn] by the women at dances, when it serves the purpose of a veil; and the females always wear the jacket, flap, and buskin, even children as soon or before they can walk; whereas the male youth go perfectly naked until they are twelve or fifteen years of age. (394–95)

Both men and women reserved their best clothes for special occasions, "or when the men assemble to act the war farce, on the evening immediately preceding their march on a hostile expedition" (395).

For daily wear the men usually wore only breechcloths, sometimes

with shirt and boots or moccasins. The tailored hide hunting coat was
another important item of daily wear (fig. 1.3). But it is not known when
Indian men first adopted this popular coat style, nor does Bartram mention
it. It seems likely, though, that the Indians adopted it around the time of
the American Revolution, given that the hide hunting coat, or rifle dress,
was an essential element of the clothing worn in the Southeast during
the revolution. George Washington preferred it as the field dress to be
worn by most of the army throughout the war. The noncommissioned
officers and privates of the United States army, as well as individual state
troops such as Georgia regiments, were supplied with the rifle dress.

Hunting shirts were not considered uniforms, but they did serve a need
when more suitable coats or fabrics were unavailable. They were made
of deer hide, linen, or homespun, dyed in various colors designating
different regiments. Long leggings or overalls were also preferred by Wash-
ington for the troops in place of breeches and stockings. Such leggings
were usually made of deerskin, linen, or undyed cotton duck, although
later on in the war, wool leggings were issued during the winter. They
were shaped to the leg, fastened at the ankle with four buttons, and held
by a strap under the shoe.

Washington went so far as to commend rifle dress in his General Order
of July 24, 1776. As he put it, "No dress can be cheaper, nor more
convenient, as the wearer may be cool in warm weather and warm in
cool weather by putting on under-cloaths which will not change the outer
dress, Winter or Summer—Besides which it is a dress justly supposed to
carry no small terror to the enemy, who think every such person a com-
plete marksman" (in Lefferts 1926, 11).

In 1790, Washington, now president, met with the influential and
acculturated Creek Chief Alexander McGillivray and his party in New
York in 1790. McGillivray was the son of a wealthy Scottish trader,
Lachlan McGillivray, and his wife, Sehoy Marchand. Her father was
French and her mother a full-blooded Creek of the powerful Wind clan,
from a town on the Coosa River in Alabama. During his meeting with
Washington, McGillivray—whose dream was to establish a unified Mus-

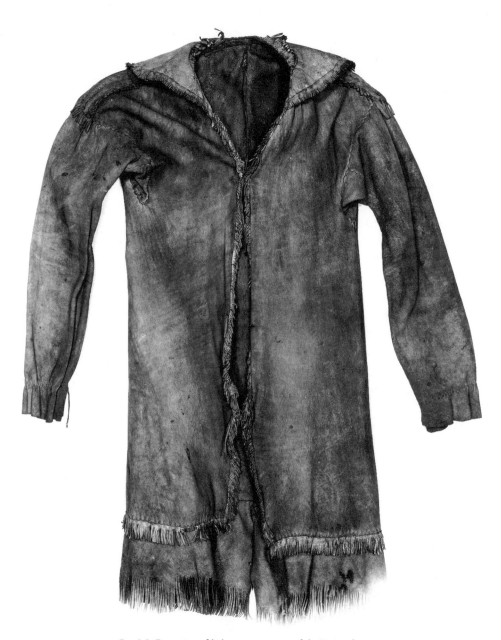

Fig. 1.3. Front view of hide hunting coat, Seminole, 1830s. Leather. Length: 43". Said to have been worn by Osceola at a treaty meeting. Photograph courtesy of the National Museum of the American Indian, Heye Foundation. Acc. no. 22/9750; neg. no. 30038.

kogee National Council controlling all Creeks as well as the Seminoles, whom he illegally claimed to represent—signed a land cession treaty known as the Treaty of New York.

There are no surviving portraits of McGillivray himself, but portraits of five Creek leaders accompanying him were drawn by artist John Trumbull. The portraits of these Upper Creeks give us a rare glimpse of the changes in Indian dress that had taken place by the late eighteenth century (fig. 1.4).

Hopothle Mico, known as Talassee King of the Creeks, and Tuskatche Mico, called Birdtail King of the Cusitahs, are drawn with prominent aquiline noses. They wear military-style coats with epaulets and metal buttons, ruffled shirts, silver gorgets, presidential medals, and earrings. The other leaders have rounder noses adorned with nose rings. They wear plain shirts with Indian-made cotton long shirts, which became more common as men's clothing styles evolved over the years (fig. 1.5). Stima-futchki, or "Good Humor," of the Coosades Creeks, has a moustache, which suggests a racial mix, since Indian men have few facial hairs. He wears three gorgets and silver arm bands.

A turban-style headdress with the customary feathers is the most notable addition to the clothing worn by Indian men in their portraits. As paintings or drawings of Creek, Seminole, Cherokee, and other Southeastern Indians, as well as Great Lakes Indians, attest, the men in those tribes had begun wearing the turban headdress—inspired by an unknown source—sometime in the late eighteenth century. These turbans might have been introduced by the British, who would have encountered them in colonial India.

The terms of McGillivray's Treaty of New York were, however, prevented from being enforced by surveying difficulties. Hopes for a unified Muskogee National Council were further weakened with his death in "the sands of the Seminoles" at Pensacola in 1793. Yet the terms of the treaty were reaffirmed by the Treaty of Coleraine, which was signed by an unauthorized group of Creek chiefs in 1796 at an American trading post on the upper St. Marys River. Boundaries were set for the ceded lands, and the chiefs further agreed that all the black slaves who lived

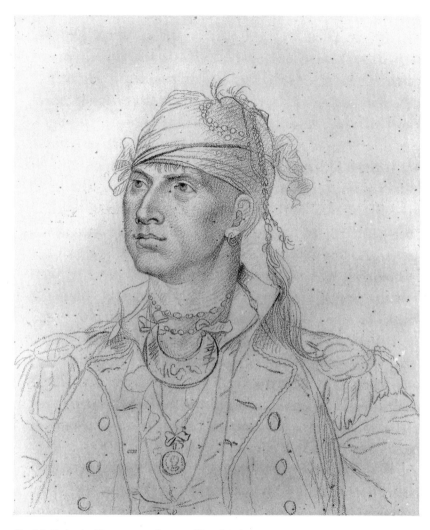

Fig. 1.4. *Tuskatche Mico, or the Birdtail King of the Cusitahs,* drawing by John Trumbull, 1790. The Creek chief wears a turban along with his gifts of clothing and silver ornaments, a combination that reveals the changes taking place in Southeastern Indian dress. Photograph courtesy of the Smithsonian Institution, National Anthropological Archives, Smithsonian Institution. Neg. no. 1169-L5.

Fig. 1.5. Men's dress styles and essential elements of clothing through the years. Top row, left to right: plain shirt, 18th century; plain shirt, 1880; long shirt, rear view, 1880.

Middle row: big shirt, 1910; doctor's coat, 1970s, front and rear views. Bottom row: big shirt, early 1940s; transitional shirt, 1940s; Eisenhower-style jacket, 1970.

among the Creeks, including the Florida "Creeks"—namely, the Seminoles—would be returned. This treaty was significant because the unauthorized promise to return slaves deepened the schism among the Seminoles, the Creek nation, and the Americans. Indeed, the issue of returning slaves was of growing concern to Americans and Indians alike. With the signing of the Treaty of Coleraine, the Indians were expected to surrender blacks who, as Joshua Giddings wrote in 1858, were by that time "their friends and neighbors and who now stood connected with them by marriage and in all the relations of domestic life" (Giddings 1964, 12–13).

Weak Spanish control of Florida had made it a haven for runaway slaves, although African blacks on the frontier included slaves, runaways, and freedmen. Seminoles were often slaveowners, but they treated slaves better than did the Creeks and other Indian groups and the white plantation owners. Seminole slaves lived more as dependents than slaves. For some time, blacks lived in separate but nearby communities: they did not seem to live among the Seminoles until perhaps as late as 1774, after which integration and personal relationships intensified (Mahon 1967, 20). Afro-Seminoles or "Maroons" had thus become an established part of the Indian community through friendships or marriage. Except in the case of arranged marriages, a simple agreement between a man and woman constituted a marriage in the Indian culture. The Indians had, moreover, been exposed to the example of white men on the frontier, who indiscriminately entered into either temporary alliances or marriages with Indian or black women.

These close relationships between blacks and Seminoles offered an opportunity for the introduction of African artistic and cultural influences. The full extent of those influences is not as yet known, but research is revealing that it appears to be more extensive than had previously been thought, especially in such crafts as appliqué, bead embroidery, and coiled basketmaking. In addition to learning various domestic skills, many slaves had also mastered Spanish or English from their experience with plantation owners. Blacks who could speak and translate Spanish, English, and Indian languages accordingly became influential advisors and interpreters.

By the opening of the nineteenth century, however, the relations among

the Americans, Lower Creeks, and Seminoles had continued to deterio-
rate. The Spanish had virtually no control over Florida, which was a
hotbed for the lawless and unruly, including renegade whites and Creek
Indians looking for runaway slaves. The Indian debt for trade goods soared
and, as white settlers crowded onto their land throughout the Southeast,
Indian leaders experienced a growing apprehension.

2

Fears of further unrest proved justified by events in the nineteenth century, which also had a great impact on dress. Highly acculturated Indian men and women adopted the clothing styles of whites, along with the associated techniques for the production of apparel. Indian interpretations of what they considered impressive dress, based on European military or other styles and materials, increasingly became the mark of leaders.

In 1803 President Thomas Jefferson appointed Colonel Benjamin Hawkins to the position of agent of the United States to the Creeks and Seminoles. His mission, as defined by the American government, was to acquire Indian land and "civilize" the Indians by teaching them the ways of white men so that they might eventually be assimilated. The Indians became alarmed when Hawkins initiated an unpopular policy of encouraging Indian women to develop their spinning and weaving skills, which would allow them more independence. Furthermore, the men were to learn agriculture, which they saw as an effort to undermine their traditional male hunting roles. Indians, once free to roam and hunt, were expected to settle on small farms owned by the male head of the household, an arrangement that would have upset the traditional matrilocal living pattern.

Moreover, in the years leading up to the War of 1812, the British were eager to incite the Indians against the Americans. After all, Indian allies had fought for the British in both the North and the South along the frontier. Now they turned to Tecumseh, a Shawnee prophet living above the Ohio River, who shared their hatred of Americans. Tecumseh, whose mother was a Creek, toured the Southeast preaching his nativistic message, which urged pan-Indian unity against American policies aimed at

changing traditional Indian lifestyles. Resistance to foreign clothing and materials became a marked part of his plea. He encouraged the people to "return to their primitive customs; to throw aside the plough and loom, and to abandon the agricultural life, which was unbecoming Indian warriors . . . to use none of their arms and wear none of their clothes, but dress in the skin of beasts, which the Great Spirit had given his red children for food and raiment, and to use the war-club, scalping knife and bow" (Pickett 1900, 512–13). Seminoles reportedly traveled to Hickory Ground at the Upper Creek town of Little Tallassee to listen to the message of Tecumseh in 1811. Prophets who were followers of Tecumseh worked among the Seminoles (Wright 1986, 152–53, 161, 168). Seekaboo, a Creek prophet and a cousin of Tecumseh who toured with him and served as an interpreter, moved to Florida and joined the Seminoles after 1814.

The same period also saw the Creek War of 1813–14, essentially an Indian civil war rooted in ancient rivalries between the various linguistic and tribal groups that composed the Upper Creeks and Lower Creeks. In addition to these long-established animosities, Upper Creeks were incensed at the compliance of some Lower Creeks who now virtually lived as white settlers, following Hawkins's directives. Americans tended to view Upper Creek policy as guided by fanatical prophets. During this period, however, much of the Creek leadership on both sides was in fact provided by the wealthy and acculturated Indian sons of Highlander or British traders. The influence of the many Indian leaders with European fathers was considerable at all levels of trade or business and in political transactions.

Nativistic Upper Creek leaders included the well-to-do prophets Peter McQueen and Josiah Francis. McQueen, the son of a Tallassee woman and the Highlander trader James McQueen, did not speak English. Josiah Francis was the son of an Upper Creek woman from a "Red Stick" or war town and David Francis, a British trader and silversmith who made buckles and ornaments for the Indians, his son following in his trade. Josiah Francis, also known by his Indian name, Hillis Haya, meaning "medicine man," had joined Tecumseh's cause and danced the frenzied dance of the Great Lake Indians. Francis became a very important prophet

in the Creek nation. He spoke some English and readily sided with the British (Sugden 1982, 277).

Josiah Francis, Peter McQueen, and other Red Stick Creeks fled to Spanish Florida after Andrew Jackson defeated the Upper Creeks at Horseshoe Bend in March 1814. Many Red Sticks arrived in Florida as destitute refugees, who then aligned with the Seminoles, the blacks, and the British. They were led by Major Edward Nicholls and Captain George Woodbine, who fed, armed, and dressed them in British uniforms and marched them in public drills in the vicinity of Pensacola and the Apalachicola River in August 1814 (Mahon 1967, 22).

When the British ultimately deserted Florida, Nicholls took Josiah Francis and a small party of Indians to England with him, where Francis was treated with distinction and given many gifts, including clothing. A London journal of the time reported that when Francis met with the prince regent he was "dressed in a most splendid suit of red and gold, and by his side wore a tomahawk mounted in gold" (Partons 1860, 397). Francis did a self-portrait, in which he is wearing his new finery. The collection of the British Museum includes not only his self-portrait but an authentic Indian costume he left behind, collected around 1816 and accessioned as the dress of the Muskogee Chief Francis. This costume provides a rare look at early examples of the hand-crafted elements of Creek Indian dress of the period. It includes a fringed hide hunting coat, leggings, and moccasins, as well as native woven wool and bead garters, sash, strap, and shoulder bag (see plate 23). The moccasins are cut of one piece of hide sewn up at both the rear and the front and laced at the ankle. A sawtooth design is embroidered over the front seam in red thread.

Francis and the other Indians sailed home in 1817. Returning to the scene of continuing hostilities, Francis was "called by his people to put himself at their head" (Sugden 1982, 311). The destruction in 1816 of a settlement known as Negro Fort on the Apalachicola River had infuriated blacks and Indians alike, who were moving farther south into Florida. Combining forces with the Seminoles, they prepared for war in the spring and summer of that year.

A group of Lower Creek warriors from Georgia led by Chief William

McIntosh, whose mother was a member of the influential Wind clan of Coweta, had earned a reputation among the Americans as "friendly" Indians because of their cooperative attitude. Although McIntosh's father had been British agent to the Lower Creeks during the Revolution, when McIntosh assumed Lower Creek leadership he joined forces with Andrew Jackson's armies, battling Red Stick Upper Creeks during the Creek War in Alabama. Not only did this earn him the reputation as the archrival of the Upper Creeks and the Seminoles, but the Lower Creek alliance with the Americans also fueled bitter fires of hatred that smoldered throughout the Seminole Wars.

The two surviving portraits of McIntosh reveal the dress of a highly acculturated Creek chief of the period. One is a bust portrait, reproduced in *The McKenney-Hall Portrait Gallery of American Indians*, which describes him as "the handsome Creek who looked like a swarthy Scots Highland chief" (Horan 1972, 122). His fur bonnet, with its plumes and silver band, is indeed similar to the style of bonnet familiar from portraits of Highland officers: Highland banded bonnets had a plaid headband and were decorated with black and white ostrich plumes. McIntosh also wears a ruffled shirt with a black neck scarf or cravat. His checkered garment is topped with a popular style of greatcoat with an attached fringed cape. A fingerwoven beaded strap crosses his chest. The broadsword he holds in his hand was probably a Highland ancestral weapon. In the full-length portrait painted by Washington Allston, McIntosh again wears a ruffled plain shirt and black cravat, but this time topped by a calico long shirt worn with decorated leggings and moccasins. His sash and garters are fingerwoven and decorated with white beads. The large diamond-patterned strap that crosses his chest holds a pouch. He has a moustache and a full head of hair, in contrast to most Creek men. This portrait was painted sometime before McIntosh was executed by angry Creeks in 1825 for signing the Treaty of Indian Springs, which illegally ceded large tracts of their land in Georgia to the Americans.

During the rivalries that continued from the end of 1817 and into 1818 and became known as the First Seminole War, McIntosh and his Creek warriors joined Andrew Jackson and other Georgia volunteers to wreak

havoc on the Seminoles in raids, swooping down on their Florida towns by the Apalachicola and Suwannee Rivers and Lake Miccosukee. They burned deserted Indian towns to the ground, took cattle, valuables, and supplies, and captured many runaway slaves and Afro-Seminoles. The period marked the beginning of a fugitive and difficult life for the once-prosperous Seminoles, resulting in a decline of their arts and crafts as well as an interruption of their ceremonial activities. At the same time, interaction between blacks and Seminoles intensified as they faced their common enemies.

The Americans, however, took a dim view of these activities. General Jackson commented to the naval officer Captain McKeever: "It is reported to me that Francis . . . and Peter McQueen, prophets, who excited the Red Sticks in their late war against the United States, are now exciting the Seminoles to similar acts of hostility, are at or in the neighborhood of Saint Marks." Jackson accordingly ordered Josiah Francis taken. Both Francis and the chief of the town of Homathle, Homathle Mico, were captured in March 1818 by Captain McKeever on board his ship, which was deceptively flying British colors in the harbor near Saint Marks. Both were taken to the American fort nearby, where they were hanged. Francis was described at the time of his hanging as "dressed with a handsome gray frock coat, a present to him while on his late trip to England. The rest of his dress was Indian" (Partons 1860, 447, 459).

When Spain turned Florida over to the Americans in 1821, Andrew Jackson was appointed the first governor by President James Monroe. Although he served as governor only for a brief time, as his influence increased he became more determined that the Indians must be removed from the Southeast. Seminoles signed a treaty at Moultrie Creek in 1823 that forced them to surrender their claim to the whole of Florida. The Indians and their cattle were no longer free to roam the territory but forced instead to live in designated areas located south of Tampa Bay and inland from both coasts by fifteen miles. Land was also set aside for the Creeks who lived in the northwest section of Florida near the Apalachicola River.

The Seminole dress of the period was discussed by Major General

George McCall in a letter written to his father from the Seminole Agency on August 26, 1826, in which McCall described the inauguration of the Miccosukee he called "Tuko-see-mathla" to the position of Supreme Chief of the "Seminole Nation." (The spelling of Indian names often differs in various historical accounts, which can cause considerable confusion. For example, "Tuko-see-mathla" has also been spelled "Tukosee Mathla," although the spelling now used by linguists is "Tukose Emathla." To complicate matters further, Tukose Emathla was also known to whites at the time by the name of John Hicks [Wright 1986, 29–30].) Three thousand people were present at Tukose Emathla's inauguration, which was conducted by his fellow Miccosukee tribal members—but only men crowded into the amphitheater where the event took place. A Miccosukee chief dressed in war paint and his best apparel led one hundred warriors in a snake dance honoring Tukose Emathla's clan.

The new chief was then called upon to address his people. He humbly stepped out with his head and feet bare, "and his only garment save the flap always girt about the loins of a Seminole, whose tapering ends, ornamented with beads and various-colored embroidery, fall both front and rear to the knee, was a simple shirt of a dingy brown, whose folds did not reach the knee." But Tukose Emathla was transformed the next day when he appeared at the agent's quarters dressed in what McCall described as "the most sumptuous habiliments you can imagine. His frock, or coat, was of the finest quality, and adorned with a quantity of silver ornaments around his neck, arms and wrists, with a gorgeous head-dress of colored shawls. He wore hide moccasins and wool leggings with woven garters and a bandolier. His bearing was that of a chief indeed" (McCall 1974, 155, 156).

Beginning in the spring of 1825 a severe drought hit Florida, and many of the approximately five thousand Indians living in their designated regions were left starving. Angry clashes and other incidents occurred between whites and Indians as desperate Indians wandered onto white land in search of food. Increased numbers of claims on the part of whites for the return of runaway slaves added to the friction (Mahon 1967, 58). In 1826 Tukose Emathla and a delegation of Seminoles traveled

to Washington to discuss the growing crisis with Colonel Thomas L. McKenney, the superintendent of Indian trade, and with the secretary of war.

The leaders of many tribes who went to Washington to meet with the president and the secretary of war passed through the doors of Colonel McKenney's office during his sixteen years as superintendent. McKenney arranged for portraits to be painted of the visitors by Charles Bird King and other artists (see Horan 1972), without which we would not have a collective record of Indian dress during a time of dramatic social and cultural upheaval in the Indian way of life. All but a few of the original paintings perished in the Smithsonian Institution fire of 1865, with the result that only prints of most of the Indian portraits remain. Most of these were bust portraits of Indian men, for it was the men who assumed leadership roles when it came to dealing with the non-Indian world, attending conferences in major cities where artists were present. There are consequently few portraits or descriptive accounts of Seminole women's dress in the nineteenth century.

Charles Bird King painted bust portraits of many Seminole leaders, but he also did a full-length portrait of Tukose Emathla that shows his fine dress in detail (fig. 2.1). He wears a scalloped and embossed turban band of silver, as well as arm and wrist bands. Although silver ornaments were worn with other finery by most nineteenth-century Indian leaders for their portraits, only the most important leaders seem to have worn turban bands. A medal bearing a portrait of the president along with his silver gorget are suspended on his chest. The bottom of his coat is decorated with rows of sawtooth designs and straight-line appliqué trim. This is the first depiction of Seminole appliqué (fig. 2.2). It verifies that the women had learned the technique of patiently hand sewing these new decorative designs onto clothing sometime prior to 1826, but the exact time and source of the introduction of the technique is as yet undetermined.

Training in the technique might have come from slave women of African origin, for sewing chores were among the many responsibilities of slave women on southern plantations. As growing numbers of blacks crossed into Florida, associations with the Seminoles intensified, whether through

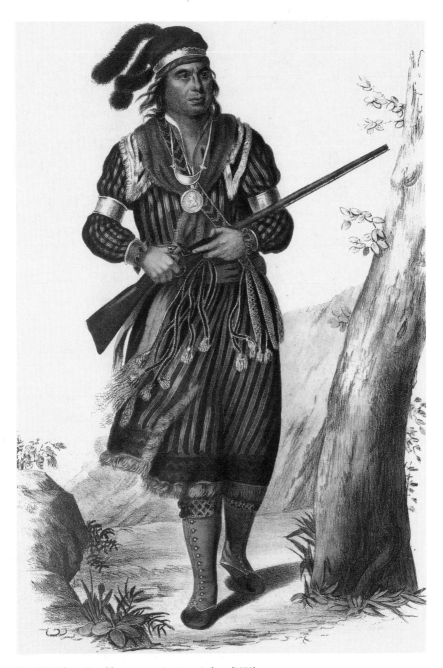

Fig. 2.1. Tukose Emathla, lithograph after Charles Bird King, 1826. Published in James Horan's *The McKenney-Hall Portrait Gallery of* *American Indians* (1972). Photograph courtesy of the National Anthropological Archives, Smithsonian Institution. Neg. no. 45, 112-F.

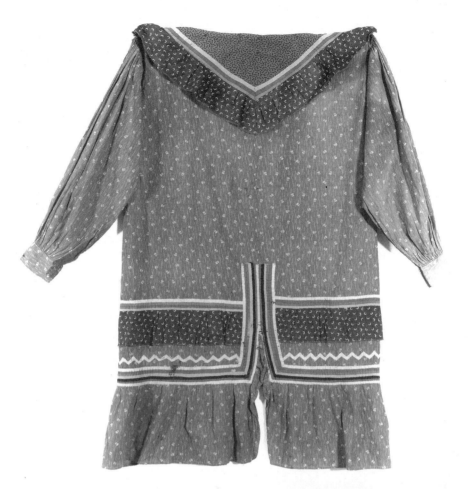

Fig. 2.2. Doctor's coat with appliqué decoration, Seminole, early twentieth century. Rear view (above). Detail of appliqué work (right) shown from the reverse side so that the hand-stitching is visible. Courtesy of the Historical Museum of Southern Florida.

friendship or marriages that produced Afro-Seminole children. Although Europeans also used the technique, appliqué was a refined art among the West African cultures that were most exploited for slavery. Cultural and artistic exchanges between Seminoles and blacks could easily have resulted in the sharing of technical skills as well as the outright borrowing of some design motifs of African origin. Sewing was, for example, part of the traditional training in arts of feminine elegance and power among African women and others of Cross River cultures. Young girls learned embroidery and many other skills, including how to make symbolic appliquéd cloths (Thompson 1984, 227–33). Symbolism played a part not only in the designs but also in the colors selected. Appliqué techniques have been found in use by groups of African origin in regions of the Caribbean and South America as well.

The problem of large numbers of runaway slaves fleeing to Florida and finding refuge with the Indians gave slaveholders an incentive to increase efforts to force the removal of all Eastern Indians to lands west of the Mississippi. A bill making way for precisely such a removal was passed by the United States Congress and signed by President Jackson in 1830. Then, on May 9, 1832, Seminoles were coerced into signing the Treaty of Paynes Landing. According to this treaty, they were to relocate on land formally designated as Indian Territory in the western part of Arkansas (now Oklahoma), which they would share with the hated Lower Creeks, who were already settled there. Adding insult to injury, their annuities would be controlled by the Creeks, and they would be under the rule of the Creek National Council.

Tukose Emathla was among a delegation of seven Seminole chiefs who departed for the West in October 1832 to inspect the proposed land. They were accompanied by Seminole Indian Agent John Phagan and their black interpreter, Abraham. A treaty approving the land selected was signed by the chiefs in Arkansas at Fort Gibson on March 28, although under duress, because Agent Phagan apparently warned the chiefs that he would not lead them back to Florida if they refused. As the party had already been stranded for some time while other negotiations were carried on, the Seminoles feared they would never see their homeland again.

46 After the delegation returned to Florida they protested about the pressure Phagan had put on them. He was subsequently dismissed, and General Wiley Thompson replaced him as Seminole Agent at Fort King in December 1833. As for the Seminole people themselves, they angrily refused to be removed when they heard of the treaty. According to U.S. Superintendent Colonel McKenney, Osceola, who was emerging as a leader against the policy of removal, had Tukose Emathla killed "by sending sixteen bullets through him" because of his support of relocation to the West (Horan 1972, 252). Deprived of the moderating influence of Tukose Emathla, the Miccosukees became the group most adamant against removal.

After Tukose Emathla's death, the Indian leaders were primarily hereditary chiefs such as Micanopy, whose title as a Seminole chief had descended matrilineally from the line of chiefs Payne and Cowkeeper, Lower Creeks from Georgia who had moved into the Alachua region in the eighteenth century. One of Micanopy's sisters was married to King Philip, a leader of Miccosukees settled east of the St. Johns. The bravery of Philip's son—best known by his Indian name, Coacoochee, or "Wildcat"—matched that of Osceola. Moreover, Coacoochee could claim the right to leadership from both his parents, which united the Miccosukee and Alachua lines. Micanopy's other sister was married to an Upper Creek warrior, Jumper. The witty and intelligent "Alligator," whose Indian name was Halpatter Tustenugee, meaning "War Leader," also exerted great influence. But a militant medicine man, Sam Jones or Arpeika, who led a band of Miccosukees, was considered the most defiant opponent of removal. In addition, other of Florida's Indian leaders, from bands of Tallahassees, Yuchi, and the so-called Spanish Indians from the coastal region, also resisted the idea.

In all this, the Indians were counseled by their black "sense bearers," or advisors, and thus were at the mercy of the latter's interpretation of the negotiations. The most influential of the interpreters was Abraham, who was considered a chief in his own right because he had married the half-black widow of Micanopy's uncle, the late Chief Bowlegs. Abraham has been described as "ambitious, avaricious and intelligent" and was probably once the house servant for an Englishman for "his words flow

like oil" (Klos 1989, 69). These black or Afro-Seminole men were generally portrayed as dressed in Indian garb, but some wore suits or trousers.

As these Indian leaders and their advisors made plans for war, the primary target of their hostility became Indian Agent General Thompson, Phagan's replacement. Thompson had made what the Seminoles considered numerous serious mistakes. For one thing, he had discontinued the practice of presenting gifts to the Indians during the payment of annuities. They were further angered when he banned the sale of alcohol, gunpowder, lead, and arms to them. But his fatal mistake, according to one account, was to infuriate Osceola by seizing his wife, Morning Dew, who had been born to a runaway slave mother and Indian father (fig. 2.3). In June Thompson had Osceola put in irons and then confined after an outburst of abusive language. The humiliated Osceola was kept in custody long enough for him to plot his revenge.

The Second Seminole War

The Seminoles thus prepared for war, securing their crops and moving their women, children, and livestock to the interior for safety. The beginning of the Second Seminole War was marked by two events. On December 28, 1835, Osceola and his warriors crouched in the palmettos and undergrowth at Fort King, waiting for General Thompson to leave the protection of the fort for his accustomed afternoon walk. Thompson and his companion, Lieutenant Constantine Smith, never returned. Thompson was apparently killed instantly, and pieces of his scalp were divided among the participants at their celebration (Mahon 1967, 104).

Meanwhile, Major Francis L. Dade was leading eight officers and one hundred enlisted men from Fort Brooke to Fort King. They were ambushed by a party led by Alligator and Jumper. Seminole warriors were described as an awesome sight in battle. Most only wore a breechcloth, and their bodies were menacingly streaked with red and black paint. Fighting began with a terrifying war whoop, an animal-like growl ending in a shrill yelp that struck fear in the soldiers, who compared it to "Gaelic war cries" (Mahon 1967, 123–24). The sole survivor of the attack on

THE NATION ROBBING AN INDIAN CHIEF OF HIS WIFE.

When monarchical Spain governed Florida, many slaves fled thither from republican oppression, and found shelter. One of them, having married an Indian chief, their FREEBORN daughter became the wife of Oceola. She was seized as a slave, in 1835, by a person, (who had probably never seen her,) holding the claim of her mother's former master. Oceola attempted to defend his wife, but was overpowered and put in irons, by General Thompson, (our government agent,) who commanded the kidnapping party. What marvel that an Indian Chief, as he looked on his little daughter, and thought of his stolen wife, vowed vengeance on the robbers?

WILL THE FREE STATES MAKE A NEW SLAVE STATE?

They must do it if it is done. They cannot do it without *enslaving themselves* while they fasten the chains on others. We have already made 7 new slave states, with a territory ☞16,000 SQUARE MILES LARGER THAN THAT OF ALL THE FREE STATES, which when as thickly settled as Mass., if proportioned like S. C., will hold nearly 20,000,000 slaves. These states use their power in Cong. to stifle the voices of states that gave them being, thus trampling on *them* as they do on their own slaves.

When the Constitution provided for the representation of slaves, it was supposed that the South had not her share of power in the Senate, and that slavery would soon cease. Now, when 4,000,000 free inhabitants of the South have the same power in the Senate with 7,000,000 at the north, the people of the South have 24 representatives for their "property." In 1833, 3,797,577 free inhabitants of the slave states had the same power in Cong. as 5,854,133 free inhabitants of the free states, i. e. 2 at the South *overbalanced* 3 at the North, and this disproportion constantly increases. Thus we give them power over us as a *bounty* on slaveholding.

If northern freemen were as largely represented as southern slaveholders were in 1833, 4,525,879 inhabitants would be entitled to our whole power in Congress, thus leaving 2,450,965 virtually UNREPRESENTED, a population which, at the average of southern representation, would be entitled to 15 Senators, and 63 representatives.* The effect, in all questions where freedom and slavery come in collision, is the same as if all New England and Ohio were unrepresented!!!

But why make Florida a **slave state**? Because, forsooth, it is the *slaveholders'* WILL. Florida was no part of the original union. She cannot pretend that we have made a "compromise" with her, promising to sacrifice liberty and justice at her bidding. Till 1819, the territory being under the gov't of Spain, occasioned great vexation to slaveholders, by affording a "refuge" from slavery. After "protracted negotiations," it was brought under "republican" government, at a cost of $5,000,000.

Hungry men-stealers soon snatched at their prey. Hon. Horace Everett, M. C from Vt. in a speech in Congress, June 3, 1836, quotes from Gen. Thompson's letters, as follows: "Oct. 28, 1834. There are many likely negroes in this nation; some

* The power of the North in 1833 was $\frac{24}{48} = \frac{1}{2}$ of the Senate, $+ \frac{14\frac{1}{2}}{240}$ of the House, $= \frac{26\frac{1}{2}}{480}$ of the whole power of Congress, while by the census of 1830, the North had more than $\frac{310}{480}$ of the free population. At the same time the power of the South was $\frac{219}{480}$, while her free population was less than $\frac{170}{480}$ of the whole.

Fig. 2.3 (facing page). *The Nation Robbing an Indian Chief of His Wife,* from the *American Anti-Slavery* *Almanac,* 1839. Photograph courtesy of the Richter Library, Mark A. Boyd Collection, University of Miami.

49

Dade's group returned to Fort Brooke to report that the Indians had taken uniforms, food, and ammunition. Blacks had killed those still alive and looted the dead.

Major General Thomas Sidney Jesup, a Jacksonian, brought Lower Creeks with him to fight the Seminoles when he took full command in Florida in December 1836. He has the distinction of being remembered as the most infamous white participant in the war, for his relentless pursuit and devious capture of Indian leaders. The loyalty and affection of the Indians for the blacks made slavery a very sensitive issue, and Jesup wrote that "this is a negro, not an Indian war" (Mahon 1967, 196).

A group of Indian warriors dancing around a fire near the St. Johns River in 1838 was observed and drawn by Hamilton Wilcox Merrill of the Second Dragoon (fig. 2.4). Their tribe was not identified, but they were probably Miccosukee. The drawing portrays eleven men in varying attire, which reflected personal preferences as well as their status or their role in the gathering—whether they were chiefs, warriors, or medicine men.

Two of the men in Merrill's drawing wear only triangular flap breechcloths and turbans, while the other nine wear long shirts of calico or hide. The bottom of one coat is fringed in the style of a hide hunting coat; the other coats have either plain or ruffled bottom edges. Five of the eleven men wear feathered turbans, and some wear garters and what appear to be leggings. The man with upraised arms seems to have been chanting and probably was the dance leader. The man to his left appears to be wearing the most impressive costume, which includes two silver gorgets, although another man wears one gorget. Two naked infants, a naked boy, and several young men in long shirts sit by the edge of the group of dancers. Merrill's drawing thus captured a veritable catalog of the male dress of the period.

Many consider Osceola to have been the singularly most popular and tragic hero of the Second Seminole War, inasmuch as he personified the spirit of Indian resistance to white domination (Hartley and Hartley 1973,

Fig. 2.4. Seminole dance,
drawing by Hamilton Wilcox
Merrill, 1838. Photograph
courtesy of the Henry E.
Huntington Library, San
Marino, California.

11). He was not a hereditary chief but a subchief who earned his leadership role because he was ambitious, intelligent, and cunning. There is considerable disagreement over his background. Osceola was born in Alabama around 1804 and, although he denied having white blood, his lineage has been traced to the Highlander trader James McQueen (Wickman 1991, 8–10). His mother, Polly Copinger, was an Upper Creek of the Tallassee group, so Muskogee would have been Osceola's native language, but in Florida he associated with Miccosukees. Polly is said to have been McQueen's granddaughter, and the prophet Peter McQueen her uncle. She married the trader William Powell, and Osceola, or Billy Powell, was their only child. His childhood Indian name is not known, but his adult Indian name was *así:yaholî* (Wickman 1991, xxi), which means "Black Drink Singer"—the title of his ceremonial role. Whites pronounced the name Ussa Yahola and then Assiola, before finally Anglicizing it to Osceola. As an adult, he was also called "Powell" by whites.

Polly and her young son arrived in Florida with Peter McQueen's band following the defeat of the Upper Creeks in Alabama. Osceola was reared with a deep hatred of Lower Creeks and a strong dose of nativistic doctrine. He also was closely associated with blacks. When he was eventually captured under a truce flag as ordered by General Jesup and imprisoned at Fort Mellon in 1837, he requested that his family join him. The party of fifty that arrived was said by Lieutenant John Pickell to include Osceola's two wives, two children, a sister, three warriors, and "the remainder negro men, women & children" (in Francke 1977, 56).

Osceola was the primary subject of several artists whose sympathies were aroused by his plight. These included Captain John Roger Vinton, who met Osceola at Fort Mellon. In addition to making several sketches of Fort Mellon (fig. 2.5), Vinton did a bust portrait pencil sketch of Osceola that contemporary sources declared an accurate likeness. Vinton also made a full-length pencil sketch of Osceola wearing a hide hunting coat with short sleeves. Another hide hunting coat that reportedly belonged to Osceola is now in the collection of National Museum of the American Indian (see fig. 1.3). It has long sleeves, gathered at the wrist, and the hide is tailored and stitched with sinew. The bottom is fringed and consists

Fig. 2.5. *N.W. View of Fort Mellon,* pencil sketch by John Roger Vinton, 1837.

Photograph courtesy of the Richter Library, Mark A. Boyd Collection, University of Miami.

of an additional strip of leather approximately ten inches wide that has been added below an upper row of fringe. The opening and collar are also fringed, the latter falling to a deep **V** in the back, essentially creating a cape.

Osceola was also depicted wearing a calico long shirt in portraits painted during his incarceration at Fort Moultrie in 1837–38. The artist George Catlin in particular was afforded an excellent opportunity to draw and paint imprisoned Seminole leaders and their families, although his work often leaves much to be desired by way of accuracy and detail. But Catlin befriended Osceola and took great care in his full-length portrait of Osceola, portraying his subject holding a gun and wearing his hide hunting pouch and powder horn (fig. 2.6). Writing in his journal, published in 1844, the artist claimed that his painting was accurate in every detail: "I have painted him precisely in the costume in which he stood for his picture, even to a string and a trinket. He wore three ostrich feathers in his head, and a turban made of a vari-colored cotton shawl—and his

dress was chiefly of calicos with a handsome bead sash or belt around his waist, and a rifle in his hand" (Catlin 1973, 2:219).

Catlin had departed from the fort before Osceola's death on January 30, 1838, but included in his journal is the letter the attending physician, Dr. Frederick Weedon, wrote to him describing the event. About half an hour before he died, Osceola "rose up in his bed, which was on the floor, and put on his full dress, his shirt, leggings, and moccasins, girded on his war belt—his bullet pouch and powder horn." Calling for a looking glass and his red paint, he carefully painted vermillion on one half of his face, neck, and throat, and on his wrists, the backs of his hands, and the handle of his knife—"a custom practiced when the irrevocable oath of war and destruction is taken." He arranged his turban and feathers. After shaking hands with all present, he was lowered to his bed, placed his knife on his chest, and quietly died (Catlin 1973, 2:221–22).

In addition, Catlin made several drawings and one painting of the women who accompanied Osceola and the chiefs imprisoned at Fort Moultrie—one of the rare instances when women are portrayed. Unfortunately, although their garments are invariably long-sleeved, it is impossible to tell from these portraits whether the women wore one-piece dresses or two-piece outfits of blouse and skirt, because their midsections are hidden. They are often shown holding infants on their laps and wearing shawls. Catlin portrayed one Seminole woman whose clothing was decorated with many silver brooches (fig. 2.7), and other women also wore numerous silver bodice ornaments. Another woman wears earbobs and circular pendants among her strands of beads (see Catlin 1973, plate 241). A row of appliqué decoration is visible on the bottom of the skirts worn by several women.

While the business of war was handled by Indian men, Indian women were sheltered from contact and rarely seen publicly. The women maintained the camp, tended their small gardens, cooked for the family, and cared for the children and elderly left in their safekeeping by the warriors. Families stayed on alert for hasty retreats. According to descriptions by soldiers, housing in the camps and villages deserted by fleeing Seminoles often consisted of temporary palmetto-thatched huts.

Fig. 2.6. Osceola, painting by
George Catlin, 1838.
Photograph courtesy of the
American Museum of Natural
History, New York. Neg. no.
327045.

Fig. 2.7. Seminole woman,
painting by George Catlin,
1838. Photograph courtesy of
the National Museum of
American Art, Smithsonian
Institution. Acc. no.
1985.66.307. Gift of
Mrs. Joseph Harrison, Jr.

Although pottery making had virtually been abandoned by the fugitive Seminoles, they found outlets for artistic expression in crafts such as needlework, fingerweaving, or beadwork. As Dorothy Burnham states in her discussion of Canadian textile handwork, "The comfortable arts of spinning and weaving . . . are a true manifestation of the human spirit rising above the difficulties of a pioneering way of life" (Burnham 1981, xii). Likewise, Seminole women channeled their creativity into fingerwork for the fanciful dress and other elements of costume they devised for their men. The showy outfits made by these women underscored the dignity or rank of Indian men on public occasions when they came face to face with their enemies. Moreover, each item the women made took on a new preciousness as supplies and means of buying cloth, thread, needles, and beads became limited. Bead designs embroidered on shoulder bags, straps, and sashes were the most creative form of artistic expression during the wars. The few examples that remain in museum collections were given as gifts, traded in exchange for other items, or collected from the battlefields and deserted camps.

There are many historical accounts of the Second Seminole War. The most familiar consist of government reports or diaries kept by soldiers in the field, who primarily wrote of their own hardships when, for example, troops marching from Fort Mellon tracked Seminoles through uncharted terrain farther into south Florida. We thus learn that saw grass cut at the soldiers' clothing and undergrowth tore away their boots as they marched through murky swamp waters. They faced swarms of disease-bearing insects and had frequent encounters with poisonous snakes. Small bands of Indians watched the soldiers' every move, launched sneak attacks on them, and then vanished into the vast inpenetrable wilderness. It was the kind of war that could have dragged on endlessly.

But the story of the war has yet adequately to be told from the perspective of the Indians, Afro-Indians, and blacks, whose families were constantly in hiding or were chased from camp to camp. Rare mention was made of the fact that Indian women, children, and the elderly suffered far more than their warriors. Surgeon Jacob Rhett Motte wrote of their plight in his journal, eventually published as *Journey into Wilderness: An*

Army Surgeon's Account of Life in Camp and Field during the Creek and
Seminole Wars, 1836–38. While at Fort Jupiter in February 1838, he noted:
"From their appearance, I should judge the burden of the war to have
principally fallen upon the female portion of the natives; for while the
men looked in good health, spirit and conditions; the squaws but with
few exceptions presented a most squalid appearance, being destitute of
even the necessary clothing to cover their nakedness; many having around
them but the old corn bags we have thrown away, which they had picked
up in camp, and along our trail." In a rare public speech by a woman,
an Indian matriarch pleaded the desperation of their situation during a
ceremonial council, when the head of the Tuskegees met with General
Jesup toward the end of February. Motte described the opening ceremo-
nies and proceedings. After the calumet pipe was smoked, the old woman
"opened the talks. All of the warriors were her children she lamented;
many were slain, their villages burned, their children perishing. The star
of her nation had set in blood," and she desired that a perpetual peace
be arranged (Motte 1953, 207, 209).

Close relationships—bonds among family and friends—had been torn
apart along color lines when blacks and Indians were separated for re-
moval with total disregard to human passion, pain, and suffering. In April
1838 Major Isaac Clark wrote from New Orleans, where long-separated
black and Indian prisoners were gathered for removal, that "no movement
of the Indian negroes can be made at present. The Indians are almost in
a state of mutiny" because of attempts to separate the Indians and blacks
(in Giddings 1964, 204–5). Many had intermarried, but families had been
broken up. After being reunited, they were determined to die rather than
be separated again.

General Zachary Taylor, who replaced General Jesup in May 1838 and
held the command in Florida for two years, led bloody attacks against
the Indians. In June the general and his limited number of regulars dealt
with desperate actions "ascribed to four or five hundred Miccosukees,
Tallahassees, and a few renegade Creeks." Taylor believed that the "Semi-
noles," his preferred term for the Alachuas, were finished (Mahon 1967,
248, 252). But with regard to the "Indian-Negroes," he would not take

the slaves from the Indians and instead ordered that all captured be shipped from Florida with them. Although his order was disputed by white slaveowners and Creek captors, some three to four hundred blacks managed to reach the Indian Territory with the Seminoles.

The courage of the women was reflected in the very fact that they were capable of creating under the dire circumstances of the war. In his 1848 account of the war, Captain John T. Sprague commented on their perilous situation during the conclusion of hostilities in the early 1840s. Families were often forced to flee from the soldiers, leaving behind prized belongings. "The Indians left the soldiers in posession of their camp . . . abandoning large quantities of deer meat, dressed deerskins, half finished moccasins, axes, hoes, kettles and articles of clothing. . . . The women and children had left the night before in such haste as to leave behind thimbles, needles, thread and several highly ornamented dresses" (Sprague 1964, 458).

The war fizzled to an end without a victory or a treaty. The U.S. government ultimately recognized the hopelessness of ever finding the last of the Indians and shipping them from Florida. Moreover, the Second Seminole War of 1835–1842 was the costliest war the American government waged against Native Americans in terms of both expense and American lives lost. At the outbreak of the war, there were probably some four thousand Seminoles in Florida, approximately fifteen hundred of whom were warriors. With the help of an unknown number of black compatriots, these warriors were able to hold at bay a total of perhaps forty thousand white soldiers, killing fifteen hundred of them—one American soldier for every Seminole warrior (Hartley and Hartley 1973, 9). Indian death tolls are not known.

In the end, a majority of the Seminole chiefs, their people, and their slaves either had been persuaded to emigrate west or had been kidnapped or killed. By 1843, 3,824 Seminoles had been shipped west to Indian Territory (Mahon 1967, 321). The approximately four hundred men, women, and children left in Florida were to stay within the boundaries of a reserve that had been established in 1842, defined as "two and a half million acres of hunting and planting ground west and south of Lake

Istokopoga and west of a line running from the mouth of the Kissimmee
River through the Everglades to Shark River and thence along the coastline
to the Pease River" (Covington 1982, 3).

The remaining Indians lived in family camps deep in the south Florida
swamps. A small group of Muskogee-speaking "outsiders," whose leader
was named Chipco, lived along the north rim of Lake Okeechobee. Larger
groups included the camps of the Seminole Billy Bowlegs and the Micco-
sukee Sam Jones south of the lake. A council ground was located near
Jones's camp. Bowlegs, called Holata Micco or chief governor, was a
nephew of the Seminole chief Micanopy. He had been born on the Alachua
savannah and suffered the hardships of the wars. Although his lineage
is unclear, he was most likely named after the late Chief Bowlegs, who
was probably his great-uncle (Porter 1967, 219–24). Little was known
of Billy Bowlegs until 1839, but by 1842 he had additionally assumed
the leadership of the Indians who had remained with Sam Jones, who
had become quite feeble.

The various small matrilineal camps on the higher and drier pine ham-
mocks surrounded by swamps were connected by the web of footpaths
that ran through the region. Overgrowth concealed the camps from view,
so whites could have been quite close to an Indian camp without realizing
it. Families typically lived in palmetto-thatched chickees arranged around
a cleared field in the center of a hammock. They maintained gardens,
horses, cattle, and hogs. The people once more could acquire supplies
from stores at nearby forts, and they thus knew seven years of relative
peace and prosperity, from 1845 to 1852. In 1850 Seminole Emigration
Agent Captain John Casey distributed three thousand dollars worth of
presents to the women and children. Besides food and some five to six
hundred blankets, these included a variety of sewing goods: 3,630 pieces
of blue and orange printed fabric and drilling, 500 gross of binding, 85
dozen spools of thread, and many needles (Covington 1982, 19). Casey
estimated that there were 450 Indians and ten Seminole blacks living in
the state in 1851—and that the women were more adamantly opposed
to removal than the men.

The Third Seminole War

Billy Bowlegs proved to be the most notable figure of the Third Seminole War (1855–58). Bowlegs's leadership abilities had received praise in 1845 from Captain John Sprague, who observed that Bowlegs spoke English. In 1852 Bowlegs, a party of six other Seminoles, and Abraham—the black translator who had considerable influence with the Indians—embarked on their first trip to Washington to meet with President Millard Fillmore. Fillmore presented Bowlegs with a presidential medal, which he wore with pride.

Several impressive portraits of Bowlegs and his group were made on that trip to Washington and a later trip to New York (fig. 2.8). Bowlegs was described in the May 2, 1852, issue of *Gleason's Pictorial Magazine* as "a short, stout-built and quite ordinary looking man of about forty years of age" who was "clad in a calico frock, leggings and a belt or two and a sort of short cloak. On his head he wore a kind of turban enclosed in a broad silver band and surmounted by a profusion of black ostrich feathers."

A daguerreotype portrait also was made of Bowlegs in 1852 (fig. 2.9). He wears three large, showy gorgets, an embroidered bead bandolier, and a wide strap and garters fingerwoven in diamond patterns. Over the years, gorgets had become larger and were the most distinctive emblem of authority. His other silver decorations include finger rings, wrist bands, and a scalloped turban band. A patterned paisley scarf is attached to his feathered turban. His long shirt is fashioned of several calico prints with a vertically striped bottom ruffle and pronounced bands of appliquéd decoration. A cloth bandana is tied around his neck.

Although Bowlegs had given his word to President Fillmore that he and his followers would leave Florida, his promise was not immediately fulfilled. Meanwhile, efforts at Indian removal had increased in order to protect the white newcomers who arrived to claim their plots of land when south Florida was opened for settlement. New military camps or forts were built, and troops filled Fort Brooke, Fort Dallas, and Fort Myers. Army patrols kept a close eye on Indian activities, and survey parties

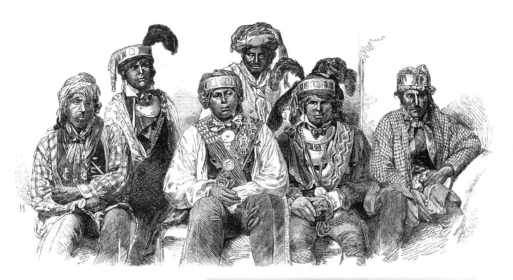

Fig. 2.8 (above). *"Billy Bowlegs" and His Suite of Indian Chiefs in New York,* 1852, line reproduction from the *Illustrated London News,* May 21, 1853. Photograph courtesy of the British Library. PP 7611.

Fig. 2.9 (right). Billy Bowlegs in New York, daguerreotype, 1852. Photograph courtesy Smithsonian Institution, National Anthropological Archives. Neg. no. 42-913.

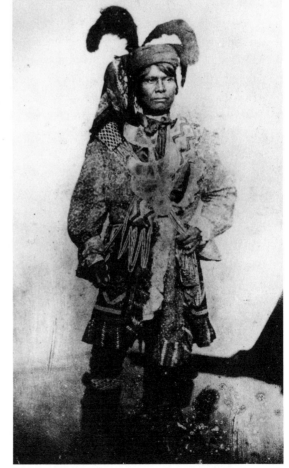

crossed reservation land, noting the location of camps. Apprehensive Indian leaders met in council in the fall of 1855 and determined that "whenever a suitable opportunity was presented, warfare would be waged against the white man" (Covington 1982, 35).

The Third Seminole War began in the early hours of December 20, 1855, when thirty Seminoles attacked a survey party led by First Lieutenant George L. Hartsuff. Several of Hartsuff's men had carried off bananas cut from plants near chickees in Billy Bowlegs's camp, which served to provoke the Indians. Perceiving no choice but to fight or be removed from Florida, the Seminoles chose to fight.

A campaign to force the Indians to surrender began in earnest in November 1856 with the arrival of the experienced Indian fighter General William S. Harney as commander of federal troops in Florida. He was greatly feared by the Seminoles, who remembered how relentlessly he had tracked them deep into the Everglades in 1838. Boat and land patrols began constant assaults on Seminole families in the Big Cypress and the Everglades in a campaign designed to force them to capitulate and agree to removal. Harney's plan was successful. One woman who succumbed said it was "much better to surrender than to run from one swamp to another, half starved and continually harassed by the troops" (Covington 1982, 63). The war hit home in Bowlegs's camp in November 1857. Some of his personal property—clothing, a shoulder bag and turban, an 1852 tintype of himself—was confiscated, which confirmed that the village was indeed his. One warrior, five women, and thirteen children were captured, and some forty nearby dwellings and stores of corn, rice, and pumpkin were destroyed.

A delegation of Seminoles subsequently arrived from the Indian Territory in Arkansas to discuss removal with Bowlegs. He agreed to a meeting in March 1858, at which an attractive financial offer convinced Bowlegs that the time had come for him and his followers to leave Florida. Efforts were then made to get word to the camps of other leaders. The leader of the band of Muskogees, Chipco, could not be reached, while the Miccosukee Sam Jones was told of Bowlegs's decision but refused to comply.

The followers of both Chipco and Jones also heard of the offer, and some decided to leave Florida. Some departed with Bowlegs; others left later.

Bowlegs's party—which consisted of thirty-eight warriors, eighty-five women and children, a number of slaves, and Ben Bruno, a black who served as a counsellor to Bowlegs—boarded the steamship *Grey Cloud* for their journey to the Indian Territory on May 4, 1858. On May 8, the Third Seminole War was declared officially at an end. Troops were transferred to other posts and the forts closed. It is impossible to know the exact count, but probably as few as two hundred Seminoles and very few blacks remained in Florida.

The colorful Chief Bowlegs and his followers attracted considerable attention when they stopped in New Orleans en route to Indian Territory at the close of the war. His visit was the subject of a three-page article, "Billy Bowlegs in New Orleans," that appeared in *Harper's Weekly* on June 12, 1858. The correspondent remarked that Bowlegs "wears his native costume; the two medals upon his dress, of which he is not a little proud, bear the likenesses of Presidents Van Buren and Fillmore." Line drawings taken from portraits of Bowlegs and several members of his party illustrated the article. The medals are prominent in his portrait. His leggings, which are more clearly visible than in the 1852 daguerreotype portrait made in New York, end by coming to a point on top of his shoes and are decorated with a serpentine design.

A comparison of the drawings of Osceola's party made by Catlin in the 1830s and the drawings of the Bowlegs party in 1858 reveals that the essential articles of clothing worn by men had remained constant. Bowlegs and Osceola both wore feathered turbans, silver jewelry, straps, big shirts and calico long shirts, leggings, garters, and moccasins. Bowlegs's accessories, however, are bigger and bolder, an exaggerated version of 1830s' styles: the straps—one fingerwoven and the other of embroidered beadwork—crossing his chest are very wide. Likewise, his silver gorgets are very large.

Women's dress also seems relatively unchanged. Bowlegs's older wife would not pose for a picture, but his young wife sat for her portrait (fig.

64 2.10). She holds one hand across her waist, probably because the long-sleeved bodice she was wearing was too short to cover her midriff and so she assumed the same modest pose women self-consciously struck throughout the years that the short style of bodice was worn. On one shoulder the decorations on her bodice—a ruffle and narrow strips of appliquéd cloth—are visible, while a paisley shawl or scarf is draped over the other shoulder. Her neck is covered with an impressive mass of beaded necklaces and she wears dangling earrings. Her skirt is shown only to her knees, so it is impossible to know if there is decoration on the bottom of the hem.

The brother of Bowlegs's old wife, No-Kush-Adjo or the "Inspector General," was described as having worn his picturesque Indian garb with "the grace of the drapery of a Greek statue" (see fig. 6.4). His long shirt, decorated at the bottom with several bands of line and triangle appliqué, is worn with double straps across his chest, three large silver gorgets, and a turban with a silver band. He wears a shoulder bag, the strap of which boasts a design of diamonds with recurved or convoluted ends. A shoulder bag now in the collection of the Smithsonian Institution has this same embroidered bead design. It is documented as having been made by one of the Mrs. Billy Bowlegs, probably No-Kush-Adjo's sister.

Long Jack, the brother of Bowlegs's young wife, was described as less impressively dressed in a plain shirt and "night gown of gaudy calico." The baldric or strap hanging loosely across his chest has a floral or vine decoration made of beadwork. His feet are bare, but he wears fringed hide leggings. Bowlegs's counsellor Ben Bruno had apparently afforded himself the luxury of a new custom-made suit, in which he is depicted.

Isolation, Contact, and Trade: 1879–1900

The approximately two hundred Indians and few blacks left in south Florida after the close of the wars sought refuge in wilderness clan camps as far away as possible from whites. As the Seminoles remained in isolation from 1858 to around 1880, virtually nothing is known about them or their dress during that period. The people were divided politically, linguis-

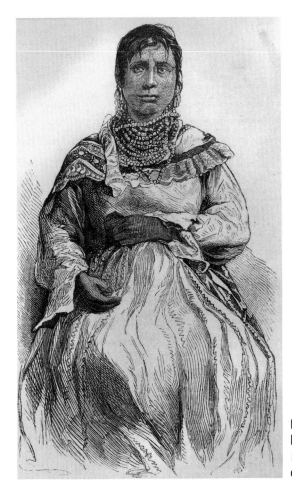

Fig. 2.10. Mrs. Billy Bowlegs, line reproduction from *Harper's Weekly*, June 12, 1858. Private collection.

tically, and geographically. In the decade following the Civil War, however, the American government pursued a new policy intended to "make the Indians more like white men," essentially by further destruction of their cultural and religious practices. Its goals were assimilation, education, and Christianization. As well as having its impact on what was left of the Florida Indians, this directive greatly affected other Indian groups, especially those who had been sent to Indian Territory in Arkansas. There, Creeks and Seminoles were forced to give up their slaves and either sell cheaply or simply turn over portions of their land to the government.

In line with the new government policy, official contact with the remaining Florida Indians was once again made when surveys of their population were conducted. In June 1879, E. J. Brooke, the acting com-

missioner of Indian affairs, assigned Lieutenant Richard Henry Pratt the task of investigating the number of Seminoles in Florida and assessing how best to "provide for the relief of the Indians and educational facilities for their children." As Brooke wrote: "It is very desirable that they be induced if possible to join their kindred and friends in Indian territory. . . . After ascertaining the localities of the different bands place yourself in communication with them and ascertain their views with regard to removal to Indian Territory" (in Sturtevant 1956, 4). Pratt was ordered to write a report to the commissioner that would aid him in understanding the Indians' condition and the measures his department could take to "civilize" them.

Pratt estimated that there were 292 Seminoles living in four villages. In addition to reporting on other communities, he visited old Chipco's village on Cat Fish Lake, where he found several men who had participated in the Second Seminole War of 1835 to 1842. The people were now very independent and did not want assistance. They had a considerable number of hides to sell, although they complained about the dwindling source of game. They kept gardens and sold produce as well as hogs and cattle. Pratt observed that the Seminoles had developed limited contact with a few white neighbors and merchants they trusted, trading at Tampa, Fort Meade, Bartow, Fort Myers, Fort Ogden, Miami, and other places.

Pratt also described the dress of the men, women, and children he saw at Chipco's camp and included drawings of several dwellings. The men wore "the usual breech clout, a calico shirt ornamented with bright strips of ribbon, and a small shawl of bright colors folded the width of the hand and wrapped around the head like a turban. The legs and feet are usually bare, but on special occasions they wear both moccasins ornamented with strips of ribbon or cloth of bright flashy colors." The women wore short jackets and skirts of calico, and their feet were bare. "Cheap beads, large and small, of all colors, are piled up in enormous, fagging quantities, about their necks. The hair of the old women is done up in a conical shape on the back of the head. . . . Small children about the camp don't wear anything" (in Sturtevant 1956, 7–8).

At the conclusion to his report, Pratt noted that the Methodist Confer-

ence of Florida had sent the Reverend W. E. Collier as a missionary to the Seminoles in 1871 but that he and other missionaries had had no success with converting the Indians. In Pratt's estimation, as long as the elderly Indians who had survived through the wars lived, the people would be suspicious of the United States government and thus little progress could be made in their education and civilization. He also deemed it unlikely that the people would agree to removal, unless some sort of trickery were employed. Moreover, there seemed little possibility of gathering the bands into one community. Instead, he suggested that a teacher should be hired to visit the communities and encourage the people to consider education. Pratt—who was to go on to found the Carlisle Indian School in Pennsylvania, the first nonreservation Indian boarding school—also suggested that a boarding school be established where the children could be educated far from the influence of the elders. At the same time, Pratt advised that "their spirit of independence and self help should not be destroyed."

The Reverend Clay MacCauley reported to the Smithsonian Institution in 1880–81 that he had located approximately 208 people consisting of thirty-seven families living in twenty-two camps, which were gathered in five widely separated settlements (MacCauley 1887, 477). Although the Pratt and MacCauley reports contain certain discrepancies regarding the number of Indians, as well as the few Indian-blacks living with them, the figures are similar enough to give us some idea of the Indian population at the time. The modern Seminoles and Miccosukees are the descendants of the families living in these communities.

Non-Indians called all of these Indians "Seminoles." But the Indian people had their own names for the family camps, which were based on distinctive features of their locations or on their inhabitants' dietary preferences, such as for fish versus beef. MacCauley's report recognized this custom when he chose names for the five settlements, using information supplied by his interpreter. He also noted the linguistic differences between the groups. Creek-speaking or Muskogee-speaking people lived in villages in the region of Lake Okeechobee, which he designated as the Cat Fish Lake, the Fish Eating Creek, and the Cow Creek settlements.

The slightly more numerous Miccosukee-speaking people settled in the camps in Big Cypress, closer to Fort Lauderdale, and on the Miami River.

MacCauley's report also contained descriptions and drawings of dress and other aspects of Seminole culture observed during his 1880 visit. His report is thus a detailed source of cultural and artistic information. Commenting on appliqué work, he noted that the Seminoles preferred straight-line or geometric designs, although the technique lent itself as readily to curvilinear designs. But as MacCauley remarked, he "saw no ornamentation in curves; it was always in straight lines and angles." The women, he said, embroider braids and strips of cloth of various colors formed in "odd and sometimes quite tasteful shapes" on clothing. Appliquéd rows of simple lines, sawtooth designs, diamonds, squares, Xs, or other geometric shapes enhanced men's coats or shirts and women's skirts or bodices (1887, 487).

Included in MacCauley's report was a drawing of a typical men's knee-length shirt made of a figured or striped cotton that he described as usually of "quiet colors." The shirt has a narrow, round collar and is buttoned a few inches down the front. The full sleeves are buttoned at the narrow wristbands. A leather belt that holds knives is worn with the shirt. Mac-Cauley said that men tied as many as six to eight bandanas, usually of red or yellow, around their necks. They kept their money knotted in a corner of one or more of the bandanas because their clothing did not have pockets. One or more pouches that contained hunting materials and flint were used by the men, but these were neither described nor depicted.

MacCauley saw a pair of leggings at the Cat Fish Lake settlement that Pratt had probably also seen. According to MacCauley, the leggings were made of bright red flannel and were ornamented along the outer seam with blue and white striped braid. They were worn by Me-le, the son of a Muskogee-speaking Seminole and a black woman adopted into the tribe as a child. Me-le could sign his name, "John Willis Mikko." Mac-Cauley noted that Me-le "has bought and uses a sewing machine, and he was intelligent enough, so the report goes, when the machine had been taken to pieces in his presence, to put it together again without a mistake" (1887, 490). This is the first documented instance of the use of

a sewing machine by Seminoles. MacCauley remarked that the women "embroidered" decoration, but he never referred to their use of sewing machines. By the 1890s, though, other sources increasingly mention Seminole women using sewing machines.

MacCauley also included a drawing of the hairstyle of a Seminole man. The hair is close-cropped except for bangs in the front and a long strip running from the crown to the nape of the neck and ending in a queue. Men were further described as having their heads covered with turbans some twenty inches in diameter and made of one or more small shawls, "generally woolen and copied in [the] figure and color of some Scotch clan." To form the turban, the woolen cloth was wrapped around the knee, which is approximately the same size as a man's head. In cool weather the woolen cloth could simply serve as a shawl. MacCauley observed that turbans were worn for special occasions in both northern and southern camps. In the southernmost Miccosukee camps turbans were worn daily, sometimes even when the men went hunting, whereas Muskogee-speaking men in the northern camps tied handkerchiefs around their heads for everyday wear.

"Key West Billy" was a Miccosukee-speaking Indian from Big Cypress. He was considered a progressive adventurer and earned his name because he had gone to Key West and stayed for some time. MacCauley pictured him in full dress wearing a long shirt with a bold appliquéd design, turban, bandana, a broad diamond-patterned strap, and four large gorgets. He wore fringed hide leggings with high-top moccasins made of a single piece of dark or yellow hide. MacCauley also noticed that a few of the men had purchased shoes.

The women were said to pull their blouses on over their heads. Mac-Cauley commented that the blouse left two or more inches of a woman's midriff bare and was thus too short to cover her breasts if she raised her arms (fig. 2.11). A full-length drawing of a woman depicts the complete dress (fig. 2.12). The blouse has a low V neckline, long sleeves that buttoned at the wrist, and a ruffle at the shoulders (plate 1). MacCauley commented that sometimes as many as five parallel rows of red, yellow, and brown braid were used on the shoulder. The ruffle is decorated with

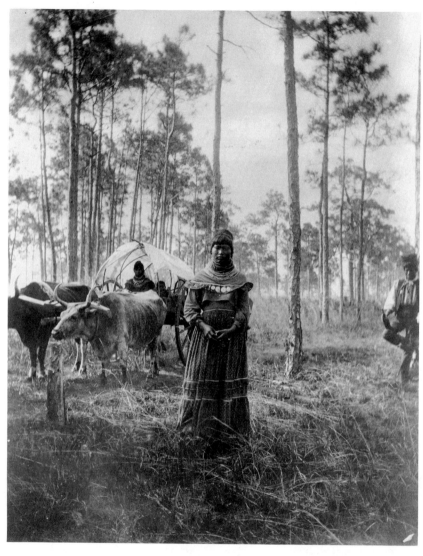

Fig. 2.11 (above). Woman with ox cart, Seminole, late nineteenth century. She wears a calico skirt and short bodice. Photograph by Dr. Charles Barney Cory, Sr. Courtesy of the National Anthropological Archives, Smithsonian Institution. Neg. no. 45, 331-H.

Fig. 2.12 (facing page). Changes in women's dress and hairstyles through the decades, 1880 to 1990. Top row, left to right: 1880 (after MacCauley), 1900, 1910. Middle row: 1920s, 1930s, 1940s, 1950s. Bottom row: 1960s, 1970s, 1990.

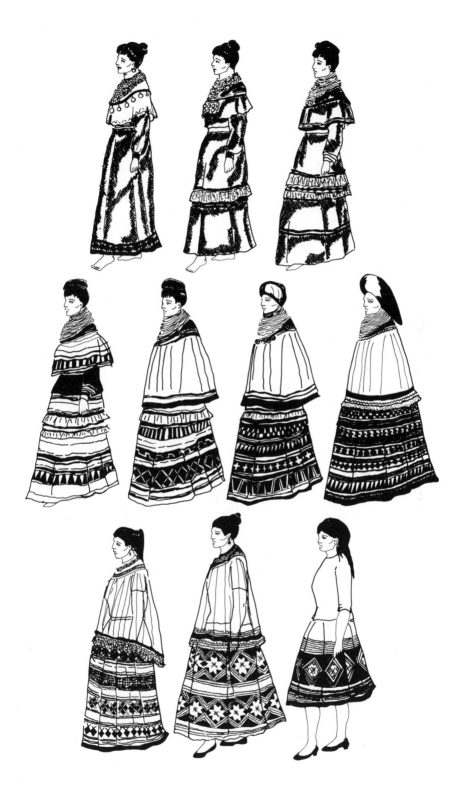

silver ornaments, and mounds of bead necklaces cover the woman's neck. The ankle-length skirt is gathered, tied at the waist, and decorated at the bottom with an appliquéd design. The same material that ornaments the shirt is also used for the skirt. According to MacCauley, the material used to make skirts and shirts was usually a dark-colored calico or gingham.

Women knotted their hair up and back on their heads and had bangs on their foreheads. Widows, however, wore their hair disheveled as a sign of mourning. Girls' hair was braided, and those from seven to ten years old wore petticoats. Boys about the same age only wore shirts, and small children were usually naked except during rare cold snaps or on visits to "the homes of the palefaces."

Families from isolated camps got together to perform rituals, to socialize, and to exchange ideas during the annual Green Corn Dance ceremonies and other dances. These events were the primary gathering times for clan groups. Muskogee-speaking and Miccosukee-speaking medicine men retained the medicine bundle of sacred objects necessary for the well-being of each of their communities. Green Corn Dance ceremonies were held separately, even though this meant there were fewer people to participate.

Pioneers and Indians alike were served by traders who ventured deeper into the Florida frontier at the end of the nineteenth century (fig. 2.13). The Seminoles made their greatest profit from the trade of alligator hides, bird plumes, and animal pelts, as they shifted from the subsistence economy into which they had retreated back to a trade economy (Kersey 1975, 25). It was a time of relative affluence for the Indians, who traded boatloads of hides not only for staple goods but for hand-cranked sewing machines, fabric, and multicolored glass beads. Trading posts became a focal point in Indian life as the families dealt with one or more of the local traders for their supplies.

The traders functioned as more than a simple source of supply: they played an important role in the development of new technical skills. The men provided the materials, while their wives taught the Indians the basic sewing techniques needed to further inspire their inventiveness. Moreover, traders supplied novelty accessory items, which also altered

Fig. 2.13. Country trader's
store at Big Mound, on the
edge of the Everglades, 1908.
Photograph by M. R.
Harrington. Courtesy of the
National Museum of the
American Indian, Heye
Foundation. Neg. no. 2969.

74 Indian dress styles. But the resulting art forms were, above all, uniquely Indian.

The trust and friendships that developed among the traders, the Indians, and their families provided an atmosphere for cultural interaction, which led in turn to further acceptance of white men's ways. Some traders initially traveled extensively through the harsh terrain to contact Indian groups before finally establishing their stores in accessible locations—but the Indian families seemed to move with ease by dugout canoes or other means to reach various trading posts. They often came from long distances and camped for a few days on the traders' porches or grounds.

Storekeepers kept credit accounts for the various Indian families with whom they traded regularly. Joe Wiggins was operating a small trading post on the lower west coast of Florida around 1880, and Miccosukees from the Big Cypress came there by canoe to trade. Sometime later Captain George W. Storter opened his store in the settlement now known as Everglades, while C. G. McKinney opened a store on Chokoloskee Island in 1886. But when Ted Smallwood's store opened at Chokoloskee in 1906, it became the trading headquarters of the area.

William Henry "Bill" Brown initially worked out of a store in Fort Myers in the late 1880s but later loaded his family and goods onto an ox cart and traveled through the almost impassable wilderness to reach Indian camps. He eventually operated a post some thirty miles southeast of Immokalee that became known as "Brown's Boat Landing" (Kersey 1975, 61, 66). Doctor Tommie, Key West Billie, and his brother, Billy Conapatchee, were regulars at the store. (Seminoles have a taboo against revealing their Indian names to strangers, which accounts for the fact that so many of them are known only by names given to them by traders [Skinner 1913, 77].) Brown and his family learned the Miccosukee language. His son, Frank, was the best of friends with Conapatchee's son, Josie Billie, who became a well-known medicine man. Brown's wife taught both Indian men and women how to use the sewing machine. Frank Stranahan set up shop on Fort Lauderdale's New River in 1893, and his store was patronized by Tom Tiger, Robert Osceola, and Jumper, among others. Stranahan's wife, Ivy, owned an upright White sewing

machine and taught the Indians how to use it. Stranahan kept treadle
models for customers to use in the store and sold hand-cranked machines
to the Indians to carry back to their remote camps (Kersey 1975, 54).

The Tigertail family had a camp along the Miami River and bought
goods from William Brickell, who opened his first trading post on the
river in 1871. William Burdine opened his small store in 1898, and at
the turn of the century James D. Girtman established a trading post that
brought many canoes loaded with Indian families along the Miami River
(Kersey 1975, 41–42) (fig. 2.14). Girtman noticed that although the
Indians at first preferred cloth in dark colors, they soon became attracted
to brightly colored cloth. Bias tape, fancy edging, and rickrack trims were
also introduced by traders around this time.

Indians from the Okeechobee region occasionally traded from as far
away as Fort Lauderdale and Miami. They also bought from Henry Parker,
who began trading near the Kissimmee River around 1871. L. M. Rauler-
son's store opened in 1905 near the present site of the city of Okeechobee.
Captain Walter Kitching began selling goods from Cocoa to Jupiter in
1887 aboard his floating store, the schooner *Merchant,* until he established
a permanent store in Stuart at the turn of the century. Captain Benjamin
Hogg, who traded along the Indian River from Titusville to Jupiter in
1879, opened his trading post in Fort Pierce in 1884. Those posts were
the haunts of Billy Bowlegs III and Chief Tallahassee, the nephew of
Chipco.

Photographs taken of Seminoles during visits to trading posts provide
information about dress at the end of the century. Numerous portraits of
Indian women were also made at that time. Chief Tallahassee was the
subject of several photographs taken to illustrate books by Minnie Moore-
Willson, author and founder of the Friends of the Florida Seminoles.
Tallahassee and a boy, both wearing turbans on their heads, posed around
1885 (fig. 2.15). The fingerwoven strap he wears is one of the last vestiges
of the more traditional accessories. It is used as a burden strap, to carry
hides to sell. The strap of his shoulder bag has bold embroidered bead
designs, while his pouch is decorated with a star or sun design.

The introduction of the sewing machine offered many opportunities

Fig. 2.14 (above). Group of Seminoles in canoes, Miami River, ca. 1900. Photograph courtesy of the National Anthropological Archives, Smithsonian Institution. Neg. no. 44, 352-B.

Fig. 2.15 (right). Chief Tallahassee and boy, Bartow, Florida, Seminole, ca. 1885. Photograph courtesy of the Richter Library, Minnie Moore-Willson Collection, University of Miami.

for experimentation. For instance, vertical rows of appliqué were added 77
to both sides of the front neck opening of men's plain shirts, both straight-
line and sawtooth or diamond patterns proving popular. Diamond designs,
associated with rattlesnakes, were also frequently used as appliqué decora-
tion on men's long shirts. Although the long shirt retained the basic
configuration of the earlier examples we have seen, it seems to have
become a new symbol of status at that time. Now known by the term
doctor's coat, it was increasingly worn only by certain men, probably those
who either were important medicine men or were known as doctors of
herbal medicine.

The changes in dress and the further overstatement of basic elements
of style are noticeable in a photograph of Tommy Jumper and Billie
Stewart taken by Charles B. Cory, Sr., in the 1890s (fig. 2.16). Cory was
known to have visited the Seminole camps along the New River, as well
as Stranahan's store. Jumper wears a plain shirt with a diamond-shaped
appliqué decoration on either side of the neck opening. A wide leather
belt circles his waist. Over the plain shirt is a doctor's coat embellished with
a small ruffle at hip height, rows of straight-line banding, and diamond or
other appliquéd designs. Billie Stewart wears four large silver gorgets and
two broad straps with diamondback rattlesnake patterns across his chest.
The straps were made with beads of many colors strung on cotton thread,
using the loomed beadwork technique. Wool yarn was used to make the
attached woven floor-length strips with white-bead edging and showy
fat tassels. Photos and artifacts from the end of the century reveal that
the loomed beadwork technique had generally replaced the fingerweaving
techniques previously used to make straps.

Both men wear numerous bandanas around their necks. Egret "feather
dusters" are stuck in their wide plaid wool turbans, from which loomed
beadwork fobs are suspended. They wear moccasins with their dark hide
leggings, which are slightly flared, like cowboy chaps. The leggings were
made of one piece of hide folded over and sewn to follow the shape of
the side of the man's leg. Fringe was added along that line and below
the knee.

His 1893 journey through the Everglades took Lieutenant Hugh Wil-

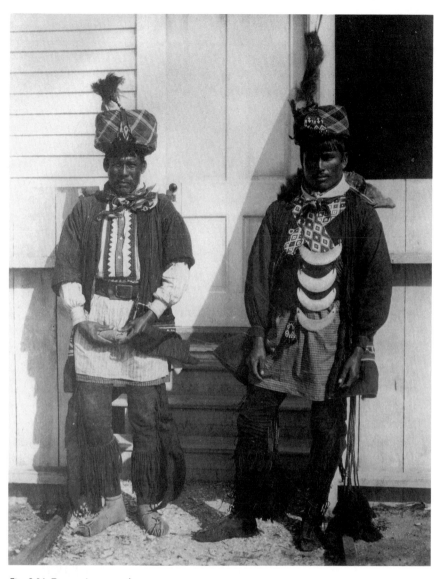

Fig. 2.16. Tommy Jumper and
Billie Stewart, Seminole,
1890s. Photograph by Charles
Barney Cory, Sr. Courtesy of
the National Anthropological
Archives, Smithsonian
Institution. Neg. no. 45, 331-E.

loughby around the tip of the peninsula from Miami to the mouth of the Shark River. During his travels he collected several items of Seminole clothing that are now in the Elliot Museum in Stuart, Florida (Willoughby 1898). His collection includes a loomed beadwork strap and a plaid wool turban with bead fobs (see plates 21 and 22) similar to those worn by Jumper and Stewart, as well as a doctor's coat. The doctor's coat is made with a deep V flap that dipped down in the back from the shoulders. It is edged with narrow bands of both patterned and solid cloth plus a ruffle, which resembles epaulets, on the front. A wide strip of decoration at the coat's midsection is also edged with narrow bands of cloth and two rows of appliquéd diamond designs, separated by a ruffle. In 1906 Willoughby acquired a reproduction of an 1896 doctor's coat and a plain shirt made by Sally Osceola, the mother of Richie Osceola. White rickrack was used for trim, documenting an early instance of the use of this decorative device.

A group of Miccosukee men, women, and children, members of the Willie family dressed in their finest clothes and best silver ornaments, posed for a picture at Pine Island in the 1890s (fig. 2.17). The occasion may have been a Green Corn Dance, as one boy holds sticks used in a ball game. All of the men wear solid or striped cloth shirts, vests with various novelty attachments, metal arm bands, and leather belts. Charlie Willie wears a turban made out of a bandana. All of the women, who posed with their arms over their midriffs, wear outfits in bright polka-dotted, striped, checkered, or floral prints. Their short shirts have banded ruffles at the shoulders. Two of the women have numerous silver coin discs sewn onto the front of their ruffles, displaying their relative affluence. All the women wear pounds of bead necklaces, and most of them also wear one or more necklaces decorated with silver coins. At knee length, their skirts are decorated with narrow bands of cloth, ruffles, and two or three other bands of wide and narrow cloth. The Willie family group was photographed again more than twenty years later, and the changes in their clothing styles are striking (see fig. 3.5).

By the late nineteenth century, men's accessories had become very eclectic. They often consisted of "what have you" novelty items purchased

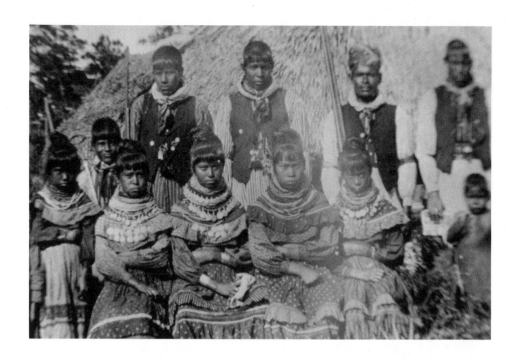

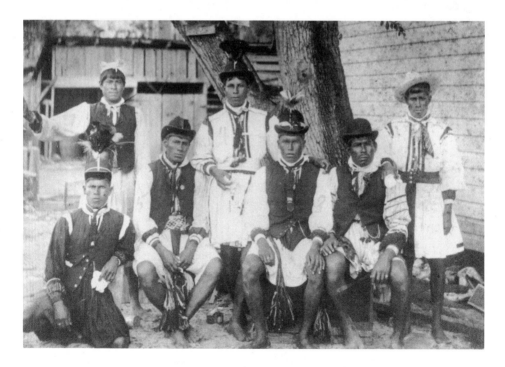

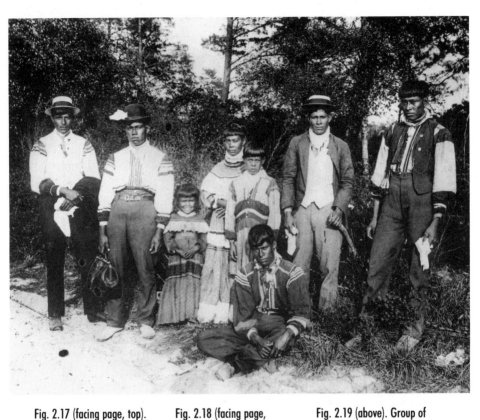

Fig. 2.17 (facing page, top). *Seminoles, Pine Island,* 1890s. Photograph courtesy of the National Anthropological Archives, Smithsonian Institution. Neg. no. 13, 187.

Fig. 2.18 (facing page, bottom). Men in conductor's caps, bowlers, and vests, late nineteenth century. Photograph courtesy of the Historical Museum of Southern Florida. Neg. no. X-36-X.

Fig. 2.19 (above). Group of Seminoles in multibanded clothing, 1890s. Photograph courtesy of the Historical Museum of Southern Florida. Neg. no. 76-89-21.

from various traders, indicating that the Indians had money to spend. Wide leather belts and vests with watch chains tucked into their pockets often were worn with their short plain shirts. Conductor's caps, bowlers, and straw hats were also popular (fig. 2.18). Sometimes old hats were used as frames for turbans fashioned out of bandanas.

In addition, structural changes occurred in the men's plain shirt some time very early in the twentieth century. The shirt was made with a half-front opening and a waistband was added, which established a new style called a *big shirt*. Prior to that time, wide pieces of cloth had been used to make men's and women's clothing. Photographs reveal that multiple bands of cloth, both wide and narrow and of different prints and colors, became popular, as the women experimented with their sewing machines (fig. 2.19). More attention was also given to details of the design, such as bands of different fabrics used at the cuff and on the upper sleeve.

Deaconess Harriet M. Bedell, who began work with the Seminoles in the 1930s, suggested that multiple-banded clothing was inspired by the colorful banded tree snails that were abundant in Everglades hammocks and were an essential element of the ecological balance of the natural environment. As she wrote on June 20, 1941, the bands "are probably suggested from the tree snails which live in the trees in the Everglades. They are very colorful and have bands around them" (Bedell 1941). This is a very plausible hypothesis: even today Indian women continue to base design ideas on elements in their environment. But regardless of the source, the late-nineteenth-century trend toward using multiple wide and narrow bands of fabric in both men's and women's clothing eventually led to the addition of rows of appliqué and, later, rows of patchwork designs. The introduction of the sewing machine had given the women an opportunity to be more creative, and their imaginations took flight.

C
H
A
P
T
E
R
3

The economic stability of the Florida Indians was endangered once more when their hunting activities were abruptly interrupted during the first decade of the twentieth century. In 1900 the Lacey Law was passed, protecting exotic birds and forbidding the sale of their plumes. This was followed by the drainage of the Everglades, which began in 1906 and took a considerable toll on the economy and way of life of the Miccosukee-speaking people south of Lake Okeechobee. By 1913 the resulting disruption of the water flow, coupled with a serious drought, had led to difficulties in water transportation, changes in animal migration patterns, and shortages of game. The people consequently had to seek other reliable financial pursuits.

The land boom of the 1920s brought with it new white settlers as well as winter tourists, who were curious about Florida's exotic Indians. Like other dispossessed Indian groups, Seminole families were quick to recognize an economic opportunity in the tourist market and so began to live, work, dress up, and make objects to sell to visitors in exhibition villages. Sometime before 1920, after a long period of decline in artistic traditions, the technique of creating patchwork designs was invented in south Florida. It was the spark that set off a creative explosion. Destined to become the best-known art of the Seminole people, patchwork still defines the "Seminole look" among non-Indians.

Alanson Skinner visited several Seminole villages in the Everglades and Big Cypress in 1910. He was sent by the American Museum of Natural History in New York to obtain specimens illustrating Seminole ethnology. His guide was a trusted friend of the Seminoles, Frank Brown, whose father, Bill, had been an Indian trader for more than thirty years. All but

one of the villages had never been visited by white men: Skinner was allowed entrance only after the Indians were convinced he was neither a government spy nor a missionary. Skinner said that although their villages were "so little known to outsiders, the Indians themselves are quite familiar with the towns of the white men, for the men, and a few of the women, often go to Miami, Fort Lauderdale, Jupiter, and other towns to trade" (Skinner 1913, 63).

Skinner's report included numerous photographs of men, women, and children, which illustrated his descriptions of their dress and hair styles. The everyday dress of the men was a big shirt that reached to the knees. According to Skinner, it was made of bright varicolored calico and narrow at the waist and wrists. Many bandanas were worn around the neck. Older men continued to wear a plain shirt. They also wore a turban made from a shawl or several bandanas wound together. This was held in place by a silver band, and elegant egret or other plumes were inserted beneath the band on special occasions.

Ceremonial dress consisted of the plain shirt, plus a calico coat with appliquéd designs, deerskin leggings dyed a rich brown by using oak bark, and soft moccasins with a round flap at the toe. Skinner also noted that silk shirts were worn as "gala apparel." Billy Koniphadjo told Skinner that the men had worn leggings and moccasins for their daily tasks in his youth, but had quit wearing them because they were "hot too much" (1913, 66). Woven bead or yarn belts completed the costume. Men now cut their hair short like white men, although some left a lock before the ears. Skinner commented that the men used to wear a double scalp lock and that some of the conservatives still did.

The women wore a "cape with sleeves attached" with their full-length skirts. Photos show that the bodice's shoulder ruffle had been slightly lengthened to resemble a cape, but the garment itself was still short and exposed the midriff. Skinner said they wore at least ten to fifteen pounds of beads coiled about "their shoulders and throats until their chins are sometimes fairly forced skyward, and causing them to look as if they were being choked" (1913, 66). Their ceremonial dress was the same, except that their capes were then decorated with hammered silver brooches and

bangles. They wore their hair coiled on top of their heads and had bangs on their foreheads. A widow in mourning wore her hair loose on her shoulders. Little girls sometimes wore a one-piece dress with an appliquéd collar, but otherwise children's dress was more or less the same as that of their parents.

Tourism

The twentieth century brought booming development to south Florida, as northerners were increasingly attracted to the warm climate and the sparkling bays and ocean. Tourists who flocked to Miami wanted to see the Seminole Indians they had read about in newspapers. In 1914 Henry Coppinger opened Coppinger's Tropical Gardens, Alligator Farm, and Seminole Indian Village on the banks of the Miami River (Downs 1981, 225–31). The exotic setting of lush tropical foliage and stately royal palms not only housed hundreds of crocodiles and monkeys but a village of several Indian families who were camped on the land when Coppinger purchased it. At least initially, he did not pay the Indians to live in the village because he bought all the souvenirs they made and sold them in his curio shop. Other Indian families came by canoe from remote camps in Big Cypress and the Everglades to sell alligator hides or to stay in the village for a while.

John A. Roop opened a rival attraction, Musa Isle, in 1917 and encouraged Willie Willie, the son of Charlie Willie, to set up an even larger village composed largely of his relatives (West 1981, 203). Additional families also lived in these villages on a semipermanent basis during the tourist season and returned to their camps in the off-season. The families were free to come and go, and some stayed only temporarily while visiting Miami. They often returned to their wilderness camps, provided that hunting and fishing supplied them with adequate food. Families living in the tourist exhibition villages were given a grocery allowance, medical assistance, and a small salary, which covered expenses for their sewing and other needs. Extra money was earned by making crafts to sell in the gift shops.

Many families were employed at both villages at one time or another. The families that lived in the villages included those of Jack Tigertail, Charlie Billie, Josie Billie, Tiger Tiger, Futch Cypress, Charlie Willie, Doctor Tommie, Sam Huff, and the Osceola brothers: Cory, John, and William McKinley. These families have provided leadership among the modern Miccosukee-speaking people, and the adults generally have some recollection of life in a tourist exhibition village. The villages established patterns that continue among many of the Miccosukee-speaking families in south Florida, who still are dependent on a tourism-based economy, including the making and selling of their arts and crafts.

Not surprisingly, a certain amount of showmanship developed in the villages, and colorful dress was an essential element of that trend. The clothing of Indian men, women, and children was constructed of many wide and narrow horizontal bands of cloth (plate 2). Comparison of Indian and non-Indian dress in archival photographs of the period reveals, however, that Indian dress styles had developed independently.

The Origin of Patchwork

It is not known exactly when, or by whom, the art of making patchwork on a hand-cranked sewing machine was invented (fig. 3.1). It appears that the technique developed sometime around the time of World War I, as the first rows of patchwork designs are documented in photographs of families who lived in the exhibition villages of this period. We do know, however, that this artistic accomplishment developed independently and was uniquely the creation of the Miccosukee-speaking Indian women of south Florida. It was not acquired by the Muskogee-speaking women who lived near Lake Okeechobee until later.

Seminole and Miccosukee women refer to patchwork as *taweekaache,* which means "design" in the Miccosukee language (*A Guide to the Miccosukee Language* 1978). The origin of such designs can be traced to a period when virtually all other design elements and technical skills of the traditional culture had been lost. Most objects the Seminoles and Miccosukees made were undecorated, with the exception of the minimal

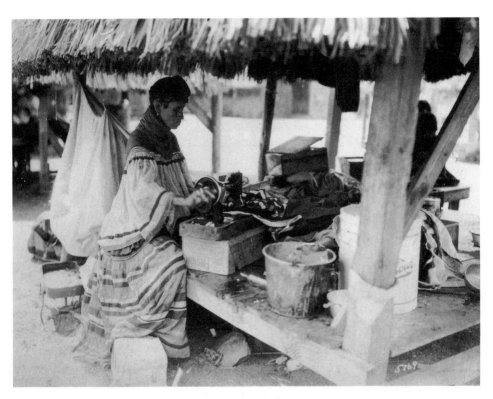

Fig. 3.1. Woman with hand-cranked sewing machine, Seminole, 1927. Photograph by Claude C. Matlack. Courtesy of the Historical Museum of Southern Florida. Neg. no. 139-30.

use of the diamondback rattlesnake design and other geometric designs in loomed beadwork, incised silver, and appliquéd artifacts. Religious beliefs and an oral storytelling tradition, rather than aesthetic traditions, served as the primary consolidating forces within their culture. Sometime after 1910, though, the Miccosukee-speaking women who were using hand-cranked sewing machines in their remote southern camps developed the needed skills and techniques to create a fresh design iconography and an original art form.

Patchwork is the process of sewing pieces of solid colored cloth together to make long rows of designs, which are then joined horizontally to other bands of cloth to form the body of a garment. Several theories have been put forward regarding the inspiration for its origin. The Seminole Sam Tommy suggested that patchwork developed sometime around 1916 to 1918, because the printed fabrics—calico and gingham—that women preferred were more difficult to obtain during World War I, given that the import of dyes from Germany had been cut off. The Indian women devised their own solution to the problem by creating designs from many pieces of solid-colored cloth.

Another theory that has been pursued by scholars is that patchwork might have been a variation on African strip-sewing or quilting techniques learned from the few remaining blacks living with the Seminoles (Wittmer 1989a). An African connection was suggested by Clay MacCauley's mention of Me-le, a half-black Muskogee-speaking man living in the Cat Fish Lake Seminole community. His mother was black, and Me-le's African features are visible in a drawing of him now in the Smithsonian Institution's collection, in which he wears a coat with an appliquéd decoration. According to MacCauley, in 1880 Me-le had already bought a sewing machine and knew how to use it.

Since it has been established that patchwork making began sometime after 1910 and was a much later innovation of Miccosukee-speaking women in the southern camps, an association between Me-Le and the invention of patchwork seems unlikely. Indeed, Muskogee-speaking women in the northern camps, the region where Me-le lived, did not learn the technique until the 1930s. Nor are there any signs that the

technique developed simultaneously in Oklahoma, where many blacks were relocated after the Seminole wars. Rather, it was Florida Seminole women who taught the skill to the Oklahoma Seminoles.

Seminole patchwork differs from African strip-sewing methods, which join strips of handwoven fabric together vertically. Patchwork is the technique of using a sewing machine to join segments of new commercial cloth to form designs. The process begins by tearing the cloth, segments of which are then cut and sewn numerous times to form long horizontal bands in various designs. It also differs from colonial quilting techniques, in which scraps of previously used cloth were sewn together piece by piece to form designs. The three techniques have conceptual similarities, but this doesn't prove that Seminole and Miccosukee patchwork derives from either African strip-sewing or colonial quilting; the basic idea could easily develop independently. (For a thorough analysis of the methods of sewing patchwork designs written by a pair of experts in stitchery, see *The Complete Book of Seminole Patchwork* [Rush and Wittman 1982].)

A final theory worthy of consideration is that the women simply got the idea from working with the strips of cloth that had been sewn together and left on sewing machines for demonstration purposes in trading stores. In other words, patchwork might have initially begun as the result of noticing, and then experimenting with, the ways in which rectangular and angular strips of solid-colored cloth could be sewn together. In addition, the introduction of the upright treadle sewing machine, operated by the feet, freed the hands for more complex work. The women recognized the possibilities, and then their imaginations took over. As the Seminole woman Judy Bill Osceola has remarked: "There wasn't any designs then, there was just pieces of cloth. . . . When they put all of the pieces of cloth together, they saw it was colorful and that's how it all began" (in Belland and Dyen 1982a, 7).

The Evolution of Patchwork Clothing

Some designs were so popular that they have continued in use since their introduction. Of course, not all design innovations were so successful:

some designs were made once and never used again. For the purpose of simplification without the sacrifice of historical context, the evolution of changes in the structural elements of clothing and in patchwork designs is perhaps best classified and studied by decades. It is important to bear in mind, though, that more subtle changes and innovations occurred that overlap these chronological periods.

1917–1930

The first two patchwork designs that are documented in photographs were both broad and bold. One design was made by alternating broad rectangular strips of two colors of cloth. It was given the name "Rain" when the women were later encouraged to assign "looks like" names to the designs that would help with identification. The other design was made of rectangular strips of two colors of cloth that were sewn together and then cut on an angle and sewn again. This design resembled an appliqué sawtooth pattern that was frequently sewn onto clothing. The design was designated as "Fire" because it resembles leaping flames. Another popular design of the period was the checkerboard square made of double rows of rectangles or squares, which became known as "Storm" (fig. 3.2). (Miccosukee-speaking Howard Osceola, an independent living on the Tamiami Trail, has been very helpful in identifying designs. In a conversation I had with him in 1975, he said the design was inspired by the Ralston-Purina logo! If so, this was indeed an early instance of adapting designs from patterns found on the containers of household goods.) During this period the segments of most designs were aligned vertically to the edge of the row of the design. The exception was the angular fire design.

Alice Willie, who became Mrs. William McKinley Osceola, might have been the first woman to wear a row of patchwork on her dress (H. Osceola, 1975). A row of the design now known as "Fire" decorated her cape when she sat for her portrait holding her daughter, Mittie, sometime around 1917–19 (fig. 3.3). We can also see that the length of the shoulder ruffle has been extended to form a cape. The drop shoulder of dark cloth provides an effective background for her rows of bead necklaces and silver

coin jewelry. Silver discs are also sewn to her cape. The bangs that frame her face emphasize her beautiful features, while a silver pendant with a pierced Maltese Cross design hangs from her upswept hair. Mittie wears a baby girl's dress with several bead necklaces and one dangling coin.

Group photographs taken during the 1920s reveal dramatic changes from late-nineteenth-century dress and the styles described by Alanson Skinner in 1910. "Indian weddings" were regularly staged for tourists at Musa Isle, and Claude C. Matlack took numerous photos at one such wedding in January 1922 (fig. 3.4). Both the men and women are strikingly dressed, and the children wear miniature versions of adult clothing. Everybody has bare feet and legs. As the photos clearly show, there is no similarity between the dress of the Indians and that of the whites who mingle in the audience.

The Indian men wear big shirts with multiple horizontal bands of wide and narrow cloth. The bands of cloth on the sleeves are not aligned with those on the body of the shirt because the pieces were constructed separately. Appliqué has been sewn vertically at the shirt openings (plate 3). One of the Willie brothers facing the camera wears two fingerwoven straps across his chest, which, if they are not heirlooms, are unusually late examples of the use of the fingerweaving technique.

The women in the group wear elbow-length capes made of multiple bands of cloth. The cape dips to a deep V in the rear, and either straight-line appliqué or rickrack trims the shoulder of the cape and also the skirt. Rows of straight-line appliqué or bias-tape trim continued in use until they were eventually replaced by wide rickrack. The women's hair is pulled into attractive full rolls that slope forward on their heads, and bangs cover their foreheads. The ruffle on the women's skirts has been raised from the knee height popular in the late nineteenth century to mid-thigh or hip height. Wide rows of appliquéd designs such as diamonds or straight lines crossed to form Xs are used in addition to the multiple bands of cloth on some of the skirts. Even a row of patchwork has been included here and there (plate 4). One or two rows of geometric patchwork designs were used with alternating wide and narrow rows of solid cloth and thin bands of appliquéd piping throughout the 1920s.

Fire

Rain

Rain or Storm

No Name

No Name

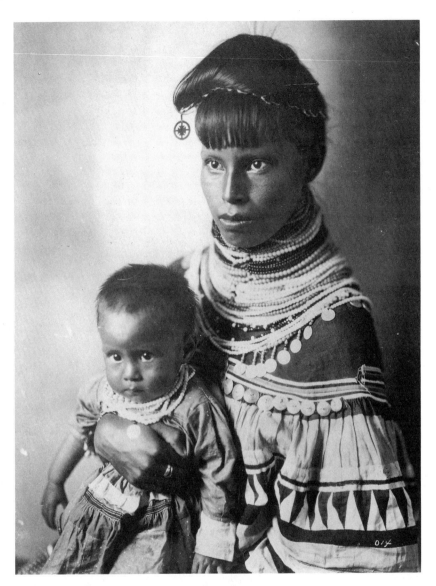

Fig. 3.2 (facing page). These large, bold designs are from photographs of skirts from the 1920s.

Fig. 3.3 (above). Alice (Willie) Osceola, wife of William McKinley Osceola, and her daughter, Mittie, Seminole, ca. 1917–19. Photograph by Frank A. Robinson. Courtesy of the National Anthropological Archives, Smithsonian Institution. Neg. no. 45, 838-H.

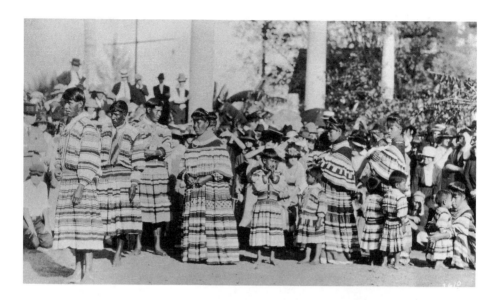

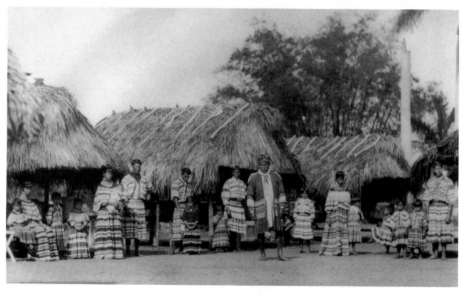

Fig. 3.4 (top). Indian wedding, Musa Isle, Seminole, 1922. Photograph by Claude C. Matlack. Courtesy of the Historical Museum of Southern Florida. Neg. no. 72-30.

Fig. 3.5 (bottom). *Seminoles, Musa Isle,* 1923. Photograph by Claude C. Matlack. Courtesy of the Historical Museum of Southern Florida. Neg. no. 89-30.

Fig. 3.6 (facing page). Rear-view photograph of Seminoles, Miami, 1929. Note the many rows of bold patchwork designs on the women's skirts and "engagement" headbands. Photograph by Gleason Wate Romer. Courtesy of the Miami-Dade Public Library, Florida Collection. Neg. no. c 445b.

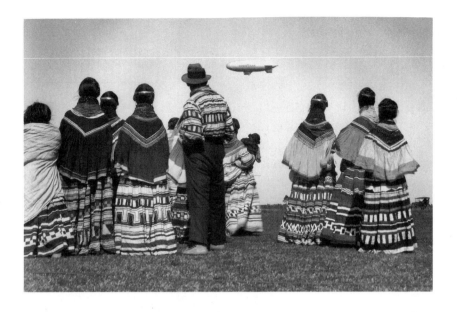

A 1923 group portrait (fig. 3.5) taken among the chickees at Musa Isle included an older Charlie Willie, who was first identified with his family in the 1890s photograph (fig. 2.17). He wears his bandana turban, a plain shirt, and a doctor's coat decorated with wide rows of sawtooth and diamond appliquéd designs separated by a ruffle. Some of the other men's big shirts and the women's skirts also have rows of appliquéd designs or patchwork. The woman standing holding a baby is probably Alice Osceola, who was a member of that family group.

The rows of patchwork designs on men's and women's clothing were quite bold and wide through the 1920s. Skirts with one, two, or three rows of wide patchwork designs are worn by women in a striking rear-view photograph taken in Miami in December 1929 (fig. 3.6). Below the ruffle at the hip alternate wide and narrow bands of cloth. The cape is of a solid-colored crepe cloth, banded at the bottom, and the shoulder panel that dips to a deep V in the back is banded with either appliqué designs or rickrack. Silver headbands attached to combs worn on the back of the head hold the women's hair in place (see fig. 7.6).

1930–1940

The 1928 completion of U.S. Highway 41, known as the Tamiami Trail, stretching from Miami to Tampa, brought more intruders in cars and trucks through Indian land, and with them came new problems. White

hunters and fishermen placed a further strain on the Indian economy by competing for the dwindling supply of game and fish. Indeed, by the late 1930s most of the game was gone, and the Indians were forced to turn to other resources. The natural flow of water was cut off in the area south of the road, causing seasonal droughts and further disruption of Everglades ecology. A *Miami Daily News* article of 1934 declared that because the Indians were unprotected and not seeking aid, Florida's "Unconquered Seminoles" had become "Florida's Forgotten Man" (Warren 1934, 3).

Moreover, the Depression had its effects on the already poor Seminoles as it did on everyone else. The federal government established Brighton Reservation for the Muskogee-speaking Seminoles on the northwest corner of Lake Okeechobee in 1935. Land for the reservation in Hollywood, initially known as the Dania Reservation, was also set aside, along with land for the Big Cypress Reservation. But the Indian people were reluctant to move to the reservations until the 1940s. The population at the Hollywood Reservation, for example, increased as families began settling on reservation homesites following World War II. Fortunately, President Roosevelt's New Deal provided Seminole men with some opportunities for job training and employment in public works projects through the Civilian Conservation Corps, Indian Division (CCC-ID) at the Hollywood Reservation. Many men thus became skilled at using roadworking equipment, in clearing land, and at other tasks. Both men and women took agricultural jobs.

The Indian men who traveled to towns or farms to work had to conform somewhat to the dress of the dominant society. The big shirt (plate 5) was adapted to form a garment termed a *transitional shirt* when the men began to wear trousers (plate 6). The top of the transitional shirt has three or four rows of patchwork, but its skirt only has several wide rows of colored cloth, which can be tucked into the trousers. A long scarf was worn over the round collar. Although men continued to go barefoot around their own people, they began wearing shoes to work and had their hair cut in the styles worn by non-Indians.

People on Brighton Reservation had requested a day school on their

reservation in 1938, using CCC-ID funds. The government sent Mr. and Mrs. William Boehmer to initiate educational and community development work (Kersey 1989, 102–4). The Boehmers also became involved in developing the handicraft industry on the reservation as a source of income for the Indians. They contacted the Indian Arts and Crafts Board in Washington, and steps were taken to establish the Crafts Guild of Glades County in 1941. The guild set standards for the quality of the work, and women and girls were soon producing patchwork clothing, dolls, beadwork, and baskets for sale on the reservation. Approved items were tagged by the Seminole Agency. The venture was successful, and artisans at Brighton provided souvenir items to sell at other gift stores around the state. The first Seminole Field Day, held at Brighton in 1939, featured contests, games, a rodeo, and traditional Indian food. Both Indians from other reservations and non-Indians from Okeechobee and other nearby towns attended. It became an annual event.

Some Indian families established camps along Tamiami Trail in the 1930s. Taking a cue from the commercial exhibition villages, they opened their camps to tourists and set up gift shops in front along the highway where they sold things that family members had made. William McKinley and Alice Osceola opened their camp at Thirty Mile Bend, and other such matrilineal family camps dotted the highway along the road to Naples. These ventures were strictly Indian owned and operated.

Commercial exhibition villages in Miami became a necessary evil for many of the economically depressed Indian families who made their homes there. The villages provided a source of income that at least allowed the people to continue some aspects of their traditional way of life, as well as providing refuge for many families. Acculturation had brought with it a breakdown in the matrilocal camp system, and, deprived of an extended family, divorced women with children often had nowhere else to turn. They would stay in the villages for a while, sew patchwork clothing to sell in order to get a little money saved up, and then go back to the swamps again. The adults thought it degrading to display themselves and their families among the monkeys and alligators in the villages, but

the children enjoyed life there. As Delores Billie explained to me when I was producing the 1989 television documentary "Patterns of Power," there were "lots of kids to play with and everyone spoke Miccosukee."

Many non-Indians, however, did not understand the void that the commercial villages filled, regardless of their drawbacks, and some condemned them in the 1930s. Critics included Roy Nash, Special Commissioner of the Indian Field Service, and members of the Dade County Federation of Women's Clubs ("Commission to View Seminole Villages" 1930). The Episcopal deaconess Harriet M. Bedell, who arrived at the Glade Cross Mission in 1933, was also opposed to the commercial villages. She found the Indian-operated tourist camps along the Tamiami Trail more acceptable: as she declared, "Exhibit arts and crafts and not people" (Bedell, n.d.). Much of her work was accordingly devoted to the development of a Seminole arts and crafts program (fig. 3.7). Although she was unsuccessful in her efforts to Christianize the Indians, she remained their dedicated friend. Bedell urged the women to make baskets and dolls to sell, and she was probably the person who introduced potholder and apron prototypes to expand their selection of inexpensive patchwork souvenir items. She also encouraged quality workmanship.

Creativity also was encouraged by Harriet Bedell's active Indian arts and crafts business at the Glade Cross Mission, and design experimentation accelerated in the 1930s (fig. 3.8). Deaconess Bedell and others collected numerous photographs that document the Indian clothing worn in south Florida from the late 1930s through 1940s, a period that was a high point in dress styles. Women's skirts, as well as men's big shirts or transitional shirts, had many rows of patchwork designs (fig. 3.9; plate 7). Capes lengthened, and sometimes an attached blouse included a pocket in the front to hold coins needed for shopping trips (plate 8). Pierced silver pendants dangled from the last row of some women's beads.

Several women have said that until then the designs were just thought of "as something the women made"; it was probably Bedell who began assigning names to the designs (Poole 1989). She certainly urged the women to give the patchwork patterns names to facilitate their distribution in the growing special-order patchwork market. Non-Indians were also

beginning to recognize the art, beauty, and skill of the women's work. **99** Deaconess Bedell wrote to the Episcopal bishop on June 20, 1941, that "each woman has a sewing machine and the designs in their costumes are works of art. The designs do not mean any thing but are suggestive of running water, a horse's mane, lightning, etc." (Bedell 1941). There were seven designs with names dating from this period or earlier that Bedell considered "traditional," as opposed to the designs that were merely "decorative." The traditional designs she promoted in the mission are known as "Fire," "Lightning," "Man-on-Horseback," "Waves," "Trees," "Mountains," and "Arrowheads" (West 1984, 65).

Some designs correspond to the most important enduring myths and nature stories. The ongoing oral tradition preserves the stories of turtle, crawdad, and other animals that provided design inspiration. Large diamond designs increasingly became more intricate, forming clustered diamondback rattlesnake or alligator designs. Motifs representative of the most powerful aspects of nature, dominated by rain and fire, were joined by a zigzag pattern that became the design called "Lightning," while variations on the checkerboard pattern became known as "Storm." Waves or water also inspired designs. There are two versions of cross designs, which convey a continuing and essential element of Southeastern Indian religious beliefs: one is a simple cross pointing to the four directions; the other is a cross with a square in the center, a design that represents the sacred fire, whose logs point to the four directions (fig. 3.10).

Letters of the alphabet were also added to the design vocabulary in the 1930s. It is not known whether the letters used were copied from containers primarily for their visual impact or instead carried their literal context for the few people who had learned how to read. A, F, H, I, L, Y, and X were repeated in rows of designs, while T was used alternately right-side up and upside down. The popular S reflected the growing power of the almighty dollar sign.

Rows of designs continued to be quite wide, the axis of the designs essentially remaining vertical to the edge of the row. The numbers of rows of designs also increased from one or two to three or even four. Two sharply contrasting colors were still used for most designs. New bolts

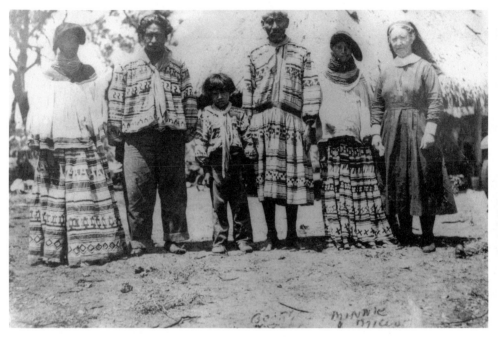

Fig. 3.7. Deaconess Bedell (at right) with Seminoles, 1930s. Photograph courtesy of the Historical Museum of Southern Florida, Harriet M. Bedell Collection. Neg. no. 75.15.

Fig. 3.8 (facing page). Designs from photos of skirts of the 1930s and 1940s.

Rain

Crawdad

Man-on-Horseback

Turtle

Tree or Telephone

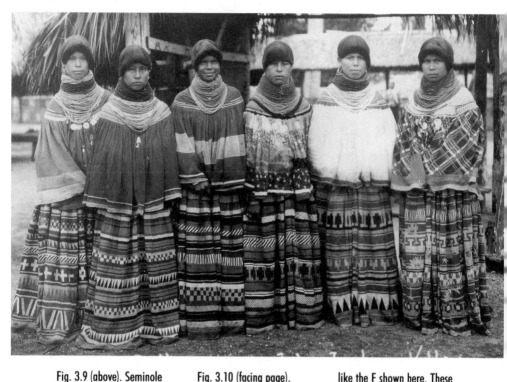

Fig. 3.9 (above). Seminole women, Musa Isle Indian village, 1930. Note use of I, T, and Y designs on skirts. Photograph by Florence I. Randall. Courtesy of the Historical Museum of Southern Florida. Neg. no. 1985-73-2.

Fig. 3.10 (facing page). Designs, 1930s–40s. The sacred fire cross designates the logs of the sacred fire, which are placed in the four directions. Letters are used in various ways, some upside down and others backward,

like the F shown here. These designs were originally drawn and identified by Howard Osceola for the author in 1976.

Cross or Sacred Fire

Arrow

Broken Arrow

T

F

104　of cotton or cotton-blend cloth in bright primary colors such as red, blue, yellow, green, shocking pink, turquoise, and purple, were often selected for the rows of designs. Wider expanses of cloth in a single color were used as a unifying element in the design of skirts and jackets. Any color could be used, but darker colors—black, navy blue, dark brown—or else bright white provided the most vivid contrast to the bright pieces of fabric used in the patchwork. The resulting kaleidoscope of colors could be either exciting or gaudy, depending on the skill and discrimination of the artisan.

1940–1950

In the 1940s many new patchwork designs were developed, and four or five rows were used on jackets and skirts. New variations were created by slanting old designs as experimentation continued during this period (fig. 3.11). A third color was used for some designs. A row of bold geometric-patterned cloth sometimes substituted for one row of patchwork as a "cheater."

Capes became more elegant, and the longer line of the cape flowed into the skirt. The long cape served as protection from insect bites. Numerous rows of large rickrack were used on the capes, as well as on skirts. A sheerer crepe material was used for the body of the cape, and lace was added below the band of rickrack at the bottom (fig. 3.12). Many more strands of solid-colored bead necklaces were added, and these were draped lower on the cape, creating the illusion that the woman had an elongated neck. The women wore a most dramatic coiffure of their own invention that involved pulling their long black hair to the front and shaping it over a frame made of cypress bark or cardboard covered with black cloth. This complex hairstyle was held in place by a hairnet.

Older men wore doctor's coats of solid-colored cloth decorated with a row of patchwork and turbans on special occasions. Big shirts were worn rarely by some of the older men and boys, and a number of boys began to wear trousers and shoes. The skirt was eventually excluded altogether from the transitional shirts worn with trousers. The shirt was worn as a jacket or a long-sleeved shirt, with a fitted waistband, that buttoned down

the front (plate 9). The neckband continued in the rounded style until a collar was added to the jacket at the request of non-Indian customers during the late 1940s (plate 10). This style became known by the term *Eisenhower jacket*, named after the military-style jacket worn by General Dwight D. Eisenhower during World War II, and is still popular today. Rows of rickrack trim the edge of the collar. The jacket is left open and a store-bought shirt worn underneath it.

1950–1960

Some designs of the 1950s were divided into more segments than before. Additional colors also were selected for the different segments of the design. For example, the "Storm" design, which had been a checkerboard of two-color squares, was reinterpreted (fig. 3.13). The new design was made up of four-color rectangles which were serrated at the midline. The serration was sometimes defined by narrow two-color bands. The addition of many very thin segments used with wider segments marked changes in other designs. A shift in axis of the designs from a vertical to a diagonal orientation to the edge of the row was a noticeable patchwork innovation in the fifties.

Cotton was always used for the patchwork designs and for everyday wear, but fancier fabrics such as satin were chosen for skirts and jackets the people made for their own use, especially for Green Corn Dance ceremonies. Many rows of tiny cotton designs used alternately with satin cloth bands of a single color became popular for jackets and skirts in the late 1950s. Women wore separate store-bought blouses under their sheer capes. They also began to wear fewer strands of bead necklaces.

The U.S. effort in the 1950s to enforce termination legislation designed to get the government "out of the Indian business" posed a threat to all Indian tribes and their reservation lands, for they had no other source of protection. Seminole and Miccosukee leaders, realizing this, arranged a meeting with President Eisenhower to discuss the situation. The Seminole Tribe of Florida incorporated in 1957 under the guidelines stipulated in the federal Indian Reorganization Act of 1934. Tribal headquarters were established on the Hollywood Reservation. The tribe drafted a constitution

Zigzag

Lightning

Bird

Wave

Mountains

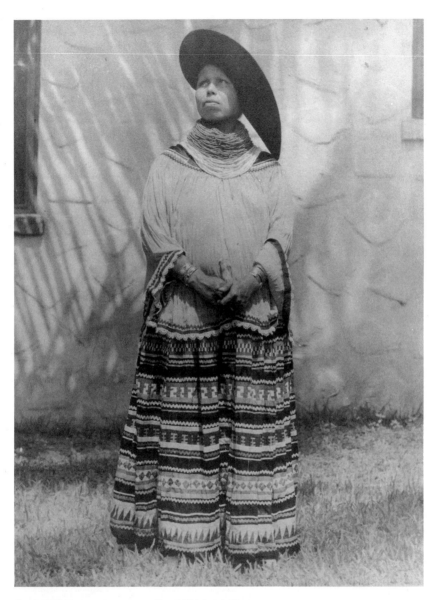

Fig. 3.11 (facing page). Designs, 1940s–50s. Lightning, waves, and mountains were three of the seven designs preferred by Deaconess Bedell, along with arrows, trees, fire, and man-on-horseback.

Fig. 3.12 (above). Elegant cape and skirt with many rows of patchwork, worn by Mickie Tiger Clay, Seminole, 1940s. Photograph courtesy of the Historical Museum of Southern Florida. Neg. no. X-380-1.

Man on Horseback

Cross

S or $

Diamondback Rattlesnake

Storm

and is now governed by a chairman, a Board of Directors, and the Tribal Council.

1960–1970

Miccosukee-speaking Indians living along the Tamiami Trail were asked to incorporate along with the Seminoles, but they did not wish to be bound by the Seminole constitution or to settle on reservation land (W. B. Tiger 1991). They wished to maintain a separate tribal identity and wanted land of their own so that they could continue their way of life in the Everglades. During this decade, Miccosukee Indian leaders also had become increasingly concerned about growing problems with the Florida Game and Fresh Water Fish Commission. Families were being disturbed by the commission's wardens, who would enter their camps and demand to know what they were cooking and eating. At a meeting of medicine men and other leaders it was decided that something should be done about the problem. They asked William Buffalo Tiger to lead the effort to organize their own tribe. Because they were not getting the response they wanted from Washington, a delegation of Miccosukees went to meet with Fidel Castro in Cuba in 1960 to attract attention to their cause of tribal recognition.

The Miccosukee Tribe of Indians of Florida was finally incorporated and their constitution and by-laws officially recognized on January 11, 1962. Tribal offices were duly opened along Tamiami Trail. Leaders of the tribe who supported incorporation felt that, in order to protect their people, they had no alternative but to write into their constitution certain concessions required by the United States government for their official recognition as a tribe. These concessions included, for example, that Miccosukee children be sent to school and learn to read and write in English as well as in the Miccosukee language. As a result, several conservative Trail Indian families who had originally supported efforts for tribal protection decided not to become members of the Miccosukee Tribe at the time of incorporation. They were simply not willing to make concessions to the government that they felt ran counter to the teachings of their ances-

tors. Most members of those families have steadfastly refused to join either tribe; they remain independent Seminoles and traditionalists.

By the 1960s, the last commercial exhibition villages had closed, and after the Glade Cross Mission was destroyed by Hurricane Donna in 1960, Harriet Bedell ceased marketing Indian products from that location. Nonetheless, a few families along Tamiami Trail, such as the Osceolas and Pooles, continued to operate their own villages and stores in their camps as their primary means of support. When the Seminole and Miccosukee tribes were officially established, however, new markets and job opportunities began to develop. Both tribes eventually opened their own stores and exhibition villages, employing men and women as arts and crafts demonstrators. The Seminole Okalee Village and Arts and Crafts Center opened on the Hollywood reservation in 1960. In 1978 the Miccosukee Culture Center and Gift Shop opened along Tamiami Trail on land previously owned and operated as a village and store by Jimmie Tiger, a member of the tribe. The women turned out great quantities of commercial patchwork to sell to non-Indians, but the quality of these products was often inferior to the work they did for themselves and their families. Also, while Indian women preferred many yards of material and a wide array of designs for their skirts, they found that non-Indians liked a slimmer look and thus began to use less material for special-order commercial work.

New decorative patchwork designs based on a central X were devised in the 1960s and used extensively for commercial work (fig. 3.14). They are still popular for commercial products because they are relatively easy to make and offer limitless possibilities for variation through the choice of colors. The designs are made of small rectangular and square pieces forming double diamonds that meet in the middle of an X centered on a small checkerboard square. A multitude of seemingly new designs result when artisans experiment with alternating light and dark values or color relationships—an op art trick capable of creating unlimited variations on a theme. Several rows of the same designs are often repeated.

Men and women also began working for the tribes in the headquarters offices. Whereas previously they had seen one another primarily on special

occasions, they now had daily contact. Concern for personal appearance consequently grew in importance, along with the need for clothing that would be practical on the job. Some men found that a patchwork vest (plate 11) worn with a sport shirt and trousers or jeans was both cool and comfortable for work. The vest has numerous rows of patchwork on the front, but the back is often made of solid-colored cloth. As the miniskirt became the fashion among non-Indian women in the 1960s, Indian women also shortened their skirts—but only to calf length (plate 12), a style that remains popular with younger women today. The calf-length skirts of the 1960s were decorated with numerous rows of small or repeated patchwork designs. They were worn with a blouse or a T-shirt (without a cape) and high-heeled or flat shoes.

Middle-aged women who were not working in offices also eased their dress styles somewhat for the sake of comfort. They still preferred a long skirt but discontinued the hip ruffle. For everyday purposes, the skirt was worn with a blouse without a cape, although a cape was added on special occasions, and the blouse adorned with only a few strands of beads. Much older women complain today of feeling "undressed" without a cape and many strands of necklaces. Many of the women pulled their long hair up into a bun, although some had their hair permed or stylishly cut. Younger women wore their shiny black hair long and loose, or sometimes pulled back in a ponytail.

1970–1980

The sociopolitical changes of the 1960s resulted in more cultural and economic autonomy and clout for the tribes, and their awareness of the importance of the arts thus mushroomed during the 1970s. Both tribes took control of their artistic future when they organized annual arts and crafts events planned and operated by tribal members. The events are money-makers both for the tribes and for individuals because they are well attended by Indians and non-Indians alike. Following on the success of the Brighton Field Day, the Seminole Tribal Fair and Rodeo, held in February, was established on the Hollywood Reservation in 1971. Similar fairs are held on other Seminole reservations as well. The Miccosukee

Arts and Crafts Festival, which began in 1975, takes place each year from December 26 through January 1. The Miccosukees also schedule a summer music festival with craft booths. These events afford the best opportunity for non-Indians to meet the people and see the finest work they are currently selling and making for themselves. In addition, such festivals provide a time for the Indians to socialize and to exchange or introduce new design ideas.

The awareness of dress as an art form was heightened by the fashion shows at the Miccosukee Arts and Crafts Festival and the dress competitions at the Seminole Tribal Fair (see plate 17). Such competitions, which feature sizable cash prizes (starting at one hundred dollars) offered by the tribe, have played an important role in encouraging the artists of today and future artists. Nontribal jurors are invited to judge these contests, with competition in such categories as late-nineteenth-century styles, the patchwork styles popular from the 1920s to the 1940s, and contemporary styles for senior citizens, men, women, and children. Adherence to traditional styles as well as originality are criteria for winning. Both Indians and non-Indian collectors frequently buy the prizewinning outfits after the competitions. Among the women themselves, these events have inspired both a sense of pride in their art and friendly competition. The women are given an opportunity to show off the innovative designs they have created and the new fabrics and color combinations they have chosen. The finest work is generally seen in the skirts the women wear in the competitions. As the Seminole Carol Cypress put it in the documentary *Patterns of Power*, "The women wear the skirts and this is where the art is shown."

As the Seminoles and Miccosukees also have also learned from these events, it is their unique patchwork that identifies them and sets them apart from other Native American groups. Native American artists from other tribes who follow the powwow circuit sell their work at these festivals, too, which allows the Seminoles and Miccosukees the pleasure of seeing the respect their patchwork commands. Moreover, their artisans also have a chance to be exposed to the styles and design elements used by other groups.

Tribal festivals and many other events crowd the Florida activities calendar during the height of the tourist season. This gives families additional opportunities to rent booths and sell their commercial patchwork products. Family members sew the patchwork items, make crafts for sale, and deal with customers in the booths. Some families make a large portion of their income from such festivals. Women who had been sewing simply to earn "coffee money" in the past now turn out great quantities of work to sell. Since the use of a sewing machine lends itself to a production-line method, a full-time patchwork maker will break her work into various tasks in order to produce the volume of items needed to sell. She may first spend many hours sewing the rows of designs, after which she would do assembly work in batches to build up her inventory, putting together a number of inexpensive potholders, aprons, and pinafores before making the more costly and time-consuming skirts and jackets. Colors and fabric are chosen either according to the artisan's preference or on the basis of what she knows is popular and will sell.

In addition, design competitions and fashion shows have inspired some of the younger women to become interested in fashion design, and they have begun creating modern clothing styles using patchwork designs in a variety of innovative ways. Slimmer skirts are popular for wear on the job or for sophisticated evening attire. Patchwork trim is used to decorate casual wear such as shorts and matching tops. These designers experiment with fabrics, which can vary from hot jungle prints to cool cotton eyelet. Straight trim is sometimes used in place of rickrack for modern styles.

New wide, complex designs, used primarily on women's skirts, were developed in the 1970s and 1980s. These bold designs are related to quilting patterns such as the "courthouse step" or "log cabin" designs because they are assembled in a similar manner, using additions of narrow banded segments. But whereas in quilting intricate designs shaped into squares are joined at the edges to form the body of the quilt, the Indian women turn the square design on its point, to create a diamond. They then join these designs point to point, making a row of diamonds. The diamonds are outlined with numerous rows of rickrack in typical Florida Indian manner. One or two wide bands of these designs are used both

in long skirts or in the newer calf-length skirts (plate 13). The Indian women may well have learned these skills from watching television programs devoted to quilting and other sewing techniques, for these shows are indeed popular with many of the women. Annie Jim, who makes complex patchwork designs, told me that she regularly watches television sewing programs from Miami. "How-to" craft books have also provided ideas subsequently adapted to Indian use.

During the 1980s color selection was increasingly influenced by non-Indian taste, a tendency that has endured. Literally "anything goes" in the selection of the vibrant print fabrics used for the body of a garment, with the solid colors selected for the patchwork designs then carefully coordinated to enhance the colors in the print. Color selection can also work the other way, women starting first with a row of designs and then finding fabric that coordinates with it. Rainbows of bright combinations are still used (plate 14), although there is an increasing tendency toward blended or monochromatic hues and earth tones. As patchwork maker Jennie Osceola Billie remarked in *Patterns of Power*, "I go into town and see the colors non-Indians use, and the colors in their buildings and clothing. So I say, 'These colors must be "in."' If I see a certain color they don't use often, I try to avoid it."

Patchwork in the 1990s

There was a time when learning to sew was considered the most important event in a girl's life, and women who make patchwork still love to tell how they learned to sew. As one might expect, girls are usually taught by their mother, aunt, grandmother, or other family member or friend. Annie Jim, the sister of Buffalo Tiger, has many sisters who also sew. She told me that she remembers learning to sew by watching her mother—and of course both watching and practice are essential to learning any craft. Jim said she could not wait for the times her family went to town to buy supplies. Then she would sneak an opportunity to work on her mother's sewing machine. "The happiest day of my life was when I got my own sewing machine," Jim recalled.

In *Patterns of Power*, Tina Osceola Clay explained that a friend taught

her to sew: "She showed me how to tear the cloth, cut the pieces, and then sew them together." A girl first learns the essentials of sewing segments of cloth together, and especially how to sew in a straight, even line. She then is taught how to make easy designs, after which she learns to make the designs she particularly likes and goes on to make her first complete project, whether a skirt or jacket. Once she has mastered the basic skills, she can then create her own designs.

It is a long-accepted practice for women to exchange design ideas. When one woman creates a new design, she either shows it to others and teaches them how to make it, or else they buy several yards of the design and figure out how to make it on their own. Design patterns are not drawn; the women simply remember how to make them. Most women keep samplers of designs they have made, showing the many design possibilities and choices of colors. Mary Frances Cypress of Big Cypress Reservation kept a sampler of 121 variations of designs, which included some passed along by her mother and those she had created herself.

Many women who have taken other jobs do not have time to make the actual patchwork themselves, and so they often buy rows of patchwork to use in clothes they then assemble or else they simply purchase completed outfits. It is thus risky to assume today that a woman made the design or even the skirt she is wearing. Although it is more economical for an artisan to turn out her own patchwork for tourist consumption or everyday wear, even the best patchwork makers may buy or trade yards of popular complex designs made by known masters of the art. These designs function as status symbols and are incorporated into outfits fashioned out of rich fabrics in carefully selected color combinations that are worn for special occasions. Although many fine patchwork makers prefer to remain anonymous to outsiders, everyone on the reservations knows the names of the women who are most admired for their innovative designs and sewing skills.

Effie Osceola is thought by her peers, for example, to be the most knowledgeable person when it comes to the techniques for making traditional designs. Osceola, the daughter of the late medicine man Josie Billie,

has also completed several large projects that were commissioned by art consultants for corporate interiors. One such project was a series of four panels, each five feet by ten feet, created for the Westinghouse Electric Corporation and titled *Rain, Lightning, Storm, and Fire.* One of the traditional patchwork designs representing these powerful forces of nature was used as the central row in each panel.

I was asked to coordinate this project, as well as a similar project that Effie Osceola completed for the executive offices of the Florida Power and Light Company, in Juno Beach. Osceola understands, but prefers not to speak, English, so her husband, Howard, served as an interpreter while she was working on these projects. The working designs for the panels were drawn to scale on graph paper using a selection of patchwork patterns from a sampler she had made. But the drawings were only used as a reference guide to proportions: Osceola was actively involved in the selection of the colors used in the panels. One of Osceola's most respected creations is a "bird-flying" design (plate 15), an exciting origami-type interpretation of a bird. Other women say this deceptively simple-looking design is in fact very difficult to make.

Irene Cypress is considered by many people, Indians and non-Indians alike, to be the best artist now making complex designs (see plate 13). Her work is so greatly admired that other excellent patchwork makers order or buy her ready-made designs for their favorite outfits. She keeps samples of all her designs, including the many variations that can be created by selecting different colors. Annie Tiger Jim also makes a complex design she calls "snowflake." Her work was included in the touring exhibition "Lost and Found Traditions: Native American Art, 1965–85" (Coe 1986, 82). Jim took her first airplane trip when she was invited to demonstrate how to sew patchwork at the Albuquerque Museum while the exhibition was installed there. She also demonstrates her techniques in the village at the Miccosukee Culture Center.

As Frances Osceola summed it up in *Patterns of Power,* "I just love to sew. I guess I don't ever want to leave it!" Indeed, she can always be found in her sewing chickee working on her industrial-grade Singer sewing machine and watching television. She makes one design consisting

of a flame whose colors ascend from white through yellow, orange, and red to burgundy, dramatically used against black. The idea of using bands of gradated colors to create a rainbow design originated in the 1970s, when Mittie Jim was inspired by the logo on a French's spice jar. We saw Mittie, the daughter of Alice Osceola, as a baby sitting in her mother's lap when the two posed for their portrait around 1918 (see fig. 3.3).

Pauline Doctor created a design that reflects the new relationship of the patchwork makers to encroaching urban areas (plate 16). Called "Big Town," it comprises a multitude of tiny squares sewn together. The design is reminiscent of the skyscrapers that have sprung up on the Miami skyline, but "Big Town" is also the name of a matrilineal clan.

The Outlook for Patchwork

Both the Seminole and Miccosukee tribes are concerned about the future of patchwork. They recognize its importance not only as a mark of tribal identity but as a tangible link to their cultural heritage. Unfortunately, many of the women who sew are now in their sixties or older, and some have failing eyesight, while few women in their forties or younger are interested in sewing. The tribes are thus taking active steps to keep the art alive. Girls are encouraged to learn to sew through cultural programs offered in Miccosukee schools. The tribe maintains a vocational education room with its door always open and instructors ready to teach any of the women or girls who drop by for lessons. In addition, Miccosukee-speaking women who married Muskogee-speaking men and settled on the Brighton Seminole Reservation brought patchwork-making skills with them, which they shared with Brighton women, and classes in patchwork making are now taught on that reservation through a cultural program developed by Louise Gopher.

The Seminole Tribe operates a commercial arts and crafts cooperative, with a large mail-order clientele, on the Immokalee Reservation. Tribal leaders have considered the possibility of developing a patchwork industry on the Big Cypress Reservation, employing the best designers and artisans, ones who are known to sew "real straight." But caution is advised regard-

ing this kind of venture. As Delores Billie said in *Patterns of Power*, "I think it could be started up as a business, but we have to understand it is an art and you just can't do it overnight."

The role of patchwork in the Seminole and Miccosukee communities has perhaps been best expressed by the Miccosukee Virginia Poole in the epigraph at the beginning of this book. As Poole recognizes, it is patchwork that sets Seminoles and Miccosukees apart from other tribes. But patchwork does more than simply identify the people: it reflects their pride in their Indian heritage.

CHAPTER 4

In the eighteenth and nineteenth centuries, North American Indians, especially those of the Woodlands and Eastern Plains, used wool yarn in several complex fingerweaving techniques to make sashes, straps, garters, and headbands (Turner 1973, 5). In most instances, though, it is almost impossible to determine the precise tribal origin of these works without some sort of additional documentation.

Prehistoric pottery sherds decorated with textile impressions indicate the existence of an extensive weaving tradition in the Southeast before the introduction of European materials (Milanich and Fairbanks 1980, fig. 33). Either the pottery was marked using fabric-wrapped paddles or impressions were made of large, whole pieces of cloth. For example, sherds of "saltpan" vessels, used for gathering salt, ornamented with impressions taken from large pieces of fabric have been found in Mississippi Culture period sites from the Atlantic coast to Oklahoma (Drooker 1992, 12–13). There is also evidence that various textile-making techniques were used in the region at least as early as the eighth millennium B.C. and that sophisticated textile production was in place by at least the sixth. As Penelope Drooker has observed, "From small items like sandals and sashes, to bags and garments, to large fishing nets and mats, enough evidence has survived to hint at the magnitude of what has been lost" (1992, 9).

Few examples of cloth exist because of the perishable nature of the material, but those that survive confirm that the people used both animal and vegetal fibers for fingerweaving (Dockstader 1978, 172). The most numerous examples of Mississippian textiles have been found at elite mortuary mound sites in Spiro, Oklahoma, and Etowah, Georgia. Wick-

liffe Mound, a Mississippian village site in western Kentucky, has yielded thousands of fabric-marked sherds. Over fifteen hundred sherds were analyzed, revealing that a wide range of textile techniques existed, from "very coarse to extremely fine," while "fabric structures run the gamut from simple to relatively complex. Only a small percentage of Wickliffe textile impressions contain combinations of two or more structures, but among these are fabrics intricate enough to hint at a truly sophisticated textile complex" (Drooker 1992, 98). Of the textile fragments impressed on the Wickliffe sherds that were analyzed, 89 percent are twined and the next largest proportion weft-faced.

A striking example of a weft-faced interlaced textile from that site indicates that techniques for weaving straps, garters, and other items with shell or bone bead decoration were already in place when Europeans introduced wool yarns and white "pony beads" sometime before the eighteenth century (Drooker 1992, 29–31, fig. 6). The small fragment (2.8" by 5.5") was made of an unidentified vegetal fiber and decorated with overlapping flat rectangular bone beads. The beads appear to have been attached as the weaving progressed because they are strung on the weft threads. The textile expert Jenna Kuttruff analyzed the fragment and has suggested that it may have been the end of a sash, such as the sashes depicted on figures incised on shell or other surfaces of Mississippian artifacts (Kuttruff 1990, 3–7).

The term *fingerweaving* includes various interlacing and twining techniques. The fingers are used to pick up the vertical warp threads through which the horizontal weft threads are passed, whereas on a loom a shuttle is used to pass the separate weft threads through the warp threads. Trader James Adair wrote in 1775 that "J.W-t, Esq; a most skillful linguist in the Muskogee dialect, assures me, that time out of mind they passed the woof with a shuttle, and they have a couple of threddles, which they move with the hand so as to enable them to make good dispatch, something after our manner of weaving. This is sufficiently confirmed by their method of making broad garters, sashes, shot-pouches, broad belts, and the like, which are decorated all over with beautiful stripes and chequers" (Adair 1930, 454). But Adair's informant was probably mistaken, as there is no

tangible proof that weaving on a loom with a shuttle predates European contact (Drooker 1992, 160–61). The process described was probably two-element interlacing, or twining.

As a natural evolution of the fingerweaving process, beads were interwoven among the threads to add design interest. Adair further described the addition of beads to yarns spun of buffalo hair in the work of Southeastern Indian women: "In the winter season, the women gather buffalo's hair, a sort of coarse curled brown wool; and having spun it as fine as they can, and properly doubled it, they put small beads of different colours upon the yarn as they work it: The figures they work in those small webs, are generally uniform, but sometimes they diversify them on both sides. The Choktah weave shot-pouches, which have raised work inside and out" (Adair 1930, 454). The drawing of Long Warrior that William Bartram included in his 1791 *Travels* depicts the Seminole wearing a headband (see fig. 1.2). Bartram described the headband as a "very curious diadem or band, about four inches broad, and ingeniously wrought or woven, and curiously decorated with stones, beads" (1955, 393).

Fingerweaving was clearly women's work. As Bartram mentioned in the 1770s, the women spin and weave "curious belts and diadems" for the men and embroider and decorate their apparel (Bartram 1955, 401). There is no mention of men weaving in the Southeast during the Historic period (1600–1900 A.D.). Moreover, the natural fibers used for weaving at the time of the Indians' early contact with Europeans were handspun, as the Woodlands people had not developed the spindle (Burnham 1981, 36). This was accomplished by plying the fiber and rolling it from hip to knee on the thigh. The result was a good, solid thread twisted in the direction of an S. In contrast, European fibers were spun on a spindle or spinning wheel, resulting in a Z-twist direction. Colorful European wool yarns were initially introduced in the form of woven fabric. With their soft feel, they had great appeal to the imaginative Indian women. The women patiently took a piece of cloth, raveled or frayed the fibers and respun them, and then wove the fibers into items for use on special occasions.

Narrow straps, sashes, and garters were made using the interlacing

technique, a process in which each interworked element passes over and under the elements that cross its path. This can be accomplished either by using a single set of warp and weft elements of yarn or thread (oblique interlacing) or by using two or more sets. In oblique interlacing, each strand alternates as both warp and weft, with the elements moving diagonally—but this approach limits both width and design possibilities (Conn 1979, 56). The Indian women devised a two-color interlocking technique that creates a design effect somewhat like tapestry weaving. It then became possible to create many geometric designs, such as chevrons, diamonds, and lightning. When beads were included they were interwoven during braiding, outlining the designs by following the line of the weaving.

Unlike straps and sashes, pouches were made using the twining technique. Twining is a warp-and-weft process of wrapping outer strands around inner foundations (Dockstader 1978, 19). It is the oldest of fingerwoven techniques in the Eastern Woodlands and Great Lakes, dating back perhaps as far as 5,000 B.C. Instead of plaiting weft yarns over and under warp yarns, multiple weft elements are used, "usually two—which twist around each other as they twine in and out of the warps. Each weft in the twisting pair passes in front of a warp and appears on the surface of the fabric; it then twists over the weft and passes behind the next warp" (Whiteford 1977, 52). Wider objects could be made in the twining technique, which also allowed greater variety in the decoration. Diamonds or joined triangles that formed hourglass shapes were some of the designs used for decoration on twined pouches (see plate 23).

The fingerwoven designs that were most popular with Creeks and Seminoles include chevrons, double chevrons, diamonds, double or multiple diamonds, rows of interlocking diamonds, and lightning or sawtooth designs. White pony beads—so called after the pack animals of the traveling traders, known as "pony traders," who introduced them—were used either to outline these geometric designs or to fill in the patterns (fig. 4.1). They accent many designs, such as the rows of chevrons or Ws that were frequently used. Other design decisions entail determining the technique of weaving to be used as well as the number of colors of yarn. Red, dark blue, and black were the most common colors, not only among

the Creeks and Seminoles but throughout the Woodlands and Eastern Plains, although green or yellow were also sometimes used. Color selection based on a sharp contrast of light and dark adds to design interest. Two-color designs can consist of simple bands of alternating colors, but certain patterns, such as the zigzag stripes of lightning, can employ three or more colors, in which case the strands of yarn might first be arranged in a sequence according to color value, such as light-dark-medium or dark-medium-light.

Fingerwoven straps, sashes, and garters were consistently in use during the first half of the nineteenth century. Straps made to be attached to the sides of a pouch are finished on each end with short braided or woven drops that end in tassels. Similarly, sashes have long woven drops at each end that are also finished with tassels. Sashes were worn two ways, either around the waist as a belt or across the shoulder as a baldric. Some portraits show the drops hanging by the wearer's side, such as the portrait of Chief Tallahassee, in which he is shown using his as a burden strap (see fig. 2.15). The portrait of Tukose Emathla appears to show his sash endings tied around his waist over the body of the sash (see fig. 2.1). His garters end in short braided strands that are tied in the front just under his knees.

Museum collections include many examples of nineteenth-century fin-gerwoven artifacts made by Creek and Seminole Indian women. The earliest documented examples are part of the costume of the Creek prophet and chief Josiah Francis, probably collected around 1816 and now in the British Museum. This costume includes a bandolier, a fingerwoven strap, and a twined pouch edged with bead trim, woven of blue, black, and red wool yarn (see chapter 6 and plate 23). Other fingerwoven components of the outfit belonging to Francis are a multicolored sash that is without beads and garters featuring interwoven chevron designs outlined with beads. This suggests the maker's skills were limited to fingerweaving and did not include bead embroidery at that time. Chief Francis's garters are woven of three colors of wool, light blue and black being used to form a series of chevrons divided by lines of dark blue. Rows of interwoven

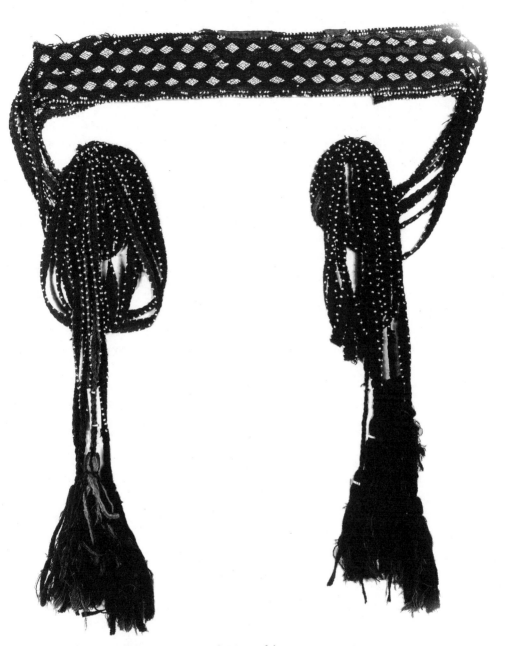

Fig. 4.1. Fingerwoven shoulder sash with filled-in diamond design, Seminole, before 1840. Wool and glass beads. Photograph courtesy of the National Museum of the American Indian, Heye Foundation. Acc. no. 1-8201; neg. no. 25316.

126 white pony beads follow the lines of the chevrons, and beads are also woven in along the edges of the garters.

Francis also wears a sash tied around his waist in his self-portrait, but it is impossible to determine what it actually looks like or how it is made. The lightning design on his sash now in the museum collection is similar to that of the strap of the shoulder bag, but is instead accented by a more varied palette that includes wool yarn in black, blue, terra-cotta (perhaps faded), yellow or gold, and red. The sash ends in colorful rows of braided wool and tassels. This technique of weaving is not unique to the Southeast: Francis's sash bears a striking resemblance to the sashes woven by Great Lakes Indians and by the French women of the village of St. Jacques de l'Assomption in Quebec.

This exchange of ideas warrants discussion because of what it tells us about how native people sometimes adapted their techniques to European materials. The fingerweaving technique was of indigenous origin but was adopted by French women on such a large scale of production that scholars initially thought it was of French origin. Canadian scholar Dorothy Burnham has written that "the threads, as they interlace, link with each other and make a turn to produce a colour change. There is no evidence that this linking and turning, this interlocking of the threads, occurs in the braiding of any part of the world, France included, other than North America" (1981, 36). But in fact the French women of Quebec first adopted the technique from the Indians, and then elaborated and improved on it by drawing from the European tradition of wide belts used as burden straps to help carry heavy loads. Worn by fur traders, such sashes proved so popular that they became a part of the folk costume in Quebec. The Hudson's Bay Company later had them produced in quantity by the women of St. Jacques de l'Assomption through a well-organized cottage industry. This led some scholars to the incorrect conclusion that "with the wide dispersal of the Quebec sashes, they, in turn, influenced Indian production" (Burnham 1981, 36; see also Barbeau 1976).

The Lower Creek Chief William McIntosh wears a wide fingerwoven belt and garters in a full-length portrait done in the 1820s. Both have multiple diamond designs outlined with white beads. The collection of

the National Museum of the American Indian includes a similar wide belt that was made for McIntosh by his daughter (Dockstader 1978, 175). Rows of interwoven white pony beads outline the multiple diamond designs on this belt, too, and white pony beads have been woven in along the edges. The belt ends in woven drops with bead edging and tassels. Although information gleaned from portraits can be misleading, the use of a multiple diamond pattern and the alternating of colors are sufficient to suggest that the sash in the collection was the one worn by McIntosh for his portrait.

For their portraits, Seminole men often wore straps or sashes and garters that appear to be decorated with woven designs either outlined in beads or filled-in with beads. The Seminole Julcee Mathla wears a strap with a double chevron design trimmed with white beads in a painting done of him by Charles Bird King (Horan 1972, 248). In the full-length portrait of him painted in 1838 by George Catlin (see fig. 2.6) Osceola was depicted wearing fingerwoven garters with outlined beadwork. A similar fingerwoven garter with a chevron pattern that was collected by Osceola's physician, Dr. Weedon, is now in the collection of the Alabama Department of Archives and History Museum. The yarn is handspun two-ply wool and the ends are tied off in braids (Wickman 1991, 35). When Chief Micanopy challenged Catlin to paint an accurate likeness of his legs, the artist carefully detailed Micanopy's showy fingerwoven garters with their outlined diamond design.

Billy Bowlegs wears a broad strap and garters that have fingerwoven outlined diamond designs in the daguerreotype portrait from 1852 (see fig. 2.9). He is wearing the same strap the 1852 group portrait that included John Jumper (see fig. 2.8), while the latter wears a strap with diamond designs that seem to have been filled in with beads. A 1990 exhibition included a strap in this style that was collected from Chief Jumper, according to the family who now owns it (Blackard 1990, plate 16).

Thus we know that fingerwoven beadwork straps or sashes and garters with outlined bead designs were prevalent at least until 1825, but at some point the women had started filling in the small diamond designs with rows of white beads (fig. 4.1). There are numerous examples of garters,

128 belts, or straps made in this manner in museum collections, although additional documentation is usually unavailable. The weaving technique used in one such piece—an otherwise undocumented garter whose diamond design is filled in with beads—has been analyzed by textile expert Dennis Lessard (fig. 4.2). The white pony beads have been alternately woven onto the warp or weft threads, which are dark blue. Three beads are woven in one direction and four in another to form diamonds that have then been outlined by surrounding threads of red wool. In a fingerwoven belt attributed to Osceola, dark blue and black wool have been used with white beads to fill in the diamond shapes. The documentation is sketchy, but the belt was part of the collection of Thomas P. Roberts in 1869 (Wickman 1991, 177). The belt is woven on a diagonal, three-over-two diamond pattern. White beads are strung on the blue yarn to fill the diamond centers.

Fingerweaving techniques seem, however, to have been largely abandoned after mid-century. Only isolated examples turn up in later portraits, and fingerwoven items do not appear in the accounts or drawings of the remnants of the Seminoles made by Pratt or MacCauley by 1880. Even so, Chief Tallahassee was photographed at the turn of the century wearing a fingerwoven strap and garters (see fig. 6.5).

In 1910 Alanson Skinner described an array of woven bead and yarn belts that were worn with men's ceremonial dress (Skinner 1913, 65–66). His report included a photograph of a man wearing two belts, one crossing his chest and one around his waist, about which he commented that "the beaded belts are woven in angular figures, in contradistinction to the otherwise similar circular designs of the Creeks, usually symbolizing some life form." Skinner also mentioned that the belts were "woven entirely of beads on a thread foundation, or largely of yarn with a few beads mixed in" (1913, 71). These comments refer to the angular loomed beadwork that had replaced curvilinear embroidered beadwork, but they also demonstrate that fingerwoven work was still around.

Several photographs were taken of Charlie Willie and his sons sometime in 1922 or 1923. The men are alternately shown wearing what appears to be the same pair of fingerwoven straps across their chests, straps that

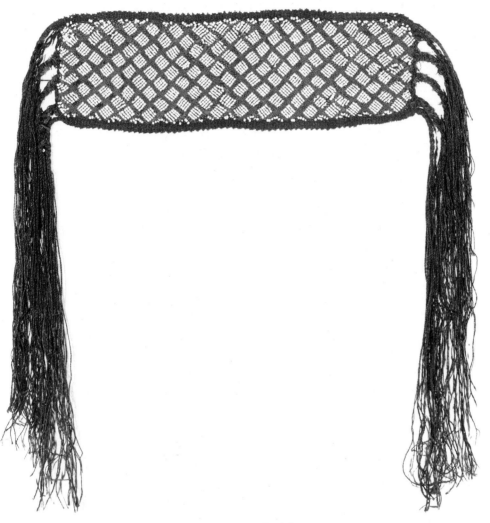

Fig. 4.2. Fingerwoven beaded garter, Creek or Seminole, mid-nineteenth century. Wool and glass beads. Width: 3⅞"; length: 11⅜". Note filled-in diamond designs. Photograph courtesy of the Lowe Art Museum, University of Miami. Acc. no. 88.0052.

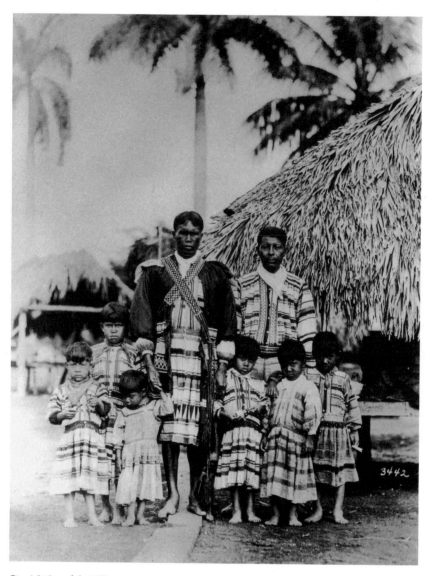

Fig. 4.3. One of the Willie
brothers wearing two
fingerwoven straps across his
chest, Musa Isle, 1923.
Photograph by Claude C.
Matlack. Courtesy of the
Historical Museum of Southern
Florida. Neg. no. 3442.

are decorated with diamond designs filled in with white beads (fig. 4.3).
But fingerwoven straps do not occur in portraits of other Indian men
made at that late date, and this pair of straps may have been heirlooms.
Examples of fingerweaving are not found in photographs taken after that
time, since by then loomed beadwork had already become the predomi-
nant technique.

It seems that the ancient craft of fingerweaving was discontinued by
Seminoles by the turn of the twentieth century at the latest. Among the
Southeastern Indians, only the Choctaw and the Cherokee women of
today continue to make fingerwoven sashes. (Cherokee women demon-
strate the technique at the Oconaluftee Indian Village in Cherokee, North
Carolina.) In his 1980s research on the contemporary continuity of fin-
gerweaving traditions, Ralph T. Coe also found that "the Great Lakes and
Southeastern women still make excellent hand-braided sashes, for wear
across the shoulder or as a waist tie, often with part of the sash fringe or
ties hanging at the sides" (Coe 1986, 101). Finally, there are a few Chero-
kee and Osage women in Oklahoma, as well as some Winnebago women
in Wisconsin, who continue the otherwise outmoded Indian craft of fin-
gerweaving.

European Glass Beads

The introduction of colorful European glass beads met with ready acceptance by Indian people, and they offered new creative possibilities. These beads replaced the traditional hand-drilled beads of bone or shell that had once been highly valued exotic items and were often traded across great distances. In the Southeast during the Mississippi Culture period, we find depictions of figures wearing wrist and calf ornaments or belts made of strings of shell beads. The masses of shell beads on the wrists and ankles and beneath the knees of the bodies of dignitaries found in graves at such Mississippian culture sites as Etowah and Ocmulgee indicate the importance of beads to their owners in both life and death.

Early European explorers, recognizing the appeal of beads to the natives, anticipated the popularity of glass beads. On his famous voyage in 1492 Christopher Columbus carried beads, with which he hoped to gain the Indians' favor. He wrote in his log of his landing on October 12, 1492: "Soon after a large crowd of natives congregated there. . . . In order to win the friendship and affection of that people . . . I presented them with red caps and some strings of glass beads which they placed around their necks, and with other trifles of insignificant worth that delighted them and by which we have got a wonderful hold on their affections" (Orchard 1975, 16).

Likewise, the Spanish explorers Pánfilo Narváez in 1528 and Hernando de Soto in 1539 carried with them several varieties of faceted chevron glass beads and colored ceramic beads, which can now be used to identify

the sites where they stopped in Florida on their travels (Mitchem 1989, 103–5). French explorers and traders in the Great Lakes were also quick to discover that the Indians were attracted to glass beads. Beginning around 1610 glass beads served both as gifts and as a coveted medium of exchange in the fur trade. In Georgia, European glass beads have been found at the archaeological site of Ocmulgee along the Lower Creek trading path, which crossed the Ocmulgee River, where, as excavations reveal, a British trading post was established as early as 1690.

Glass beads had been manufactured in Murano, near Venice, since the fourteenth century or earlier, and most of the beads traded by the early Spanish and British explorers probably came from that source. In addition, evidence is emerging to indicate that from quite early on the Spanish also used Chinese beads for trade (Miller 1993). A glass-bead factory operated in Amsterdam from 1608 to 1680. Later, there were glass factories located in Sweden, France, and Spain, and in America at Jamestown. "Bohemian" beads were manufactured in Czechoslavakia after the mid-1800s. Trade records reveal that vast quantities of glass beads were shipped to the frontier annually.

Until recently, it was thought to be virtually impossible to identify the origin and date of manufacture of glass beads (Quimby 1966, 82)—with the result that beads alone were of little value in dating archaeological sites. Other methods have had to be used for dating. But researchers are now pinning down information that might eventually shed light on specific dating of beads, although there is still much work to be done in this field.

Bead styles changed over time, and they have been classified and typed by shape, color, method of manufacture, and size. By charting the beads from dated sites in chronological order, archaeologists have been able to establish which types of beads were in use during a given period of time. The presence of beads of known date is then useful in dating undocumented sites. For example, specific types of beads are associated with the early, middle, and late Historic periods. Larger multicolored glass beads of various shapes primarily were used for neck ornaments in the early

period of contact. During the late Historic period, solid-colored, round pony beads used for fingerweaving and globular seed beads used for embroidery were more prevalent.

European glass beads come in many identifiable varieties, both translucent and opaque, of a solid color or polychrome. The methods of manufacture are also distinctive. Beads that were "drawn" or "wire wound" while the glass was molten are the most common. Size and shape vary as well: tubular, faceted, doughnut, barrel-shaped. As we have seen, opaque white pony beads were used most often with woven items. Pony beads are usually at least an eighth of an inch in diameter, often approximately twice the size of the tiny seed beads used for embroidery, which have a flattened globular shape and range in diameter from about a sixteenth to an eighth of an inch or more. Seed beads can be either opaque or translucent, and they come in an unlimited range of solid colors—although the preferred colors were white, turquoise, blue, red, rose, green, yellow, and black. Indeed, the importance of color symbolism appears to have influenced the choice of bead color. For example, color symbolism associated with mythology or medicine has been shown to be significant among the Muskogheans (Mitchem 1991, 313), who assigned special symbolic value to blue, white, and red. Blue beads in particular seem to have held some special meaning among many Native American groups.

Beadworking techniques vary, from the ancient and simple method of stringing to more intricate procedures such as weaving and embroidery. As we saw in the previous chapter, fingerweaving techniques using glass beads and commercial wool yarn began during the eighteenth century; embroidered beadworking techniques were introduced in the nineteenth century. Both techniques were used extensively during the nineteenth century, but their use declined at some point either just before or during the early twentieth century, when loomed beadwork became the dominant beadworking technique.

The necklaces worn by women consisted of simple strings of beads, although these women spent long hours making imaginative beaded ornaments for their men. Beautiful beaded accessories were an essential element of the impressive look of Creek and Seminole men's dress styles

during the nineteenth century. Both fingerwoven and loomed beadwork were limited to geometric designs by the nature of the process, whereas the intricate bead designs embroidered on wool shoulder bags, sashes, leggings, and breechcloths were more varied in form, using both geometric and curvilinear shapes. There was also more variety in content, which could be abstractly symbolic, vegetal, or zoomorphic. A bow or frame loom was used to make beaded straps or other items toward the end of the century, a technique that continues to be popular today.

Strung Beads

As noted previously, long shell necklaces were depicted on figures during the Mississippi Culture period and on the native men and women drawn by early European artists at the time of the first contact of Indians with whites in Florida. The prehistoric tradition of stringing shell beads was then continued using the decorative glass beads brought by Europeans, which could be tubular, round, or faceted in shape and were available in a great variety of colors. Long or short strands of these beads were worn by both men and women. Excavations have been made at a Spanish Franciscan mission site in Florida, San Luis de Talimali, which was also the site of a large Apalachee village during the late seventeenth century (Mitchem 1991, 301). Most of the beads found there are of types found at other sites in the Southeast dating from the late sixteenth to the eighteenth centuries. These included gilded glass beads, drawn opaque necklace beads of turquoise glass, burgundy barrel-shaped beads of wound construction, and a bead of a type known as "Florida cut crystal," which dates from the late sixteenth to early seventeenth centuries (1991, 309). Two Cornaline d'Aleppo beads were also recovered—a bead of Venetian origin with a pale green core and brick red exterior that was widely distributed throughout North America from 1600 to 1836.

Bead chokers are depicted on Indian men during the late eighteenth and nineteenth centuries. For example, John Trumbull drew Creek chiefs wearing glass bead chokers with their silver gorgets in 1790—although by then silver gorgets were considered the more impressive status symbol

(see fig. 1.4). Smaller glass seed beads interwoven with wool yarn or embroidered in fanciful designs on articles of clothing or other items were more abundant in the nineteenth century.

At least fifty glass beads were excavated by Brent Weisman from a Seminole site at Nicholson Grove, west of Lake Pasadena in Pasco County. These include a variety of types, dating from throughout the Seminole occupation of the site, and reflect the relative prosperity of the Indians during the late eighteenth and early nineteenth centuries. Bead types included Cornaline d'Aleppo, varieties of monochromatic faceted beads, and a drawn round polychrome bead. Weisman determined that these three types of beads seem to have remained popular among the Seminoles through the 1830s. They appear as items of personal adornment included with Seminole burials dating to the 1830s at the military post at Fort Brooke and were probably the kinds of beads that were used for the colorful multibead necklaces drawn by Catlin in his portraits of the Seminoles (Weisman 1989, 69–70). Men continued to wear one or more short strands of beads, while women wore many long strands.

After the years of isolation following the Seminole wars, men had begun to wear numerous bandanas around their necks, but women continued to wear abundant necklaces. Clay MacCauley observed in the 1880s that Young Tiger Tail's principal wife, Moki, wore no fewer than two hundred strings of good-sized beads. The beads, which were probably at least one quarter of an inch in diameter, were sold by a Miami trader for $1.75 a pound. MacCauley wrote that Moki "had six quarts [of the beads] gathered around her neck, hanging down her back, down upon her breasts, filling the space under her chin and covering her neck up to her ears. It was an effort for her to move her head. . . . Even girl babies were favored by their proud mammas with a varying quantity of the coveted neck wear. The cumbersome beads are said to be worn by night as well as by day" (MacCauley 1887, 488).

The Brickell Store at the junction of Biscayne Bay and the Miami River was an important center for Indian trade from 1871 to 1900. Excavations and materials collected from the Brickell home and its adjacent grounds were conducted by Dade County archaeologist Robert Carr from 1961 to

1964. Although others have collected beads from the site, Carr managed to recover 654 glass and ceramic beads that have been classified into at least thirty types, which is indicative of the quantity and selection of styles available (Carr 1981, 187–90). A large number of seed beads were also collected but were not classified. The source of supply of the beads was evidently a dealer in New York, but no information is available regarding their country of origin. A slim majority—52 percent—of the beads that were classified were tubular. They exhibit varying degrees of complexity in manufacturing technique and decoration. For example, 346 layered tube beads in doughnut and barrel shapes with rounded edges in two-color variations were recovered. The beads average from two to seven millimeters in length, and their diameters vary from three to seven millimeters.

In 1982 Carr also excavated the Stranahan House and store site on the New River in Fort Lauderdale, where Frank Stranahan operated a store from 1896 until 1906. Sixteen basic bead types were found; among these, an additional ten color and size variations were found (Carr 1989, 31). Comparable bead types and varieties were found at the Brickell store. Given that Stranahan was an agent for the Brickells, he might well have bought some of their excess stock.

Black and white photographs of Seminole women from the period indicate that they probably wore a few novelty beads with numerous strands of single-color beads that alternated with bunches of strands in other colors. Masses of bead necklaces would naturally indicate a degree of wealth, but otherwise they have no clear-cut significance. Many colors of both opaque and translucent beads were used, although there was a preference for red, yellow, black, white, and blue beads, gathered into bunches of strands of each color. In the close-up portrait of Alice Osceola done somewhere between 1917 and 1919, she wears high on her neck multiple rows of shorter strands of colored beads that tied at the front for easy removal (see fig. 3.3). Below these she has added longer strands of various solid-colored beads, along with a bead necklace with coins that could be pulled over her head. Her baby daughter, Mittie, wears four strands of necklaces, one with a single coin pendant.

Necklaces with attached silver coins as drop pendants were in vogue from the late nineteenth century through the 1920s. Both dimes and quarters were used, but usually only one denomination was used on each necklace. The Crane Collection of the Denver Museum of Natural History includes one necklace of red and green beads to which forty-two dimes dating from between 1892 and 1923 plus a half-dime from 1851 are attached. Another necklace in the collection, made of orange and white beads, has forty-one quarters that date from 1859 to 1906.

Coins sometimes were worn only in the front, but they often encircled the woman's neck. Usually, the bead necklace with coins was dramatically draped around the wearer's shoulders along with the last row of beads (see fig. 2.17). In some instances, two bead necklaces with coins were worn: a necklace with quarters attached to it might be worn as the bottom row, for example, with a dime necklace worn higher on the neck. Although bead necklaces with coins generally have not been worn since the 1920s, both collectors and Indian people interested in period dress inspired Bill Osceola to start making them again in the late 1980s. His daughter, Debbie, also makes such necklaces and also earrings with coins (fig. 5.1).

Many strands of bead necklaces continued to be an important element of the distinctive look of Florida Indian women from 1930s to the 1950s, but by the late 1950s only elderly women were observing the tradition. The author asked several Miccosukee-speaking women in 1989 about the use of bead necklaces. The Miccosukee Minnie Bert told me that her grandmother had recently objected to removing her necklaces when she had to enter the hospital because she felt "undressed" without them. The grandmother had a name for each strand, probably recalling the time or occasion when it was acquired. Another woman mentioned that when a man dies, his widow sometimes removes and abandons the necklaces her husband had given to her (this being a typical way of dealing with objects relating to the dead). Middle-aged and younger women wear only a few long strands of bead necklaces, for they generally consider wearing the traditional mass of strands too hot, heavy, and impractical. Several women said they continue to wear bead necklaces simply because they

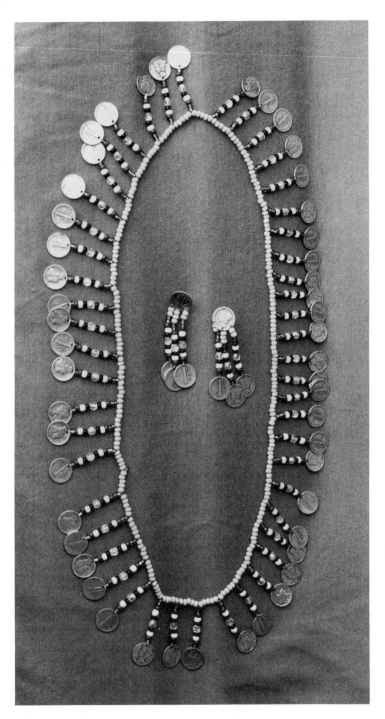

Fig. 5.1. Dime necklace and earrings, 1992. Glass beads, cotton thread, silver dimes. Made by Miccosukee-speaking Debbie Osceola, Tamiami Trail.

like them. Infants and young girls often wear a strand or more of bead necklaces, too.

Seminoles and Miccosukees now make lacy-looking bead necklaces and dangling earrings that have become popular items both on the tourist market and for personal use. They are usually made by adult women, but, as Debbie Osceola told me in 1993, girls and boys make them "when they want money to go to the movies." William C. Orchard has described this technique of making the necklaces as a netlike weave, "the same fundamental principle being applied throughout; that is, a bead is made to function as a knot in netting" (Orchard 1975, 139). The beads are then joined to form a series of diamond or other patterns. The first North American Indian groups to use the technique probably were the Mohave or Quechan tribes in the Colorado River region around 1880 (Tsosie 1992, 37), who are known for their large and intricate collars. Over the years Indians from a few other tribes have also experimented with the netting technique.

Innovations such as this reached the Seminoles and Miccosukees around the 1970s, as a result of exposure to the work of other groups who travel the powwow or festival circuit. There is thus nothing particularly "Seminole or Miccosukee" about the necklaces, but many young people like to do this kind of beadwork because of its relative ease, the creativity it permits in color and pattern selection, and the fact this jewelry can be made inexpensively and sells well. As a result, probably more of this kind of beadwork is going on today than is sewing, which is far more time-consuming and takes much more skill.

Discussing beadwork in her family, Debbie Osceola mentioned that one technique is called "spiderwebbing" while another version is known as "daisy" (fig. 5.2). "No one teaches you how to do it," she said. "You just look at it, figure it out, and start doing it"—although her daughter, WinterDawn, did confide that she was taught how to do beadwork in classes at the Miccosukee Elementary School. Once they have the basics down, beadworkers simply figure out in their head what they want to do, select the colors, and begin working. Sometimes the bead colors are deliberately chosen to go with the colors in a special new patchwork

Spiderweb weave

Daisy weave

Fig. 5.2. Netlike weave bead-stringing techniques used for making necklaces.

outfit the woman plans to wear herself. One necklace made by Roy Poole featured beads in the colors traditional to Indian medicine—yellow, red, black, and white (fig. 5.3).

No symbolic attributes are given to the beadwork that forms diamond patterns. Necklaces with rows of spiderwebbed diamonds—such as the one made by Roy Poole—are simply called "modern style" necklaces, while others end in a point that is known as a "V yoke." In the other version of this technique, "daisy," four beads are strung together leaving a central hole to form a design that looks like a daisy. The daisy may have beads looped below it to create a popular style called "drop earrings." Another drop-earring style uses both seed and tubular beads: this technique was learned from the work sold by members of an Aztec dance troupe that performs annually at the Miccosukee Art Festival. In short, among the Seminoles and Miccosukees, many adaptations of this basic beadstringing craft now exist, from ongoing styles to completely modern innovations.

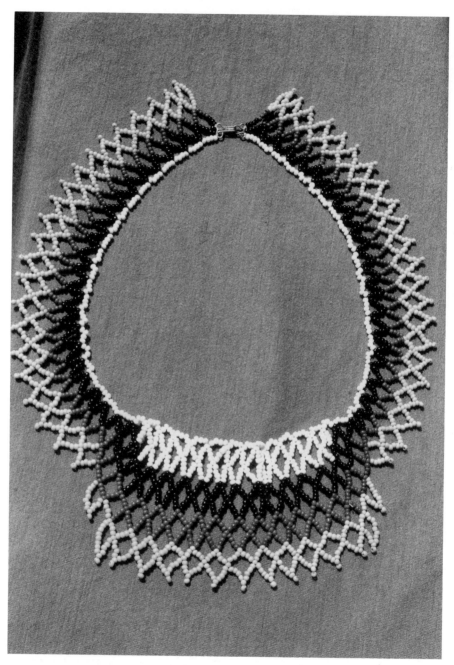

Fig. 5.3. Necklace in spiderweb weave of diamond shapes, Miccosukee, 1993. Glass beads in medicine colors of yellow, red, black, and white. Made by Roy Poole.

Plate 1. Woman's bodice, Seminole, ca. 1890. Cotton cloth. Historical Museum of Southern Florida.

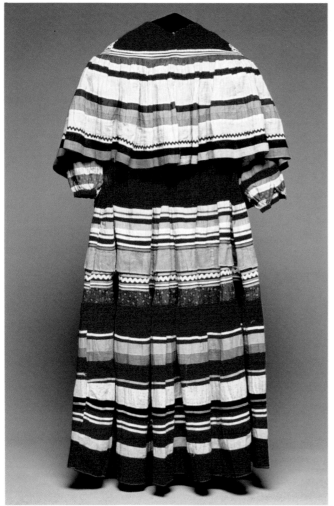

Plate 2. Woman's cape and skirt, Seminole, early 1900s. Cotton cloth. Cape length: 24". Skirt length: 41". Photograph by Rick Wicker. Courtesy of the Denver Museum of Natural History, Crane Collection. Acc. nos. 11347 A and B.

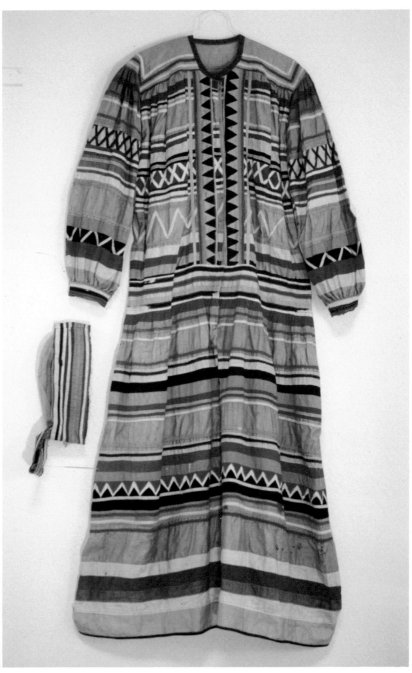

3

Plate 3. Man's big shirt and hat, Seminole, 1920s. Cotton cloth. Length: 50½". Note appliqué decoration. Miccosukee Museum, Tamiami Trail.

Plate 4. Woman's cape and skirt, Seminole, 1920s. Cotton cloth. Cape length: 25". Skirt length: 41". Photograph by Rick Wicker. Courtesy of the Denver Museum of Natural History, Crane Collection. Acc. nos. 11422 A and B.

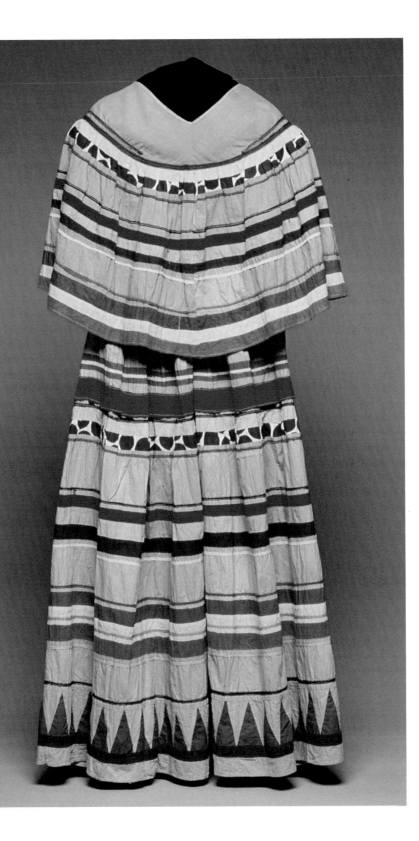

4

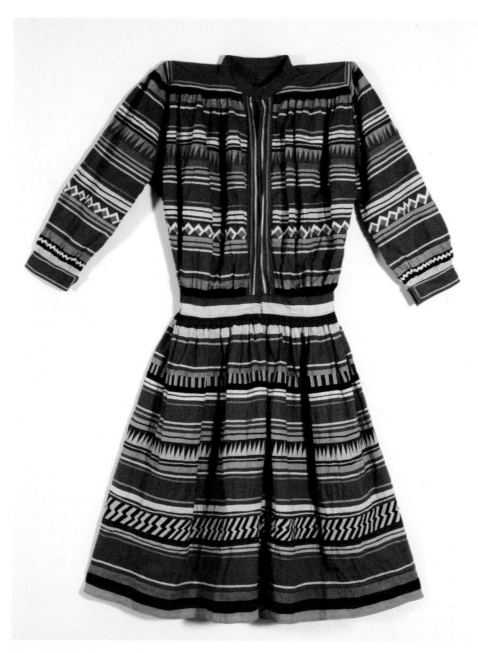

Plate 5. Man's big shirt, Seminole, 1930s. Cotton
cloth and rickrack. Length: 44″. Historical
Museum of Southern Florida. Acc. no. 73.29.1.

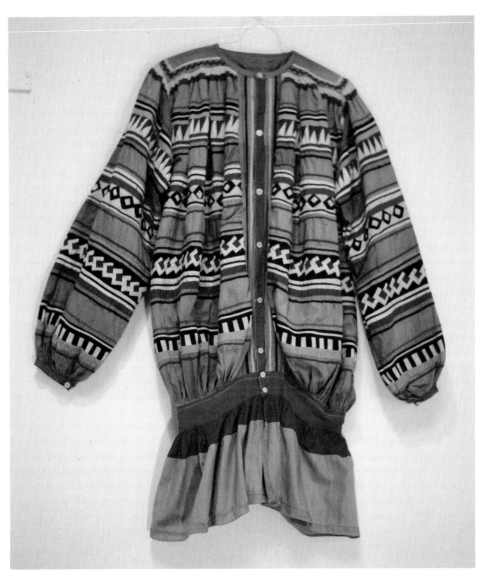

Plate 6. Man's transitional shirt, Seminole,
1930s. Cotton cloth. Length: 39". Miccosukee
Museum, Tamiami Trail.

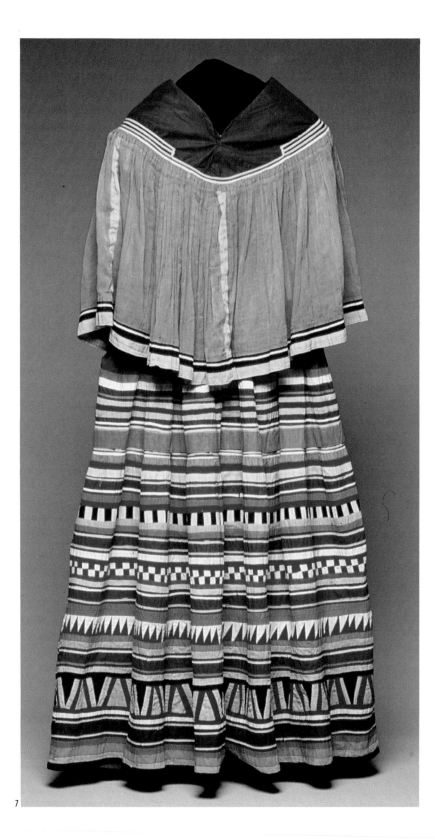

7

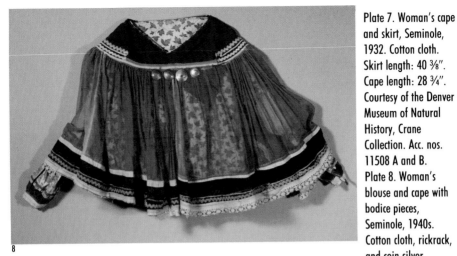

8

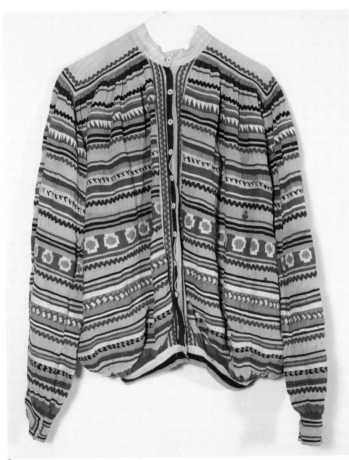

9

Plate 7. Woman's cape and skirt, Seminole, 1932. Cotton cloth. Skirt length: 40 ⅜". Cape length: 28 ¾". Courtesy of the Denver Museum of Natural History, Crane Collection. Acc. nos. 11508 A and B.

Plate 8. Woman's blouse and cape with bodice pieces, Seminole, 1940s. Cotton cloth, rickrack, and coin silver. Length: 24". A pocket was often sewn in the front of such blouses to hold money for shopping trips. Crane Collection, Denver Museum of Natural History. Acc. no. 7948.

Plate 9. Man's jacket, Seminole, 1940s. Collarless style. Synthetic fiber, cotton cloth, rickrack. Length: 26". Tropical Audubon Society, Miami. Gift of Arden Hayes Thomas.

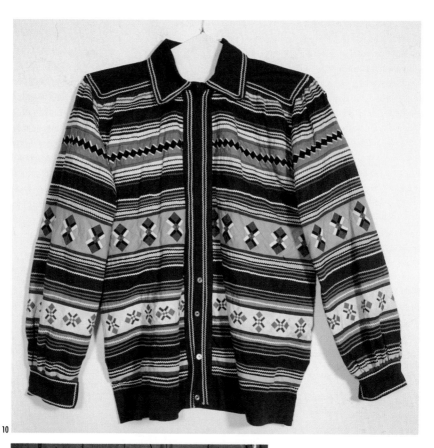

10

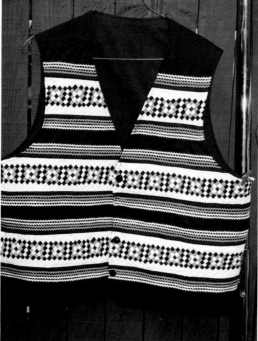

11

Plate 10. Man's Eisenhower-style jacket, Miccosukee, 1970s. Cotton cloth and rickrack. Length: 26". Private collection. Plate 11. Man's vest, 1990. Cotton cloth, rickrack, plastic buttons. Made by Seminole Jimmie O'Toole Osceola, Hollywood Reservation.

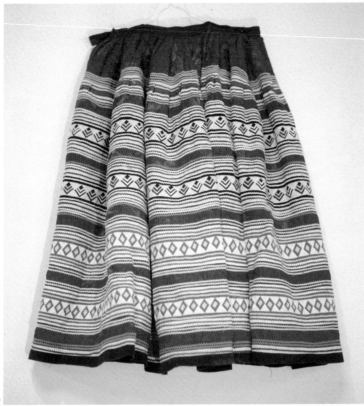

Plate 12. Woman's calf-length skirt, Miccosukee, 1960s. Satin, cotton cloth, and rickrack. Length: 29". Private collection. Plate 13. Calf-length skirts, two complex designs in different color combinations, 1991. Cotton cloth and rickrack. Designs created by Irene Cypress, Miccosukee Reservation; skirts sewn by Miccosukee-speaking Debbie Osceola, Tamiami Trail.

12

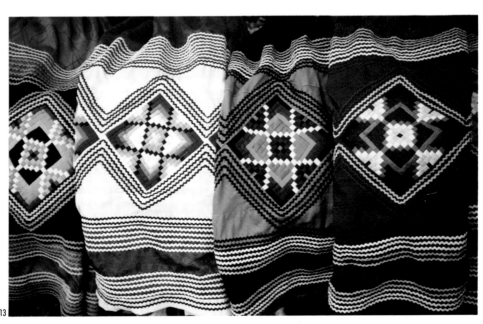

13

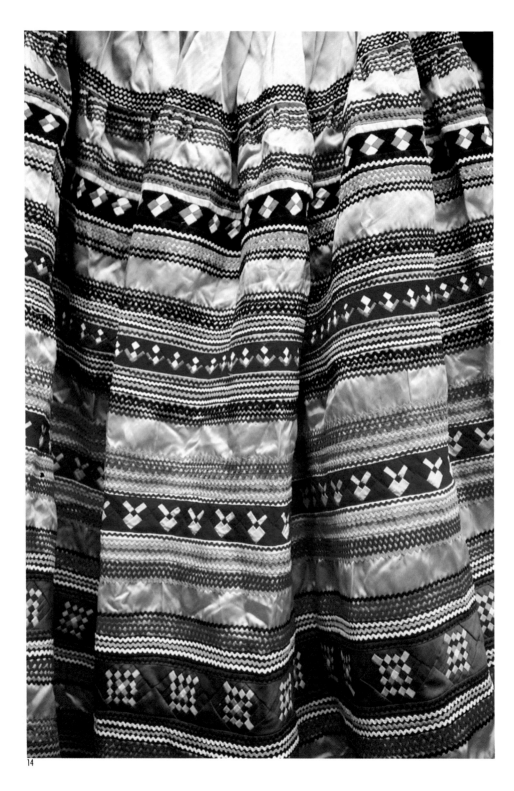

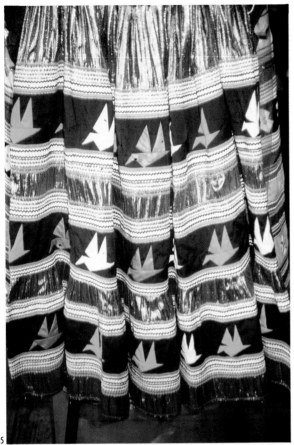

Plate 14. Satin skirt with five rows of designs, 1970s. Satin, cotton cloth, and rickrack. Length: 39". Made by Miccosukee-speaking Effie Osceola, Tamiami Trail.
Plate 15. Skirt with "bird-flying" patchwork design, 1990. Cotton cloth, synthetic cloth, and rickrack. Length: 39". Made by Miccosukee-speaking Effie Osceola, Tamiami Trail.
Plate 16. "Big Town" patchwork design, 1989. Synthetic cloth, cotton cloth, and rickrack. Made by Pauline Doctor, Miccosukee Reservation.

15

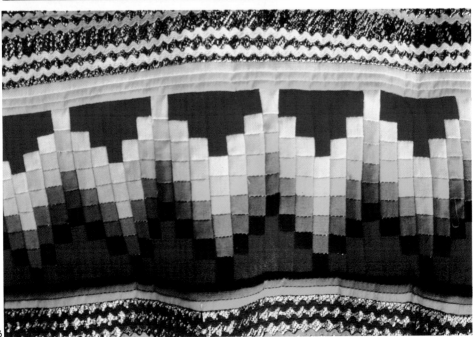

16

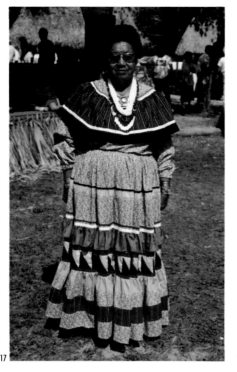

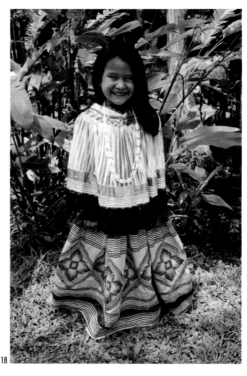

17

18

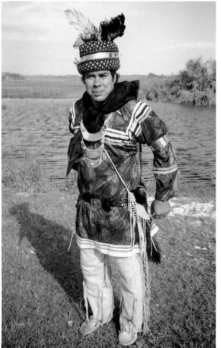

19

Plate 17. Frances Osceola in prizewinning dress, Seminole Tribal Fair, Hollywood Reservation, 1989. Cotton cloth and rickrack. Dress made by Miccosukee-speaking Debbie Osceola, Tamiami Trail.

Plate 18. Girl's one-piece dress with cape, 1991. Synthetic cloth, cotton cloth, and rickrack. Worn by Miccosukee-speaking WinterDawn Billie, Tamiami Trail.

Plate 19. Seminole men in clothing competition. Smallwood's Store, Chokoloskee, 1992.

Plate 20. Bead-embroidered sash, Seminole, nineteenth century. Wool cloth, cotton cloth, and glass beads. Total length: 128″; panel length: 25 ⅝″; panel width: 4 ½″. Photograph courtesy of the Lowe Art Museum, University of Miami. Acc. no. 88.0055.

Plate 21. Loomed beadwork strap, Seminole, ca. 1890. Glass beads, cotton string, and hide. Willoughby Collection, Elliot Museum, Jupiter, Florida.

Plate 22. Man's turban with bead fobs, Seminole, ca. 1890. Wool, egret feathers, and glass beads. Willoughby Collection, Elliot Museum, Jupiter, Florida.

Erratum: Plate 19. James Billie, Chairman of the Seminole Tribe, in 19th-century dress style, at investiture of Sonny Billie as Chairman, Miccosukee Tribe, 1985.

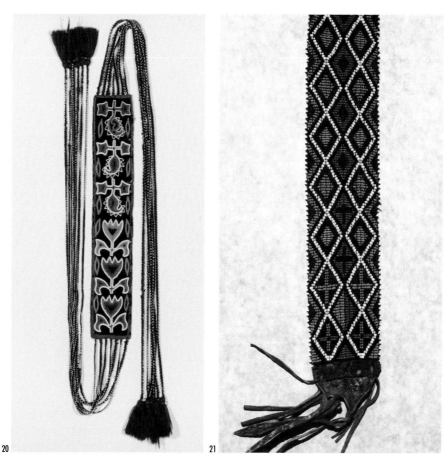

20 21

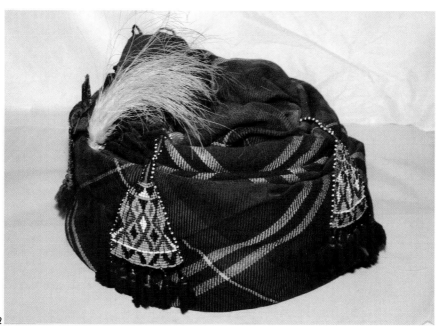

22

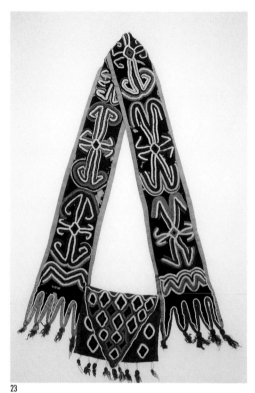

23

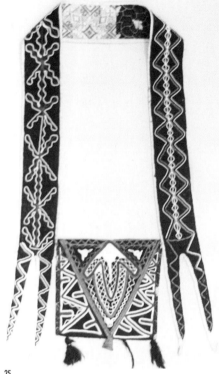

25

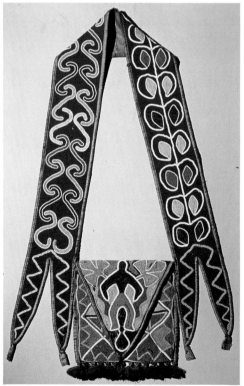

24

Plate 23. Shoulder bag of Chief Francis, Creek, ca. 1817. Bag of wool and glass beads. Length: 8 ¾", width: 8 ½". Strap also of wool. Length: 31"; width: 4 ¾". Presented to the British Museum by Sir Walter E. Trevelyn-Bard, March 30, 1871. Photographs courtesy of the British Museum. Acc. no. 7479e.

Plate 24. Shoulder bag, Seminole or Creek, ca. 1840. Wool cloth and yarn, cotton cloth, silk ribbon, and glass beads. Length of strap: 27 ½". Note black man clad in trousers on the flap. Photograph courtesy of the Field Museum of Natural History, Chicago. Acc. no. 258646.

Plate 25. Shoulder bag of Chief Cloud, Seminole, before 1840. Wool cloth, cotton cloth, and glass beads. Photograph courtesy of the National Museum of the American Indian, Heye Foundation. Acc. nos. 8/4299 and 8/4300.

Plate 26. Shoulder bag of Chief Alligator, Seminole, 1839. Wool cloth, cotton cloth, glass beads, thread, and yarn. Length of strap: 28"; width of pouch: 9 ¼". Collected from the chief in "Indian Country" by John Alexander. Photograph courtesy of the Los Angeles County Museum of Natural History. Acc. no. A.2135.30-4.

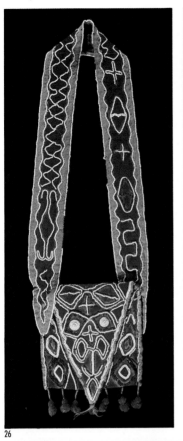

26

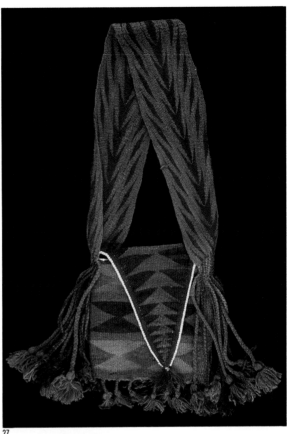

27

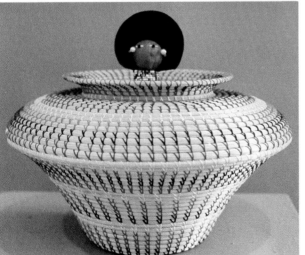

28

Plate 27. Shoulder bag, Seminole, 1894. Wool cloth and yarn, glass seed beads. Collected by Dr. Charles Barney Cory, Sr. Photograph by John Weinstein for the Field Museum of Natural History, Chicago. Acc. no. 167917; neg. no. A111697c.

Plate 28. Lidded basket with doll's head, 1986. Sweet grass, cotton thread, beeswax, palmetto fiber, cardboard, cotton cloth, glass beads. Height with lid: 15 ½". Diameter: 10½". Made by Seminole Donna Frank, Immokalee Reservation. Collection of James Billie, Seminole Tribe of Florida.

Erratum: The photographs in plates 23 and 27 should be transposed.

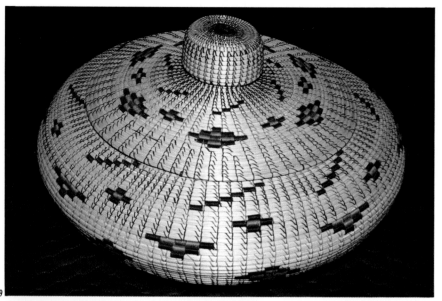

29

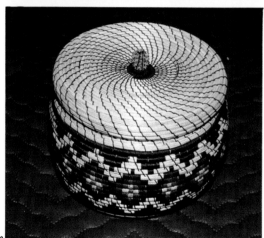

30

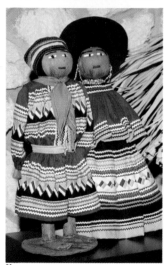

31

Plate 29. Coiled basket, 1989. Sweet grass, cotton thread, beeswax, palmetto fiber, and cardboard. Height: 10"; diameter: 16". Made by Seminole Elaine Aguilar, Immokalee.
Plate 30. Coiled basket, 1989. Sweet grass, cotton thread, beeswax, and Australian pine cone. Height: 4 ½"; diameter: 8 ½". Made by Seminole Mary Frances Johns, Brighton Reservation. Private collection.
Plate 31. Pair of dolls, Miccosukee, 1970s. Palmetto fiber, cotton cloth, rickrack, cotton thread, cardboard, and glass beads. Miccosukee Museum, Tamiami Trail.
Plate 32. Pair of dolls, 1985. Palmetto fiber, cotton cloth, rickrack, cotton thread, cardboard, and glass beads. Height of female: 12 ¼"; height of male: 14 ¼". Made by Miccosukee-speaking Effie Osceola, Tamiami Trail. Private collection.

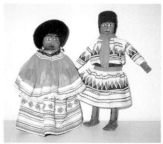

32

Fig. 5.4. Two-thread overlaid or spot-stitch technique of bead embroidery. After William C. Orchard, *Beads and Beadwork of the American Indian* (1975).

Embroidered Beadwork

The leggings with curvilinear bead designs worn by Lower Creek Chief William McIntosh in the portrait discussed in the preceding chapter indicate that the technique of bead embroidery had been introduced from some unknown source to Southeastern Indian women prior to the 1820s. Nineteenth-century Creek and Seminole women used a two-thread overlaid or spot-stitch technique for bead embroidery (Orchard 1975, 151–52) (fig. 5.4). Seed beads are pulled onto a thread and arranged in the desired pattern, and a second thread is then drawn through the material and crossed over the first thread every three or so beads in order to secure the design in place. Sharp turns and curvilinear designs can be made by using stitches over every one or two beads, and one, two, or more rows of beads can be used to outline designs.

Leggings, sashes or straps, shoulder bags, and breechcloths also are decorated with embroidered beaded designs. Very few examples of either leggings or breechcloths are found in museum collections, whereas there are numerous examples of Creek or Seminole bead-embroidered sashes or straps and shoulder bags. Leggings were most often decorated with a simple meandering line representing a serpent motif. Bead-embroidered shoulder bags can be considered one of the most noteworthy Seminole art forms because of their creative designs (see chapter 6).

Embroidered bead sashes or straps have relatively short beaded panels that end in long fingerwoven ties with beaded borders and tassel tips. They were not designed to be attached to a pouch. A rare documented example of a beaded Seminole sash in a private collection was collected at the same time as a knife and sheath. A tag on the sheath reads: "A relic of the Florida war of 1835-43. Given to me when a boy by my father,

Thomas Hart, who received it from Lieut. John H. Hill of the second dragoons United States army—Lieutenant John H. Hill from Gouchata-minchas Nutilage Hammock, March 10, 1840" (Coe 1976, 82). The sash has a row of vegetal designs made of many different colored beads on a black background. A similar undocumented example also has a vegetal motif, with three budding sprouts on one side and three flowers or plants on the other (plate 20). Again, many colors of beads have been used against a black background. This sash has seven long, thin woven ties with bead edges and ending in red tassels.

It is probably because of the personal nature of the breechcloth and the deterioration of leggings caused by wear and tear that so few examples of these items survive in museum collections. Documented examples are extremely rare. But we know from travelers' descriptions and from por-traits that Creek and Seminole men wore wool breechcloths and leggings decorated with bead embroidery. In addition to mentioning an embroi-dered bead breechcloth, William Bartram's late-eighteenth-century ac-count of the Seminole chief Cowkeeper's dress describes his leggings: "The leg is furnished with cloth boots; they reach from the ancle to the calf, and are ornamented with lace, beads, silver bells, &c" (Bartram 1955, 394). George McCall wrote in 1826 about Tukose Emathla's breechcloth, "whose tapering ends, ornamented with beads and various-colored em-broidery, fall both front and rear to the knee" (McCall 1974, 155). Like-wise, two members of the group in the 1838 drawing of a Seminole dance by Hamilton Wilcox Merrill are shown wearing breechcloths with tapered ends (see fig. 2.4). An undocumented breechcloth acquired in the South-east and now in the collection of the Ocmulgee National Monument in Macon, Georgia, also matches these descriptions.

Documented examples of a breechcloth and leggings can be found as well in the Denver Art Museum. These were collected in 1832 in Indian Territory by Count de Pourtalés, a Swiss who accompanied Washington Irving to the region (fig. 5.5). Count de Pourtalés mentioned in his journal that he collected a "complete outfit" made by the daughter of a Creek chief at Fort Gibson. The breechcloth and leggings are both made of dark blue wool. The breechcloth is not beaded, but the leggings are. The

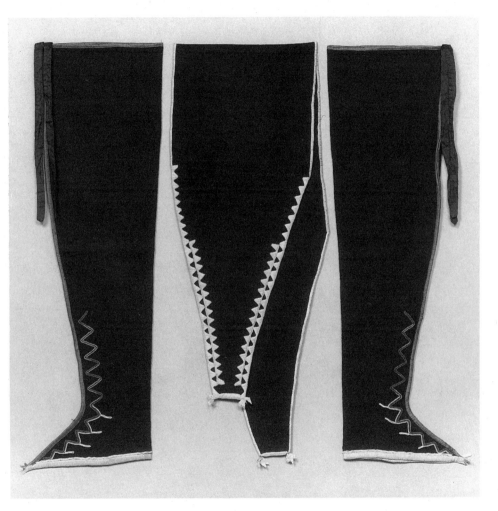

Fig. 5.5. Breechcloth of wool and leggings of wool with glass seed beads, Creek, 1832. Collected in Indian Territory by Count de Pourtalés. Photographs courtesy of the Denver Art Museum. Acc. nos. 1970.379 and 1970.395.

breechcloth has tapered points in the front and back that are appliquéd with blue ribbon and a now-faded red ribbon. As was typical, the leggings open at the front seam and are bound with ribbon. They close at the top with cotton ties, and white beads outline blue and red bead zigzag designs on both sides of the front. Documented examples such as these provide invaluable clues to identifying other samples of Seminole or Creek work.

An undocumented pair of leggings and matching breechcloth, erroneously called a cradle cover, were purchased by a private collector at a Sotheby's auction in 1988 (see the November 29, 1988, issue of *Important American Indian Art*). Both are made of red wool cloth. Seminole men are frequently depicted wearing red leggings with black trim and gold buttons, such as those worn in the portrait of Tukose Emathla by Charles Bird King (see fig. 2.1) and in the George Catlin portrait of Osceola (see fig. 2.6). Indeed, the leggings from the Sotheby's auction are quite similar in many ways to those worn by Seminole Chief Micanopy when he sat for his portrait, also by Catlin, in 1838. Catlin commented that Micanopy only agreed to sit if the artist could make "a fair likeness of his legs, which he had very handsomely dressed in red leggings" (Catlin 1973, 221). Both Micanopy's and the Sotheby's leggings have a row of embroidered serpentine designs on the bottom. A herbal motif of fernlike bead patterns climbs up the sides of the leggings. These designs might have served as a protective device, in this instance to defend the wearer from deadly snakebites. The tapered ends of the Sotheby's breechcloth are appliquéd with green and black cloth and also are decorated with meandering serpentine patterns fashioned of white beads.

Embroidered wool beaded leggings were worn until the end of the nineteenth century. Seminole Chief Tallahassee posed for his portrait wearing wool beaded leggings in April 1901, which is perhaps the last documented appearance of the style (see fig. 6.5). Tallahassee, who was the nephew of old Chipco, also wears woven garters with his pair of wool leggings that have embroidered bead serpentine designs on their bottom edge. But by the beginning of the twentieth century, the new style of fringed hide leggings worn without garters had generally replaced the old wool leggings with bead embroidery.

The embroidered beadwork technique now is used only to make small items. As Debbie Osceola explained, some women make embroidered hair ornaments by sewing pony beads onto the round inside liner from the cap of a mayonnaise jar (fig. 5.6)—surely one of the more imaginative uses for such an item. The design for these ornaments is started in the middle of the liner and the beads are sewn outward, with one, two, or three beads used in a spot-stitch technique. The ornament is attached to a metal clip.

Loomed Beadwork

Loomed beadwork is an ongoing tradition first used by Seminoles in the late nineteenth century. The traders who sold the beads also probably introduced this simple weaving technique, which is used to make straps, garters, fobs, and other articles. Geometric designs such as clustered or large diamond patterns appear most frequently, owing largely to the restrictions of the technique. The clustered diamond pattern is a lingering remnant of a Mississippian period ceramic design. Many colors of beads are used. Opaque white beads are generally used to outline designs. The clustered diamonds are often randomly filled in with rows of three or more colors, and a cross frequently is woven into the center of diamond designs (plate 21).

The most common weaving technique is the square weave, which uses a bow loom or wood-frame loom strung with cotton warp threads. Weft threads holding beads cross at right angles. The two-thread method is used, with the weft thread, which holds the beads, first passing under the warp and then over it for a tight weave. For example, if eight warp threads are used, then seven beads are threaded onto the weft thread with a needle and then passed under the warp at right angles and held in place, one bead sitting between each pair of warp threads. The weft thread is then looped over the outside warp thread and passed back through the beads along the upper side of the warp. Finally, the warp thread ends of the straps or garters are tied off and attached to hide. On a strap, long colorful yarn ties and plump tassels are added.

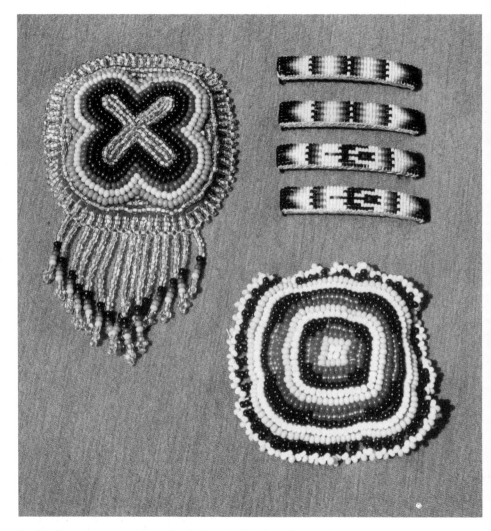

Fig. 5.6. Hair ornaments, Seminole, Big Cypress Reservation, 1993. Left: Bead-embroidered ornament with cross in black, white, red, and gold beads. Top right: Four loomed bead barrettes on metal clips. Bottom right: Bead-embroidered ornament.

Museums have numerous examples of late nineteenth-century loomed beaded straps and fobs, and photographs document their use. Billie Stewart wears two broad and impressive loomed beadwork straps across his chest in his 1890 portrait (see fig. 2.16). The straps end in long woven drops with thick tassels. Two fobs decorate his plaid wool turban.

Fobs were used as turban ornaments and also worn elsewhere for decoration in the late nineteenth and early twentieth century (plate 22). They are woven by the warp reduction method, a technique in which the number of warp threads is gradually reduced to produce an object with a tapering shape. Beads secure the edges. The wide end of a fob is placed toward the bottom of the turban. Beads strung onto the warp threads toward the wide bottom of the fob are then tied off. Similarly, the top warp threads are woven in to reduce the number of threads that are then attached to a strip of hide that is used to suspend the fob. Diamond patterns were the most popular, but a double-arrow design also was associated with this distinctive item. Oklahoma Seminoles identify the double-arrow bead design as a representation of the leaf of a powerful plant that is one of the four important medicines used in the Green Corn Dance ceremonials (Howard and Lena 1984, 61).

Alanson Skinner described Seminole loomed beadwork that he had seen in 1910, remarking that they made belts, fobs, and garters (1913, 71–72). He had not seen any beads sewn on cloth or hide. The men wore two kind of belts, and he included in his report a photograph of George Osceola wearing them. The first was worn around the waist and had a set of long trailing tassels at the end and in the middle, while the second was worn over the shoulder and had tassels only at the ends. Beaded garters, described as similar to those of the "northerly tribes," were wrapped around the outside of the legging below the knee. Small plain heddles made of split palmetto ribs were used for weaving the beads onto a foundation of threads. Skinner was told that the bead designs "are often symbolic, but the only meanings that could be obtained were: (1) diamond back rattlesnake, (2) 'ground' rattlesnake, (3) everglade terrapin, (4) terrapin spear-point" (1913, 71).

Beadworkers are still very active, using seed beads or pony beads to

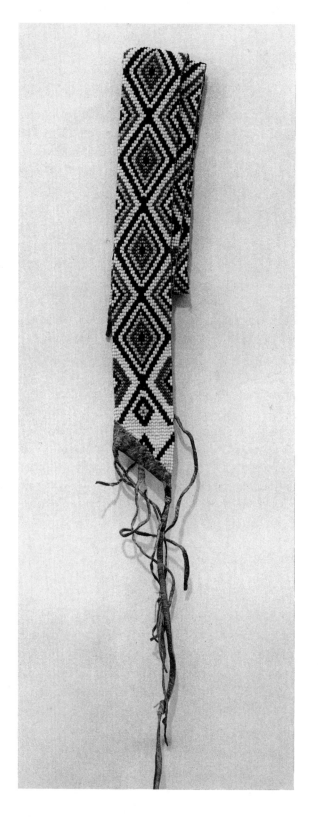

Fig. 5.7. Loomed beadwork strap, 1970s. Glass beads, cotton string, and hide. Courtesy of Iron Arrow, University of Miami.

make loomed hatbands, belts, bracelets, barrettes, and other items (see fig. 5.6). For this kind of work, however, Seminole and Miccosukee artisans use designs more typical of those of other Native American groups. Large pony beads are used for making wide loomed straps with diamond-back rattlesnake designs. These are worn with ceremonial dress and have been worn publicly with pride by men who participate in costume competitions at Seminole fairs since the 1970s (fig. 5.7).

C H A P T E R 6

A shoulder bag consists of a pouch suspended from a strap worn over the shoulder and across the chest. The introduction of shoulder bags by Europeans coincided with a time of major changes in Southeastern Indian culture. Shoulder bags worn by Creek and Seminole Indian men have always held a special fascination for scholars and collectors owing to their rarity and the scarcity of information concerning their provenance. They were worn from the eighteenth century until 1900 and have not been used since then. Many contemporary Seminole and Miccosukee people had no knowledge of their use until recently.

A precedent for the use of pouches by Southeastern Indian men can be inferred from Mississippian artifacts with figures incised on shell or embossed on copper. Many of these figures are shown wearing a breechloth and a long triangular pouch on the hip, held by a sash at the waist. Made of fur or feathers, these pouches had rectangular flap openings decorated with shell beads.

Shoulder bags, also known as bandoliers (also spelled bandoleers) or bandolier bags, were worn by British soldiers during the eighteenth century. They did not escape the notice of Indian men in Georgia, Alabama, and the Carolinas, who readily adopted this useful gear to hold their shot, tobacco, and ritual or other necessary items. By the nineteenth century, shoulder bags had become an essential part of the complete costume of Creek and Seminole leaders. The decoration and configuration of the pouch and strap were, however, uniquely Indian innovations, although European trade materials and techniques were used.

From a study of examples in museum collections and of those worn in portraits, at least four distinct types of Creek and Seminole textile

shoulder bags can be distinguished. The characteristics of the four types are:

1. Native twined wool pouch and fingerwoven strap with tapestry designs woven of two or more colors of wool yarn. White pony beads may decorate only the edges and are not interwoven.

2. Native twined wool pouch and fingerwoven strap with geometric designs outlined with interwoven white pony beads.

3. Native twined wool pouch with tapestry designs outlined by embroidered white pony beads. The strap is fingerwoven with or without interwoven bead decoration.

4. The commercial wool pouch and broad strap decorated with embroidered designs made of multicolored glass seed bead. The edges of the strap and the flap are sometimes bound with another material and trimmed with beads.

Because of a lack of documented examples, it is impossible to determine whether there was a chronological progression in the development of these four types. Study of the portraits of Creek and Seminole leaders painted by Charles Bird King that are included in *The McKenney-Hall Portrait Gallery of American Indians* (Horan 1972) suggests that by 1826 all four types of shoulder bags were in use. Creek leaders wear straps or shoulder bags that exhibit all four styles of construction, whereas Seminole men appear primarily to wear fingerwoven straps with interwoven beadwork.

The earliest documented example of the first type of shoulder bag was collected around 1816 from the Upper Creek prophet Josiah Francis (plate 23). The bag has a twined square shape and a triangular flap opening. It has tapestry woven triangular motifs; arrows ascend on the flap and white pony beads trim its edges. Wool tassels are suspended from the bottom of the pouch and the flap. The strap is approximately fifty inches long by four inches wide and is joined to the side of the pouch. It is woven in a flame design from the middle outward, with the design turning in opposite directions on each side of the strap. The different colors of yarn end in braided drops tied on the bottom to form tassels. In general, the twining technique allowed greater variety in the decoration of pouches than of

straps, the range of strap designs being limited by the fingerweaving technique.

The second type of shoulder bag is worn by Chief Tukose Emathla, who is depicted in Horan's McKenney-Hall volume (see fig. 2.1). The strap has a row of interwoven chevron designs, while the pouch appears to be decorated with interwoven geometric designs outlined with white beads.

An example of the third type can be seen in an undocumented shoulder bag now in the collection of the Natural History Museum of Los Angeles County. Embroidered white pony beads outline the meandering serpentine lines on the twined pouch and the ascending diamonds with central diamond pattern used on on the flap. The flap is edged with a twilled fabric and a row of embroidered sawtooth shapes. The remains of a tassel are visible on the point of the flap. The strap has alternating two-color rows of wool yarn with beads interwoven in triangular or sawtooth shapes. It is finished with woven yarn drops edged with white beads that end in tassels, and wool cloth also covers the back of the strap. Creek Chief Apauley Tustennuggee wears a similar shoulder bag in one of the rare extant portraits of him, painted by Charles Bird King and now in the collection of the Smithsonian Institution (Viola 1976, 61). Another undocumented shoulder bag of this type has serpentine designs of embroidered white pony beads on the handwoven twined pouch (Blackard 1990, no. 13). The triangular flap is also decorated with embroidered white pony beads to form coils or spirals in the center of diamonds and is edged with meandering serpentine motifs. The strap is fingerwoven with alternating rows of two colors of yarn.

The fourth type of shoulder bag that has curvilinear or geometric designs embroidered on commercial wool was worn from approximately 1800 to 1900. Yoholo-Micco, who was the headman of the Creek town of Eufaula, and his son Mistippee wear this style in their portraits, also painted by King (Horan 1972, 138, 140, 132). Their straps are boldly edged with another material, indicating the use of commercial wool cloth and binding. McKenney commented that Mistippee's parents also gave him the name "Benjamin . . . having decided to rear him in the fashion

of their white neighbors" (Horan 1972, 138, 140). The identity of those white neighbors remains unknown, as do the other influences they might have had on Indian families. Embroidered curvilinear designs also decorate the shoulder bag worn by the Creek Great Warrior, or Menewa, in the portrait King did of him (Horan 1972, 132).

By the 1830s men of all Southeastern tribes were wearing shoulder bags with bead designs embroidered onto commercial wool cloth. They are decorated with motifs that preserve the last vestiges of an ancient design tradition as well as with new, innovative patterns. Rendering these designs, whether old or new, in the embroidered bead technique can be regarded as the single most distinctive and important artistic accomplishment of the nineteenth-century women who made them.

It is not known exactly when or how Creek Indian women learned the bead embroidery technique that incorporated European materials and flourished in the Southeast during the nineteenth century. Colorful glass bead designs were embroidered onto commercial wool cloth, stroud, or feltlike baize, using a steel needle and cotton thread in the two-thread overlaid or spot-stitch technique (Orchard 1975, 151–52) (see fig. 5.4). One possible source of instruction was the neighboring Moravian missionaries, who taught bead embroidery techniques in the boarding school for Cherokee children that opened in Spring Place, Georgia, in 1801 (Cotterill 1954, 226). The influence of African decorative design elements on Creek and Seminole beadwork must also be considered because of the close geographic and cultural association of the Indians with blacks during the period when embroidered bead shoulder bags were first made. Given that people of African heritage are known for their beadwork, they could well have had technical or design influence on Creek and Seminole embroidered beadwork. Historians of African art have considered some of these possible influences. Robert Farris Thompson has, for instance, analyzed examples of Yoruba embroidered beadwork in the Americas, specifically in nearby Cuba, that date from the nineteenth century (Thompson 1984, 93–95).

In addition, the art historian Marcilene Wittmer observed that beaded shoulder bags from the Southeast show "some of the most intriguingly

irregular patterns of any comparable body of American Indian art." This tendency—toward the lack of symmetry, repetition, and regularity in design—is probably best exemplified on one half of the strap of a shoulder bag now in the collection of the Denver Art Museum (see Conn 1979, plate 18). By taking into consideration the rhythm patterns and motor habits of both Africans and Native Americans, Wittmer concluded that the rhythmic placement of some of the more irregular or "jazzy" Creek or Seminole beadwork designs on shoulder bags was very possibly African-inspired (Wittmer 1989a). Native American music, Wittmer noted, is characterized by rhythmic repetition, and their design arrangements like-wise tend to be uniform and symmetrical, with fairly simple color alterna-tions (Wittmer 1989b). In contrast, black music and design both manifest a preference for irregularity of form, striking and unusual juxtapositions, and a lack of symmetry. This carries over into color selection: Afro-American quiltmakers, for example, refer to colors that "hit," or contrast sharply (Wahlman and Scully 1983, 79–93). Although it is generally thought that slaves eventually lost touch with all of their indigenous African material culture, they were put to work not only in the fields but also in craftwork, where their culturally inherited sense of rhythmic patterns might have found expression and thus been retained in one form or another, such as in beadwork. Research is continuing into the fascinating possibility of African influence on Seminole beadwork.

Southeastern embroidered beadwork styles were divided by anthropol-ogist John Goggin into Western and Eastern group styles, differences in the configuration of shoulder bags and the style of bead decoration being the chief factors that distinguish the work of one group from the other (Goggin 1967). Goggin defined the Alabama, Choctaw, Chickasaw, and Koasati as tribes belonging to the Western group. The most distinctive examples of Western-style shoulder bags and sashes were made by the Choctaw. The style is characterized by the use of white pony beads to outline motifs derived from Mississippian period ceramic decoration, con-sisting of scrolls and circles edged with ticking. The lobe or strap endings are usually curved.

The Eastern groups identified by Goggin are the Cherokee, Yuchi, Creek,

and Seminole. Their designs are more varied and are dominated by nature themes or religious motifs. Comparisons of Cherokee and Creek or Seminole examples further revealed noticeable differences in technical skill between these groups. The beadwork is more finely embroidered on the shoulder bags identified as Cherokee than on the Creek and Seminole samples. Cherokee beadworkers used more beads in numerous tightly embroidered rows to create their carefully executed designs. Their formal training in sewing techniques at the Moravian missionary boarding school doubtless accounts for the refined skills of some Cherokee women. Although many examples of Creek or Seminole bead embroidery are also expertly crafted, there also are examples of careless craftsmanship. In the instance of Seminole shoulder bags, this probably reflects the hardship of the situation of the Seminoles at the time the work was done and a dwindling supply of beads. It is basically impossible, however, to distinguish between undocumented Creek and Seminole shoulder bags on the sole basis of design elements and color selection. Many similar design motifs are used on examples that could be either Seminole or Creek, although the more varied designs are often thought to be Creek.

Creek and Seminole shoulder bags made of commercial cloth with embroidered bead designs also share the same basic configuration as the woven and twined examples. The wool pouch is square in shape and has a triangular opening. It is attached to a strap that is finished in one, two, or more strap endings or lobes. The decorative pattern on the front of the strap typically splits in the middle, with two or more different designs on either half of the strap. Less often the strap is decorated with repeated forms of one motif. Meandering serpent or diamondback rattlesnake motifs usually are used on or near the lobes of the straps. The bottom of the pouch, flap, and lobes have tassels held in place by beads.

Slight structural differences in the configuration of the shoulder bag can also be a determining factor in distinguishing the work of one group or individual from others. One noticeable difference is the variation in the number, shape, and width of the lobes (fig. 6.1). Some examples have two or more long thin lobes, while others have only two wide lobes, in addition to which one documented Seminole example has but a single

lobe. The material used for tassels and the manner in which they are made and attached constitute other notable differences. Although the tassels are usually made of yarn, some are made of strips of felt or other materials. Four faceted, large blue beads are most often used to hold the tassels in place, but at times seed beads have been substituted.

A complete survey of all of the known examples of bead-embroidered shoulder bags is beyond the scope of this book. Nonetheless, a representative sampling of examples from various museum collections, together with images found in portraits, can provide considerable information. In what follows, I will discuss five documented Seminole shoulder bags now in collections and four examples from portraits of Seminole men, as well as a few undocumented examples that have unusual designs or motifs. Among the important factors to be considered are the significance of the designs, the repetition of motifs, and the colors chosen for both beads and fabrics.

It took considerable time and effort to create a shoulder bag, so designs were carefully selected. The designs also held a special meaning for the maker or owner of the bag, and so they cannot be considered merely decorative. Nor do the designs on Creek and Seminole bags appear to have been dictated by outside sources. They bear little resemblance to the symmetrical floral beadwork motifs introduced by nuns and others that Indian women copied in some regions. Rather, Creek and Seminole styles represent a fresh, independent design interpretation of the beadwork technique.

Some motifs used for embroidered beadwork reflect continuing traditions dating from the Mississippi Culture period. Designs from that period incised on pottery, stone, shell, or other surfaces include ascending arrows, coils, meandering serpentine motifs, and interlocking diamonds. Other recurring designs found on Mississippian artifacts are scrolled lines or lines with recurved ends, crosses representing the four directions of the logs of the sacred fire, birds, spiders, stars, and "whirlwinds" or swastikas. The repeated use of these symbols suggests their significance to the people.

A further indication of the importance of these designs is seen in their continued use for body decoration, as shown in a drawing entitled "An

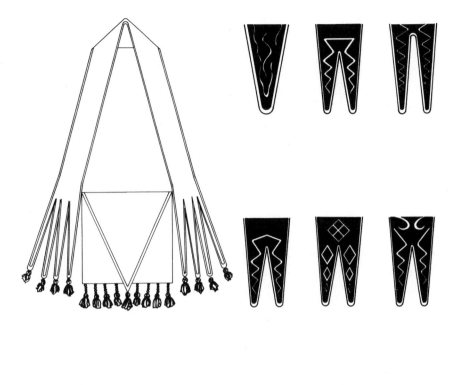

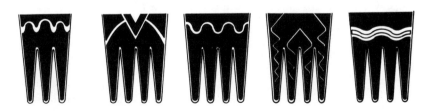

Fig. 6.1. Basic configuration of Seminole or Creek shoulder bag: a square pouch with triangular flap opening and four strap lobes. The shoulder bags examined in this study end in one to five lobes. Two lobes can be short and fat or long and thin; three or more lobes are usually thin. All have some form of serpentine meanders either on the lobe or above it.

Indian Inhabiting the Country North of Louisiana, in 1741," now in the collection of the Howard-Tilton Memorial Library of Tulane University. The serpentine and sawtooth lines on the man's legs and body, as well as the smaller scrolled designs and star or sun on his chest, are clearly a continuation of Mississippian design elements. In his *Travels* of 1791 William Bartram described similar patterns tattooed on the bodies of Creek men: scrolls, flowers, figures of animals, stars, crescents, and the sun at the center of the breast (Bartram 1955, 394). Many of these motifs were of such significance that they were retained as bead embroidery designs. Once the Indian men began to cover up their bodies with European-style dress, the designs were transferred to straps, pouches, and other beaded items.

In my search for an understanding of these designs, one idea I considered is that designs on shoulder bags might symbolize the clan affiliation of the owner. This interpretation was suggested by Bartram's description of a ceremony he and his party attended in the council house at the large Creek town of Attasse in the 1770s (1955, 359). While a black drink is passed among the assembled men of the tribe, a fur pouch, the "skin of a wild cat or young tiger stuffed with tobacco is brought, and laid at the king's feet, with the great or royal pipe beautifully adorned; the skin is usually of the animals of the king's family or tribe, as the wild-cat, otter, bear, rattle-snake." A skin full of tobacco was likewise brought and placed at the feet of the peace chief of the town. It was then passed from him around the group, so that each member could fill his pipe, although each person also had "his own peculiar skin of tobacco." Bartram's negotiations with the Seminole Chief Cowkeeper at Cuscowilla began in a similar manner. In addition to suggesting the important role of tobacco pouches in Indian ceremonies, his accounts also reveal that the fur or feathers of the specific animal representing the owner's clan was used to construct the pouch.

This hypothesis finds additional confirmation in the comments of an officer during the Second Seminole War, Lieutenant Dan Dowling. The lieutenant noted that "the pouches are armorial bearings, and when they come into Council, each clan or family throws its down separately, and

when the ceremony of smoking commences, each clan or family uses its own tobacco." Extreme care was taken in selecting a suitable hide, fur, and tail from the clan animal to make the pouch, and only birds with their feathers intact could be used. Boys carried such pouches as soon as they were old enough to hunt, and warriors were never seen without them. Each pouch contained flint, steel, punk, tobacco, a knife, and other items, and, as Dowling informs us, the hunters' wives or sweethearts "exerted all of their ingenuity in decorating it with beads and other fancy work" (Dowling 1836, 96).

Evidently, then, there were hide tobacco pouches that were linked with clan affiliation. It thus seemed plausible that designs on beaded shoulder bags might continue that association. In search of answers, in 1975 I visited Josie Billie, a Miccosukee-speaking former medicine man. He was living on the Big Cypress Seminole Reservation and had been suggested as a knowledgeable source on the subject of shoulder bags. When he was shown photos of shoulder bags and asked about the designs, however, he said that the designs definitely do not designate clan. According to him, the designs were "ritually significant" but related to religion or medicine, not to clan. Billie also commented that while he could remember seeing such bags long ago, they had not been used for many years. Billie has since passed away at the reported age of 113.

The information that the designs had something to do with medicine next led me to the study of Dr. William C. Sturtevant's extensive research on herbal medicine, carried out with Josie Billie's collaboration in the 1950s (Sturtevant 1970). Among other things, Sturtevant's research explored the Seminole belief that illnesses are often caused by animals (though they also have other sources) and that certain plants used in the appropriate medicine rituals can cure those illnesses. Sturtevant also discussed the role of color symbolism in the healing process.

Sturtevant's findings propose many possible answers to some of the mysteries of shoulder bags. For example, numerous designs on the bags are vegetal, which suggests the relevance of comparison of those designs with some plants known to be used for medicine. The significance of the colors of material selected to make the bags also must be considered.

Fig. 6.2. Embroidered bead shoulder bag motifs. Top, left to right: meandering serpentine design, four types of scrolls, diamond with convoluted ends. Bottom: Raccoon paw print, vine, star or sun, swastika, cross.

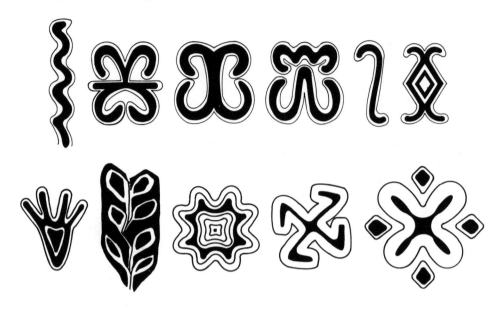

The study of a number of examples has revealed that several categories of designs can be readily identified (fig. 6.2):

1. Various representations of snakes, such as meandering serpents or diamondback rattlesnake designs.

2. Vegetal designs such as trees or leaves, flowers, and vines that refer to the herbs used for medicine. These designs can either be abstract or shaped to resemble identifiable herbs or trees that were used in medicine.

3. Illustrations of animals, some of which are represented by body or facial characteristics (such as an alligator), others only by their tracks (such as a raccoon, a deer, or a cow).

4. Symbolic designs with spiritual or religious significance, including swastikas and crosses that represent the four directions. Crosses also represent the four directions of the logs of the sacred fire. As Mary Frances Johns explained to me in 1990, scrolls or circles are said to be symbolic of Breathmaker, breath, or puffs of smoke. This category includes diamond or other designs with recurved ends or convoluted finials.

5. Figurative designs that are representative of specific life-forms such as birds, fish, or humans. Human effigies can provide us with information relating to the personal history of the owner.

Designs identified by Seminole or Miccosukee sources as meandering serpent or diamondback rattlesnake motifs are the most frequently used on strap lobes. Different categories of serpents exist, including land and water snakes, harmless garden varieties, dangerous poisonous constrictors, and horned snakes. Snakes are considered messengers to Breathmaker and deliverers of knowledge. As Howard Osceola explained to me, "We don't worship that snake. We talk to God through that snake" (H. Osceola 1975). Writing in his *Travels* (1791), Bartram remarked of the Seminoles that "these people will never kill the rattlesnake or any other serpent, saying if they do so, the spirit of the killed snake will excite or influence his living kindred or relatives to revenge the injury or violence done to him when alive" (Bartram 1955, 220). Bartram also reported an incident in which the Indians blew puffs of tobacco smoke toward a snake to placate it.

The Indians of today continue to both dread and venerate snakes. Howard Osceola confirmed that the beliefs mentioned by Bartram are still active: "If they do have to kill a snake, it is disposed of in a special way, to not anger the snake's relatives." The repeated use of serpent designs on shoulder bags refers to the crucial role of snakes in Indian religious tradition. In addition, these designs seem to have served as protective devices, especially when used near the feet or on the legs as body decoration, or on beaded leggings or moccasins. After all, snakes abound in the Southeast—and there was good reason to avoid those with deadly venom.

Like serpentine motifs, plant and animal designs were used as decoration for specific reasons. For example, the owner of a shoulder bag might have had some kind of personal experience or association with the plant or animal that inspired him to select a certain design. The choice could also be based on medicine: as we have seen, designs resembling the plants used for herbal cures have been identified on Creek or Seminole shoulder

bags. It has also been confirmed that Indian beadworkers from other tribes incorporated designs representing medicinal herbs on their shoulder bags. Recently, when Maude Kegg—an Ojibwa beadworker who lives on Mille Lacs Indian Reservation in Minnesota—was being interviewed by the anthropologist Kent Smith for a television documentary about her work, she began by explaining the medicinal use of a floral design she was beading onto a shoulder bag.

Creek or Seminole herbal motifs that correspond with plants used for medicine include a design representing running vines with grape leaves. Muscadine grape leaves are used to treat snakebite (B. Cypress 1991). Sprouts and flowering plants are also frequent themes. One pouch is decorated with conifer needles similar to the needles of cedar or juniper trees, which are again important for medicinal purposes (Conn 1979, 40, plate 18). Perhaps in the future ethnobotanists will systematically compare botanical examples with vegetal designs.

Some animals are represented on shoulder bags by their tracks rather than their body shapes, which reflects the Indian hunter's knowledge of tracking. Easily identifiable raccoon tracks decorate one strap made of black stroud cloth—black being associated with the night. The raccoon, a nocturnal creature, is said to be the cause of "raccoon sickness" (Howard and Lena 1984, 49). The symptoms are sleeplessness and dark circles under the eyes. Not surprisingly, then, the strap of this shoulder bag is decorated with circled eye shapes as well as closely spaced paw prints. On part of the strap, though, fewer beads have been used, as if the supply of beads was dwindling, and the paw designs are also spread farther apart, to cover more space. Triangles or arrow designs are used on the body of the pouch and the flap is covered with clustered diamond-on-diamond designs. These two motifs are frequently used together on pouches (fig. 6.3).

The designs representing fish, birds, and human beings are used on a few shoulder bags. Bead bird and fish designs were described by Andrew Canova in his account of the "Winston Stevens" expedition into Big Cypress (Canova 1906, 58–59). (There is some confusion about the spelling of the latter's name: records show that a Captain Winston J. T. Ste-

Fig. 6.3. Pouch and flap motifs. Pictured are three recurring motifs that decorate the flaps and pouches of shoulder bags illustrated in this book.

Top row: Arrows pointing up on the flap and arrows pointing in different directions on the pouch. Left: The earliest known instance of this motif, shown on the shoulder bag of Chief Francis (plate 23). Right: Design on the shoulder bag of Chief Cloud (plate 25).

Middle row: Alligator or serpent motif on the flap and pouch. Left: Alligator face with open and closed eyes, shown on the bag collected from Chief Alligator (plate 26). Center and right: Clustered-diamonds serpent motif. The designs on the straps accompanying these two types are not necessarily similar to those on the pouch and flap (see plate 27).

Bottom row: Scrolls or diamonds with convoluted ends on the pouch and flap (see figs. 6.2 and 6.4). The motif used is usually repeated on the strap.

phens led the 1857 expedition into Big Cypress. However, shoulder bags were among items in the collections of both a "Stevens" family and a "Stephens" family.) Canova describes a surprise raid on a camp during the final stages of the Third Seminole War. "Hanging in one of the wigwams were two chiefs' costumes, richly embroidered with beads. Some breastplates, hammered out of silver dollars, were also found. We made a dash for these, and I was fortunate enough to secure one of these costumes. This consisted of a sort of waistcoat, a pair of leggings and moccasins, and a sash. Each article was covered with elaborate designs worked in beads and silk, representing birds, fishes, and must have caused much time and patience."

The present whereabouts of these costumes is unknown, but Canova's comments confirm the fact that Seminoles used these designs. In addition, the Denver Art Museum has one shoulder bag decorated with a fish and another adorned with a bird and two women wearing dresses. As noted above, shoulder bags decorated with human figures can often give us quite personal information about the pouch's owner.

Worthy of special mention is an unusual undocumented shoulder bag decorated with the figure of a black man that has always mystified scholars (plate 24). The bag has all of the physical and many of the design characteristics distinctive to the Creek or Seminole style. The red strap finishes in two long lobes that are decorated with meandering serpentine designs. Designs on the strap are split in the middle, with spiral interlocking Ss on one half and a row of agricultural or sprouting seed designs on the other. Clustered arrows decorate the body of the pouch. The astounding feature is the representation of a black man in trousers on the flap. Indian men did not wear trousers in the nineteenth century, but most black men did. Moreover, the figure does not wear headgear, whereas all Indian men did. There is a red diamond shape in the center (or heart) of his black chest and a thin "bloodline" of red projects down the trouser leg. The shapes are solidly filled in with beads, another feature more typical of African beadwork (Wittmer 1989a, 275). A trileaf design sprouts from each shoulder.

The interpretation of this design is more or less left up to the viewer's

imagination. One scholar suggested to me that since other Indian groups display spirit helpers seen on vision quests on their shoulder bags, this might be true for the Seminoles as well. I asked Mary Frances Johns, a Seminole, about this hypothesis. She replied that, although Seminoles do have such spirit helpers, this is something that would only be privately discussed with a medicine man and not openly represented. In Johns's opinion, the figure simply represents one of the black warriors.

This particular shoulder bag—which does not fit comfortably into any particular stylistic niche—obviously makes some sort of strong personal statement about the owner, but it leaves unanswered questions about the woman who created it. This in turn raises the issue of whether the owner, the maker, or both decided which designs would be used on the bag. This anomalous example also encourages further study of both the social relationships and the cultural implications of the close contact between Seminoles and people of African origin during a time of mutual conflict with an outside aggressor. In other words, it raises one of many yet unanswered questions concerning degrees of assimilation and the possible influence of African art traditions on Creek and Seminole arts.

Another important factor concerns the symbolic significance of the colors of fabric and beads that were selected for a shoulder bag. Josie Billie provided Dr. Sturtevant with a number of examples of the association between specific colors and certain medicinal remedies. This association is still acknowledged, as the Miccosukee medicine man Pete Osceola continues to receive for his services bolts of cotton cloth in the appropriate colors (P. Osceola 1990). Given the critical symbolic significance of colors in Indian medicine, artists presumably considered this factor when selecting the colors of fabric and beads for a shoulder bag. In all likelihood, whenever possible such crucial decisions were not randomly determined by personal taste or the limitations of colors readily available from trade sources.

Indian people who are knowledgeable about the contemporary interpretations of the relationship between colors and medicine have been shown examples of shoulder bags. From conversations in 1990 with Seminole Mary Frances Johns, who lives on the Brighton Reservation,

and the Creek anthropologist Charles Randall Daniels, of Tallahassee, I learned useful information about color symbolism in Muskogee tradition and how this symbolism might function in the context of shoulder bags. As both Johns and Daniels pointed out, certain motifs and colors are consistently used together. Red, yellow, black, white, blue, and sometimes green are the colors associated with both Southeastern Indian medicine and religious rituals. These also happen to be the colors of wool cloth and beads most often chosen for shoulder bags.

Red, blue, or black wool cloth is usually selected as the foundation material for the pouch and strap, with red appearing most frequently in the documented examples of Seminole pouches and straps. Red is also the color most often used in certain recurring motifs relating to serpents or alligators as well as in various designs with recurved ends, whereas dark blue or navy blue and black tended to be characteristic of vegetal or animal motifs. Sometimes the pouch is of one color and the strap of another; in such instances, the two components probably were not made together. Moreover, although in practice the pouch and strap were probably lined with whatever kind of cotton cloth happened to be available—whether calico, gingham, or plain—it seems reasonable to assume that, when possible, all the cloth colors would have been carefully selected. As for the beads, turquoise or dark blue, white, rose, dark green, and yellow or gold seed beads, both opaque and transparent, appear most frequently. White, said to have spiritual connotations, is the dominant color selected for serpent motifs. It also is used most often to create sharply contrasting outlines.

Aside from the few clearly documented Seminole examples, it is impossible to distinguish between Creek and Seminole shoulder bags. It would be useful to have more facts concerning the identification and linguistic affiliation of a bag's owner, and when or where it was made or collected, but unfortunately this information is seldom available. Some shoulder bags were collected from opponents about whom we know nothing, on obscure battlefields in Florida during the Seminole Wars—and in any case, most of these bags have since been lost. The examples now in

museum and private collections had often been stored in family chests as antique trophies, and any information about their provenance long since forgotten.

Nor have we been able to determine the exact time when various Creek groups crossed into Florida to join the Seminoles, which complicates the question of distinguishing between Creek and Seminole shoulder bags. In other words, these two tribes are in fact an amalgam of many diverse groups, each of which probably had its own variations in artistic styles. The issue is further confused because some examples were collected from Creek or Seminole men after they had relocated in the West. Even so, several examples in museum collections have been positively identified as Seminole, and a few men whom we know to be Seminoles are portrayed wearing shoulder bags. These snippets of information at least provide some criteria for comparison when we turn to the many undocumented shoulder bags that can be considered either Creek or Seminole.

John Goggin has suggested that Seminole design variations might be classified along linguistic lines by separating the designs of the Hitchiti- or Miccosukee-speaking Seminole people from the Creek- or Muskogee- speaking Seminoles (Goggin 1951, 12, 14). Goggin argued that certain designs are consistently repeated on both the pouches and straps of the Miccosukee-speaking people. These designs include clustered geometric shapes—diamonds, circles, or triangular patterns, for example, that resem- ble arrows pointing in different directions—as well as scrolled designs such as linked Ss and diamonds or straight lines with convoluted ends. This theory is worthy of consideration, but unfortunately it is of necessity based on those rare examples that can be documented as Seminole.

A shoulder bag collected sometime before 1840 from "Chief Cloud during the Seminole War" is one of the earliest of the known documented Seminole examples in museum collections (plate 25). Cloud was most likely the prominent chief Ye-how-lo-gee, who was politically aligned with Micanopy, the hereditary Seminole chief descended from the original Alachua band. A drawing now in the Newberry Library was done by George Catlin of Chief Cloud while the Seminole leader was imprisoned

at Fort Moultrie in 1838. The pouch he wears in this portrait is similar to the museum example: on both, the flap has a V-shaped central panel and border.

Cloud's pouch and strap are made of red stroud. White seed beads fill in the tip of the large arrow that points up on the flap. The rest of the arrow is worked with beaded diamondback rattlesnake patterns. The pouch has clustered triangles or arrows pointing in different directions. Both the arrow pointing up on the flap and the triangles pointing in different directions on the body of the pouch are reminiscent of motifs that occur together on the early twined pouch of Chief Francis. Two variations of a serpent design decorate each half of the front of the strap: one half is ornamented with a row of small diamonds inside rows of larger diamonds, while the other has a long line with repeated Xs in the center. The strap is edged with trim of a different material, and it finishes in two long thin lobes decorated with meandering serpents. Blue beads outline the yellow beaded serpent on one half; white beads outline the blue beaded serpent on the other.

The second example of a shoulder bag that we know to be Seminole is that presented by the Seminole chief Alligator to John Alexander, an officer of the Foreign Missionary Society, in December 1839 (plate 26). This shoulder bag and John Alexander's diary have remained in relative obscurity in the collection of the Museum of Natural History of Los Angeles County since 1930. Alexander wrote in his diary that he met Alligator in the Cherokee country of the Indian Territory, where Alligator had moved because he was dissatisfied with the land originally allotted to him. In his diary, Alexander recounted their meeting, mentioning that "Alligator presented me with his shot pouch and a pair of garters which he told me was made by his daughter" (Alexander 1839, 54–55). Apparently, then, shoulder bags were considered appropriate as gifts to non-Indians.

The pouch of Alexander's bag is ornamented with diamond, serpent, cross, and spiraling circle designs; decorating the flap is the face of an alligator with two sets of eyes, one set open and the other closed. A design of diamonds with convoluted ends is repeated on the strap, which has

only one rounded lobe on each end. Seven red tassels held by four large faceted blue beads are suspended from the bottom of the pouch.

The third documented shoulder bag is a "fine belt and shot pouch worked by one of the Mrs. Billy Bowlegs" that was collected at Charlotte Harbor by Anthony Breath, commander of the steamer *Colonel Clay*. The pouch contained a letter from Breath to his brother dated October 29, 1849, which declares his friendship with Chief Billy Bowlegs and documents the source of the shoulder bag—although it doesn't say whether the bag was made by the older or the younger Mrs. Billy Bowlegs. Both the shoulder bag and the letter are now in the collection of the Smithsonian Institution.

Because this was one of the first well-documented examples of a Seminole shoulder bag, scholars used it to establish basic criteria for the size, configuration, material, and design typical of a bag from a Seminole group. The pouch and strap are made of red wool stroud. Both are decorated with repeated designs of diamonds with convoluted ends, fashioned from white, turquoise, and dark green beads. The strap and flap are edged with blue twill trim that has white beads running down either side. The strap finishes in four long thin lobes that are edged with beads but is otherwise undecorated: meandering serpent designs have been placed above the lobes instead of on them. The lobes, flap, and bottom of the pouch have tassels made of strips of cloth. Each of the tassels on the bottom of the pouch is secured by four large faceted blue beads.

A similar strap is worn by No-Kush-Adjo, identified as Bowlegs's "Inspector-General" and the brother of the old Mrs. Bowlegs in the portrait of him that accompanied an article in *Harper's Weekly* on June 12, 1858 (fig. 6.4). His broad strap is decorated with the same designs of diamonds with convoluted ends used on the strap and pouch collected by Breath, but neither the strap's lobes nor the pouch itself are shown, so further comparison is impossible. All the same, the recurring use of this particular design on the strap suggests that the museum example was also made by the older Mrs. Billy Bowlegs. By contrast, Long Jack, the brother of the younger Mrs. Bowlegs, is depicted in the article wearing a loose strap that is ornamented with a floral or vine design.

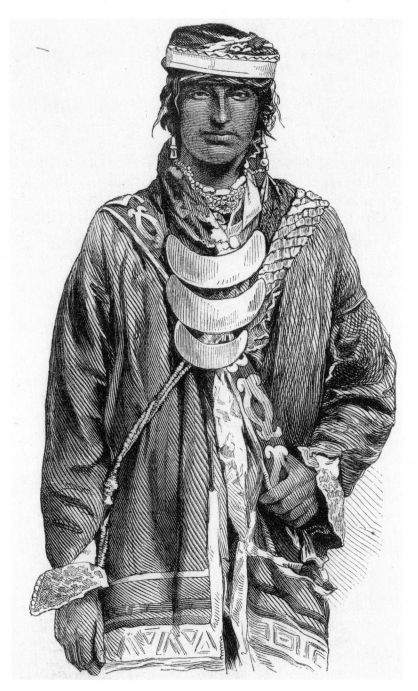

Fig. 6.4. No-Kush-Adjo, brother of old Mrs. Billy Bowlegs, line reproduction from *Harper's Weekly*, June 12, 1858. Note the design of diamonds with convoluted ends on the strap of his shoulder bag.

Data gathered from several examples indicate that certain similar design elements tended to occur together, such as the repeated use of diamonds or other shapes with convoluted ends, and the designs on the red cloth strap and pouch of the Bowlegs bag conform to this trend. These designs are primarily done in white and turquoise beads against a background of red wool cloth. When the designs are used on the flap, they also are found on the body of the pouch, although usually these designs are used exclusively on the strap.

A finely made Seminole or Creek shoulder bag lacking provenance that shares these design characteristics is in the collection of the Lowe Art Museum (see lot 48 in Sotheby's auction catalog, *Important American Indian Art*, November 29, 1988). In both the Lowe and the Bowlegs bags, the beadwork has been carefully executed, and each has a repeated use of analogous designs on strap and pouch executed in a similar configuration of colors. As in the Bowlegs bag, the pouch and strap of the undocumented Lowe model are made of red stroud and the strap also finished in four thin lobes. Both pouch and strap are decorated with designs with convoluted ends worked in two rows of white beads outlining turquoise beads. The cross of the sacred fire has also been included. A shoulder bag in the Detroit Institute of Art is so similar to this example that it might well have been made by the same woman (Penney 1992, 99).

As further evidence of the importance of this motif, similar choices of colors and designs are shared by another undocumented example, which for many years was in the private collection of the Henry Stevens family, in Barnet, Vermont. The pouch and strap are again made of red wool. Variations of diamonds with recurved ends decorate the pouch, flap, and one half of the strap, although another design is used on the other half of the strap. In this case, the strap ends in two lobes instead of four.

Billy Bowlegs himself did not, however, wear a shoulder bag decorated with these designs. He has always been portrayed wearing a showy strap with a broad diamond design that Howard Osceola said is known as "alligator." (Bowlegs assumed his leadership title, Halapatter-Micco or "Alligator King," through matrilineal descent from his uncle, Micanopy, and the Alachua dynasty of "King Payne," leader of the Alligator clan.)

The four long lobes of the strap, similar to those used on the Bowlegs pouch collected by Breath, can be seen clearly in the daguerreotype of Bowlegs made in New York in 1852 (see fig. 2.9). The lobes are decorated on either side with rows of white beads, and although the serpent motif is not present on the lobes it may have been used above. It is impossible to make out the precise designs on the pouch, but clearly they are curvilinear.

The 1852 delegation to New York mentioned in chapter 2, which included Billy Bowlegs and four Seminoles and the black interpreter Abraham from Indian Territory, was the subject of a story and portrait in the *Illustrated London News* (see fig. 2.8). The portrait includes John Jumper, who had emigrated to the West with Micanopy and his band in 1838. Jumper headed this entourage, which had been recruited to encourage Bowlegs to relocate to the West (Porter 1967, 229). Bowlegs wears his two familiar straps, the one fingerwoven and the other embroidered with interlocking diamond designs. Jumper, seated next to him, also wears two impressive broad straps, one with fingerwoven geometric designs and the other decorated with more varied and erratic designs.

The fourth documented example of a Seminole shoulder bag in a museum collection was taken by Captain Winston J. T. Stephens, company commander of the Florida Mounted Volunteers, during a skirmish with Seminoles at the edge of Big Cypress in 1857 (Florida State Museum 1976, 1). It is part of a complete costume that includes a hide coat, a fingerwoven garter, a blue faceted bead necklace, and an Iroquois Glengarry-style bonnet. The black stroud strap of the bag is decorated with one continuous leaf design, with a long stem that begins in a cluster of diamonds. The stem bears thin leaves shaped like the bay leaf, which is an important Seminole medicine herb (see the "vine" motif in fig. 6.2). The quality of the beadwork is progressively uneven, and it appears that the maker of the bag was running out of beads as the bag neared completion, which suggests that it was made during a time of insecurity, if not crisis. It also is possible that more than one person worked the design. The strap has two wide lobes decorated with diamondback rattlesnake designs, and a powder horn is attached to it.

The red stroud pouch and flap are both decorated with clustered dia-

mondback rattlesnake designs. Four large faceted blue beads hold the tassels on the bottom. The pouch contained numerous packets of herbal medicine material and other sacred items, which were used as personal bundles of war medicine. Josie Billie explained that, prior to the wars, there was only one medicine bundle per tribe. During the wars, however, "Little Chiefs came to the Medicine Man. 'Going on long trip,' they would say. 'Got to have some of that Medicine.' So the Medicine Man would make up a Bundle with a little bit of each kind of Medicine in it, and the Little Chief would take it with him and his war party. In that way, a lot of the little Medicine Bundles were lost" (in Capron 1953, 167–68).

The fifth shoulder bag that can be positively identified as Seminole was collected in Florida in 1894 by Dr. Charles Barney Cory, Sr., although we do not know from whom (plate 27). It is now in the Field Museum of Natural History in Chicago. According to the museum's documentation, it was thought that Dr. Cory was principally in contact with Cow Creeks. He was also familiar with the Miccosukee-speaking people who frequented Stranahan's on the New River, however, for he noted in his *Hunting and Fishing in Florida* that "several of the Indians have permanent camps on New River. Tom Tiger, Robert Osceola, Jumper, Old Tom, Old Charlie, and Tom-a-luske all have camps there" (Cory 1896, 96–97).

The designs with convoluted ends used on the red pouch and the showy black stroud strap of the Cory example are exaggerated renditions of common motifs found on prehistoric Southeastern Indian pottery. Similar motifs decorate one of the undocumented shoulder bags in the Denver Art Museum. The designs on the Cory bag are overstated or distorted, as are many major elements of the traditional costume worn by Seminole men photographed at the end of the century. The strap finishes in four short undecorated lobes topped by a meandering serpent design. The pouch is decorated with the familiar diamond on diamond design, and white seed beads secure the tassels on the bottom of the pouch.

The last public appearance of a shoulder bag was at the beginning of this century, when Muskogee-speaking Chief Tallahassee was photographed in 1901 (fig. 6.5). His showy strap, which ends in two wide lobes, is decorated with a sacred fire and other designs. The pouch hanging

176 at his side has a star or floral pattern on it, as well as other designs that cannot be made out. Of all of the photographs taken of Seminole men at the turn of the century, this is the sole instance in which the subject wore a shoulder bag.

Until recently, then, the general public and most Seminoles and Miccosukees were unfamiliar with shoulder bags. When I asked the Miccosukee Minnie Bert about shoulder bags in 1975, she replied that she'd never heard of them. Moreover, in 1989 she added, "I was curious and have talked to some old people about those beaded pouches you asked about several years ago. They said they have never seen any like that and don't know anything about them." Now that the Indian people are becoming reacquainted with their traditional dress through examples in museum collections, exhibitions, and books, however, there has been a revival of interest in special nineteenth-century items for wear on ceremonial occasions. A few modern interpretations of old-style shoulder bags have been attempted, although their handiwork is not as skillful as that seen in earlier examples. It is not known whether these contemporary bags have actually been worn at ceremonial or other events.

A black wool shoulder bag was made around 1970 for a Miccosukee-speaking medicine man. The edges of the pouch and strap are bound in green cloth, and the bag is decorated with turquoise, green, and white beads to form a design of diamonds with convoluted ends, like the designs on the bag made by Mrs. Billy Bowlegs. The medicine man might have seen photographs of the Bowlegs bag or the bag itself, which is on permanent display at the Smithsonian Institution. Another shoulder bag—now in the Crane Collection of the Denver Museum of Natural History—was collected from Ada Jumper, a Seminole, in the 1960s. The pouch is decorated with clustered diamond designs, along with a small cross on the flap. The strap, which has three lobes ending in tassels, is decorated with a continuous band of small diamonds inside rows of larger diamonds, like half of the strap of the Chief Cloud shoulder bag. The beadwork is clumsily and loosely done.

Embroidered bead shoulder bags of the nineteenth-century Creek and Seminole Indian men served them well. On a purely practical level, they

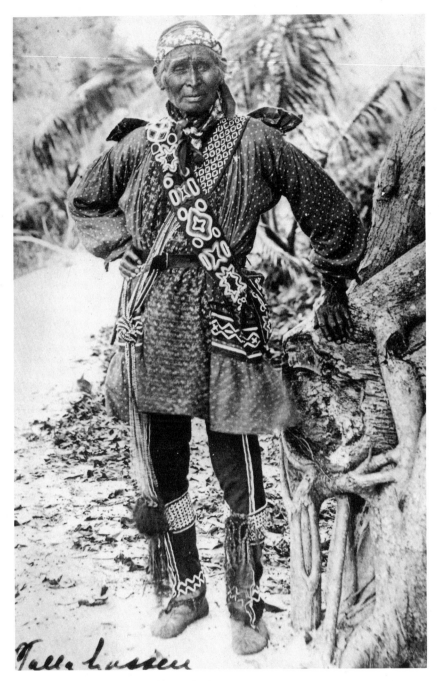

Fig. 6.5. Chief Tallahassee, Seminole, April 1901. Note in particular the embroidered bead designs on his shoulder bag and his fingerwoven strap and garters. Photograph courtesy of the Florida State Archives.

178 served as containers for the most important personal, religious, or medicinal belongings of men forced into a fugitive existence. But they also reflected pride in dress and functioned as emblems of identity for the owner. Their carefully embroidered bead designs are a link to the once rich artistic and cultural heritage of their owners. The fact that women had the inspiration and the ability to produce these works of art during an era of such chaos is a monument to both their courage and their creativity.

C
H
A
P **7**
T
E
R

Seminole silversmiths were at their most productive during the nineteenth century and into the early twentieth. Their knowledge of silverworking techniques could derive from one or more of three possible sources: certain silverworking skills might have been retained from prehistoric times, in addition to which the Indian artisans could have been influenced by Calusa work with Spanish coins during the early Historic period, or by military contact and trade with the British.

Copper ceremonial objects from the Mississippi Culture period survive as evidence that the Southeastern Indian people were skilled at metalworking techniques long before the arrival of Europeans. Indeed, Mississippian burial mounds have revealed that the Indians had already developed quite refined metalworking designs and techniques—as ritual paraphernalia, gorgets, plates, and elaborate hair, ear, and other ornaments of sheet copper, all decorated by embossing, piercing, or incising, amply testify. (Piercing and incising techniques were also employed to create striking symbolic designs on shell or bone.) But native copper had to be brought from the distant Great Lakes region and thus would have been considered an exotic trade good. Silver was rarely used by the natives until the Spanish began introducing small amounts of it in the sixteenth century (Goggin 1940, 25). The indigenous Calusa people on Florida's west coast made beads, pendants, and breast ornaments from Spanish coin silver, although we do not know whether they applied previously existing skills or were taught new techniques by the Spanish (Johnson 1976, 93). Salvaged silver from Spanish wrecks off the coast was probably their source of supply.

Eighteenth-Century Silverwork

Willam Bartram commented in his eighteenth-century *Travels* that among the residents of the Seminole town of Cuscowilla lingering influences from the Spanish mission period were visible. "There are several Christians among them," he wrote, "many of whom wear little silver crucifixes, affixed to a wampum collar around their necks, or suspended by a small chain upon their breast"—although it must be remembered that the cross is a design compatible with Native American iconography as well. Other silver ornamentation also was in evidence; some of the men were seen wearing silver earrings, and, according to Bartram, Indian women "never cut their hair, but plait it in wreaths, which are turned up, and fastened on the crown, with a silver broach" (Bartram 1955, 164, 395).

The British gave away large quantities of silver, and their silversmiths shared trade secrets with Indians throughout the Woodlands and Great Lakes. Traders would either give or trade silver ornaments to the Indians as the situation demanded. James Adair, who traded with many Southeastern tribes in the 1740s, mentioned the "silver arm plates, wrist plates, gorgets, earbobs, etc." that he had distributed at an Indian gathering to repay a favor (Adair 1930, 355). Adair also noticed that the people loved to gamble at their ball games and would wage bets with their "silver ornaments, their nose, finger and earrings; their breast, arm and wrist plates" (431).

In addition, the British distributed silver items as introductory friendship gifts to Indian tribal leaders and at the signing of agreements in the eighteenth century. A list preserved in the Colonial Office Papers reveals that gifts given to the Southeastern Indians at the Congress at Picolata in 1765 included seventy-five pairs of earrings, twelve silver brass buckles, four silver gorgets, two arm plates, and four silver medals (Covington 1960, 72). Boxes of silver gorgets, arm bands, and wrist plates were among the items shipped to Pensacola and Saint Augustine in 1776 and 1777 (Shaw 1931, 168). Impressive crescent silver gorgets similar to those worn by British officers were given to honor Indian leaders and thereby win their favor.

The Creeks who were part of the delegation led by Chief Alexander McGillivray to confer with George Washington in New York in 1790 were depicted by artist John Trumbull wearing silver earrings and one or more silver gorgets (see fig. 1.4). Stimafutchki, or "Good Humor," of the Koasati Creek group wore three gorgets and silver arm bands (Fundaburk 1969, figs. 132–36). One gorget is marked with a crown, clearly indicating that it was a British gift.

European silversmiths worked among the Creeks, Seminoles, and other Woodlands Indian groups in the late eighteenth century. Iroquois silversmiths are known to have learned their craft from the Scots; British smiths taught silverworking to Creeks as well (Parker 1910). The tradition was usually passed from European father to Indian son, as was the case with the Creek prophet Josiah Francis. His father, the English trader and silversmith David Francis, made buckles and ornaments for the Indians in the Upper Creek town where he lived in the late eighteenth century. The son learned his father's trade, although, as we have seen, he ultimately became better known as a prophet and leader (Sugden 1982, 277).

Nineteenth-Century Silverwork

Indian silversmiths used coins of lower denominations that had a higher silver content. Various Spanish coins, British shillings and sixpence, and American half dimes, dimes, quarters, and half dollars were melted down, and the silver in them used to make copies of popular ornaments, such as thin gorgets modeled on those worn by British officers (fig. 7.1). These gorgets, which were worn dangling from hide thongs, had incised lines and sometimes additional decorations. Other ornaments, such as turban bands and arm or wrist bands made by Indian silversmiths, were decorated with incised or embossed line designs.

In their portraits, nineteenth-century Indian leaders from many tribes are shown wearing silver ornaments along with their other finery. With the exception of presidential medals presented to leaders of delegations who went to Washington, these ornaments were generally the work of Indian smiths. Tukose Emathla displays the full regalia of a chief in the

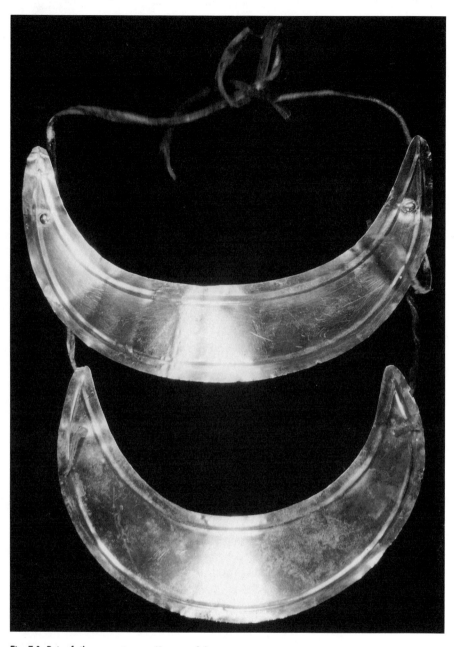

Fig. 7.1. Pair of silver gorgets, Seminole, nineteenth century. Silver and leather. Photograph courtesy of the National Museum of the American Indian, Heye Foundation. Acc. no. 1/8253; neg. no. 11145.

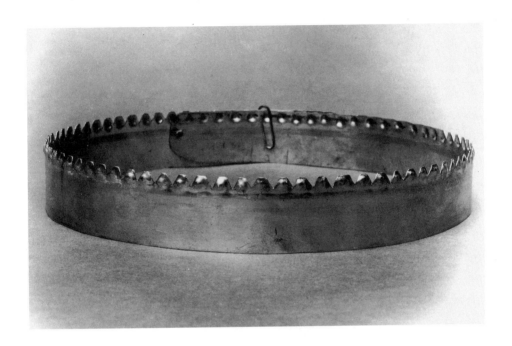

1826 portrait painted of him in Washington by Charles Bird King (see fig. 2.1). In addition to arm and wrist bands he sports a scalloped and embossed turban band made of silver, an item that only the most important leaders seem to have worn (fig. 7.2). A medal bearing a portrait of President John Quincy Adams is suspended just below his silver gorget, a sad reminder that his alliance with the United States government over the issue of resettlement ultimately led to his death at the hands of Osceola.

Osceola himself wears three silver gorgets, earrings, and thin silver bracelets tied to his wrists with ribbons or thongs in the portrait done of him in 1838 by George Catlin (see fig. 2.6). The bracelets are included in an inventory of items that supposedly accompanied him to his grave, while other silver items—such as earrings, gorgets, and a circular orna-

ment—are thought to have been removed by his attending physician, Captain Weedon. The dangling earrings, made for pierced ears, are now in the Weedon Collection of the Alabama Department of Archives and History in Montgomery. The circular ornament, which has a cutout design and small holes for sewing it onto a garment, did not appear in the Catlin portrait, nor in that done at roughly the same time by Robert John Curtis (Bearss 1968, 39). In his drawing of Chief Cloud, however, Catlin did include a circular pin with pierced decoration, which is attached to the chief's robe (Fundaburk 1969, fig. 266).

Over time, gorgets not only became larger but developed into the most distinctive emblem of authority. For example, Billy Bowlegs wore three large gorgets for his portraits in the 1850s (see figs. 2.8 and 2.9). His other silver decorations included a scalloped turban band, presidential medals bearing portraits of Van Buren and Fillmore, finger rings, and perhaps wrist bands.

Silver bodice pieces or brooches were popular among women from early in the first half of the nineteenth century into the early twentieth century. Although there are very few early likenesses of Southeastern Indian women, George Catlin did make several drawings and one painting of Seminole women. In 1837 he portrayed a Yuchi girl in the Indian Territory and commented that her clothing was decorated with silver brooches and that she wore a silver bracelet (Fundaburk 1969, fig. 197). When Catlin painted a Seminole woman with the men imprisoned at Fort Moultrie, he again mentioned the "silver brooches" on her chest (see fig. 2.7). In another of his portraits, a woman wears earrings and circular pendants among her strands of beads (Fundaburk 1969, fig. 241). Likewise, the young Mrs. Billy Bowlegs wears silver earrings in the 1858 drawing of her that appeared in *Harper's Weekly* (see fig. 2.10).

Seminole silverworking traditions continued in the wilderness camps in the late nineteenth century. In his report to the Bureau of Ethnology about the condition of the Seminoles in the 1880s, Clay MacCauley commented that "conspicuous among the other ornaments worn by

women are silver disks, in a curve across the shirt fronts, under and below the beads. As many as ten or more are worn by one woman. These disks are made by men, who may be called 'jewelers to the tribe,' from silver quarters and half dollars. The pieces of money are pounded quite thin, made concave, pierced with holes, and ornamented by a groove lying just inside the circumference" (MacCauley 1887, 488). Larger disks made from half dollars were worn as "breast shields," according to MacCauley, one suspended over each breast.

MacCauley noted, however, that Seminoles generally did not wear earrings. The few silver earrings he did see were made by Indian silversmiths, and he included a drawing of a woman's ear with a silver coin drop earring in his report. For some unknown reason her ear is pierced nine times above the earring, and slivers of palmetto stems have been inserted in the holes. Nor did MacCauley see many finger rings (1887, 489). He described the few he saw as well made by Indian artisans. These included several rings with large elliptical tablets extending from knuckle to knuckle. (In the 1990s I saw an elderly Miccosukee-speaking woman wearing a similar style of ring that was made for her by a relative.) Another style was a "diamond ring," which had a silver diamond shape soldered to the band.

Seminole men were said to wear accessories—fashioned by local craftsmen out of silver coins—for special occasions or for visits to trading posts. These included silver wrist bands held in place with thongs or a cord, turban bands, and belts ornamented with silver. MacCauley also described crescent gorgets made of silver coins that "are generally about five inches long, an inch in width at the widest part and of the thickness of ordinary tin" (1887, 489). As noted earlier, by the end of the century, the gorget style had grown quite exaggerated. Thus Billie Stewart wears four wide gorgets in the photograph taken of him by Dr. Charles Cory in 1890 (see fig. 2.16). Hugh Willoughby in 1898 rightly commented of the Seminoles that "at different times they have had among them men who were quite noted as silversmiths and became celebrated through the tribe" (Willoughby 1898, 45).

Twentieth-Century Silverwork

As dress styles changed in the early twentieth century, men began to wear very little silver ornamentation. Rather, silver ornaments were made primarily for the women. Alanson Skinner commented in 1910 that like all the Woodlands tribes, "the Seminoles are very fond of silver ornaments, most of which they make themselves. This jewelry is not as elaborate nor as handsome as that made by more northerly tribes, nor does it have much variety in form" (1913, 74); see fig. 7.3. He observed and collected "turban or head bands, spangles, crescents, earrings and finger rings."

Skinner described in detail the process used by Seminole silversmiths to form coins into "spangles" or disks:

The process of manufacture and tools employed is simple. To make a spangle, a coin is heated in a small fire; it is then removed with a pair of pincers and hammered out with an ordinary commercial hammer. The poll of an ax driven into a log serves the purpose of an anvil. The process of alternate heating and pounding is repeated again and again until the coin has been flattened out considerably and the design defaced. One smith observed at work greased the coin from time to time as he heated it. After it has been heated and hammered to the satisfaction of the smith, the spangle is pared down with a butcher-knife or a razor-blade until it has been reduced to the desired degree of thinness.

In this state the blank form is sometimes decorated with a design incised with a file or a knife-blade. Any irregularities are filed off and the trinket is polished on a whetstone. Sometimes the designs are cut out with a cold-chisel and finished with a knife. Holes for sewing the bangle to a garment are made by driving a nail through the metal and smoothing the edges with a knife.

This process of silverworking was observed on two occasions and there was but little difference in the tools or the manipulation of the smiths. Antler prongs are used as punches to make raised lines and bosses, and the only other tool which was seen or collected, besides those described, was a crude blow-pipe used in the manufacture of the plain finger-rings which are much worn by the Indians. (74–76)

Fig. 7.3. Robert Osceola, Seminole silversmith, Charlie Tigertail's camp, Big Cypress Swamp, 1910. Photograph by Alanson B. Skinner.

Photograph courtesy of the National Museum of the American Indian, Heye Foundation. Neg. no. 1501.

In 1990, the silversmith Bill Osceola described another method of making convex discs, in which the flattened coin is placed on the open end of a metal pipe. The coin is hammered down the hole of the pipe until it forms the desired rounded bulge. A nail is then driven through the disc to make one or two holes.

Silverworking died out in the 1930s, possibly because of the shortage of coin silver during the Depression. In addition, women's cape styles changed, sheerer material being used to cover the arms. This material was used nearer the shoulder, so there was less sturdy fabric for attaching the silver bodice ornaments.

Types and Dates of Silver Ornaments

Men's Ornaments

1. Crescent Gorgets Crescent gorgets in the style of those worn by British Army officers were initially given to Indians leaders in the eighteenth century by the British in order to win their friendship. Copies of these gorgets were made by Indian silversmiths during the nineteenth century.

2. Turban Bands Turban bands—designed to hold the cloth wrapped around a man's head as a turban—were used throughout the nineteenth century and as late as 1910, as noted by Skinner. Recently, a few men have revived the tradition by wearing gorgets and turban bands, sometimes made of tin, for special occasions or dress competitions.

3. Wrist and Arm Bands Wrist and arm bands were strips of silver, thin or wide, that were tied in place with a hide thong. Tukose Emathla (see fig. 2.1) wears both arm and wrist bands tied over the sleeves of his long shirt in the portrait of him before 1826, whereas Osceola wears only wrist bands with long ties in his 1838 portrait (see fig. 2.6).

1. Earrings Silver earrings are among the items included on eighteenth-century British gift lists. For example, the Creek men portrayed in 1790 by John Trumbull wore silver earrings (see fig. 1.4), although we know from other sources that both men and women wore such earrings in the nineteenth century.

2. Finger Rings Finger rings varied from plain bands to those decorated more or less elaborately with pieces of metal, in shapes such as diamonds or ellipses, soldered to them. In his *History of the American Indians* (1775) James Adair observed that Indians sometimes gambled away their nose and finger rings. Finger rings continued to be made into the twentieth century, albeit on a more limited basis.

Women's Ornaments

1. Bodice Pieces Bodice pieces were worn from the nineteenth century to 1930. They are convex discs ranging in size from roughly one to two inches in diameter, although larger discs, called "breast shields," were used as well. The decoration on these discs almost invariably included embossed raised or incised concentric lines (fig. 7.4). The edges of the disc could be plain, embossed with dots, or scalloped. Two holes were usually made in the disc, which was then sewn onto the bodice, although sometimes only one hole was made in the center and the disc held in place by thread run through a bead. Photographs from the 1920s and 1930s show women wearing varying numbers of bodice pieces on their capes, from only a few discs up to as many as twenty-five. The silver ornaments were worn only on special occasions.

2. Pierced Pendants Pierced pendants, which were first mentioned by Alanson Skinner in 1910, also were abundant until about 1940. Since the Mississippian period, circular pierced pendants have tended to be a much-favored type of metal or shell ornament. In the photograph of her

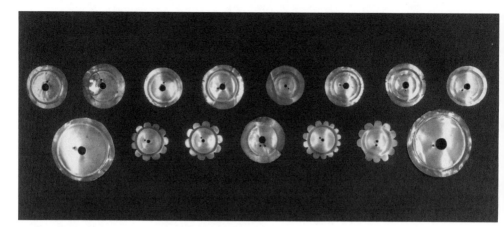

Fig. 7.4 (above). Set of silver
bodice pieces, Seminole,
twentieth century. Photograph
by George Chillag. Courtesy of
the Historical Museum of
Southern Florida.

Fig. 7.5 (below). Assorted
pierced silver pendants and
brooches, Seminole, twentieth
century. Photograph courtesy
of the Crane Collection, Denver
Museum of Natural History.

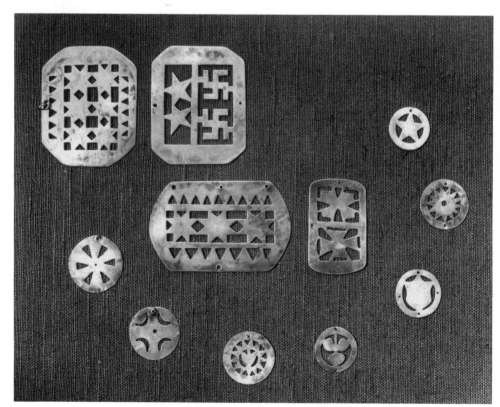

done by Frank Robinson (see fig. 3.3), for example, Alice Osceola wears a pierced pendant dangling in her hair. The pendants, which could be rectangular as well as circular, were cold-chiseled with a variety of geometric and realistic designs. These included cutout whirlwinds or diamond shapes and swastikas, arrows, stars, Maltese crosses, hearts, and nautical images such as anchors and Seminole sailing canoes (fig. 7.5). The pendants were suspended on a beaded thread or on a chain, worn individually as dangling hair ornaments, or pinned to a woman's blouse like a brooch. They also could be attached to a necklace of beads and coins or worn in groups on a chain below the bottommost row of bead necklaces. Some designs were worn in pairs as earrings. Although pendants were primarily a women's item, men also sometimes wore them as ornaments attached to their watch chains or sashes.

3. "Engagement" Headbands Thin silver headbands known as "engagement bands" could be plain or decorated with a row of embossed dots along the top edge (fig. 7.6). The band was attached to a curved hair comb that held the women's upswept hair in place. These bands can be clearly seen in a rear-view photograph of women taken in 1929 (see fig. 3.6).

Prized Possessions

Silver ornaments held a special meaning to their owner: men, women, and children all had favorite silver ornaments that they wore only on special occasions. Such items, then, were not necessarily status symbols indicating wealth or marital status. Despite the abundance of silver ornaments made, however, few have survived for us to see, primarily because when people died their most prized possessions were buried with them. But sometimes, as people got older and began to anticipate their death, they started to give away valued possessions to relatives as heirlooms. In addition, some pieces were sold to collectors or given in payment of debt out of economic necessity, and have thus ended up in museum collections.

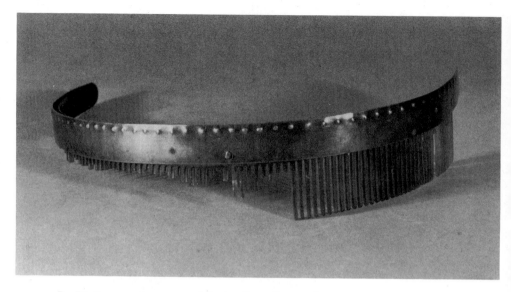

Fig. 7.6. Engagement
headband, Seminole, late
1920s. Coin silver with plastic
comb. Courtesy of the Crane

Collection, Denver Museum of
Natural History. Acc. no.
7977A.

Today, Bill Osceola continues a family tradition of silversmithing. As one of the few men who continue to make special-order silver items, he proudly boasted to me in 1988, "I'm just like Japan! Show me anything and I can make it." Indeed, Bill has made a set of crescent gorgets and a buckle for Seminole Tribe Chairman James Billie, as well as making silver buckles, old-style turban headbands of tin, and other ornaments for men to wear on special occasions or for clothing competitions at the Seminole Tribal Fair. Bill has also started a revival of the bead-with-coin necklace, which he makes for women.

Another craftsman, Jimmy O'Toole Osceola, uses tin to make reproductions of arm and turban bands both for himself and others. He annually creates a new outfit in a traditional style with silver or tin ornamentation, for which he has often won prizes in the senior citizen dress competition at the Seminole fair. Fortunately, having seen the quality (not to mention the prices commanded) of the silver and turquoise work done by members

of other tribes at local tribal fairs and festivals, young Seminole and Miccosukee men are acquiring a renewed interest in their own tradition of silverworking. The Miccosukee Tribe has, for example, started jewelry classes, taught by an Iroquois silversmith, and promising work has already been done by several artisans.

C
H
A
P
T
E
R
8

Archaeological evidence indicates that in prehistoric times and in the Historic period in the Southeast, basketry included the making of both flat mats and shaped baskets that can be used for gathering and in preparing food, for transporting and storing items, and for interring the dead. The primary construction technique was "interlacement, often in complex patterns based on twill structures," in which split cane and bark strips were used (Drooker 1992, 83). There is no prehistoric evidence of the use of coiling techniques east of the Mississippi.

Seminole basket makers initially constructed their baskets of split cane, which was readily available in northern Florida. They continued to rely on whatever material was to be found in their environment, turning to palmetto stems as they moved farther south in the late eighteenth and nineteenth centuries. At some unknown time during that period, they also learned to coil sweet grass and pine needles to make baskets.

Early accounts refer to Seminole mats and baskets. Recalling a visit to a Seminole town in 1774, William Bartram wrote in his *Travels* that he was "seated on mats, curiously woven, of split cane dyed various colors. Here being seated or reclining ourselves, after smoking tobacco, baskets of the choicest fruits were brought and set before us" (Bartram 1955, 251). Bartram's mention of mats that had been dyed in various colors is particularly intriguing, because there are no surviving Seminole samples of basket-weaving material that show any evidence of having been dyed. But the use of dyes in Southeastern basket weaving was confirmed by traveler James Adair in his *History of the American Indians* (1775). Commenting on the use of dyed strips of split cane in the clothing baskets made by the Cherokees, Adair remarked that they "divide large swamp

canes into long thin, narrow splinters, which they dye of several colors, and manage the workmanship so well that both the inside and outside are covered with a beautiful variety of pleasing figures" (Adair 1930, 456).

The tradition of using dyed cane strips as a weaving material has continued among other Southeastern tribes, but not the Seminoles. The Eastern Cherokee are known today for their superb single- or double-weave plaited baskets in which geometric designs have been woven using natural dyed split cane (Coe 1986, 86–87). The Chitimachas and Koasatis of Louisiana also continue to produce colorful baskets. Natural materials are used to dye red and black strips of cane, which are woven into a variety of designs.

Twill-Woven Baskets

In the northern region of Florida, the Seminoles primarily used cane—a firm, easily worked material—for weaving. Museum examples are exceedingly rare, but in the Florida Museum of Natural History there is a small, well-documented cane basket that is probably the earliest surviving example of Seminole basketry (Deagan 1977, 28–29); see fig. 8.1. The basket was acquired at Wacahoota, Florida, through trade with Seminoles in 1826. Since naturally colored fibers were used, the pattern of the weave determined the design elements. In this case, the split cane has been worked in a twilled weave to produce a herringbone pattern. The basket, which was made to hold small articles such as sewing needles, thread, and a thimble, has a square bottom and a round rim, two characteristics more typical of Creek baskets. Later Seminole baskets made of palmetto, whether rectangular, square, or round, do, however, have analogous rims.

Clay MacCauley commented in 1880 that the "Seminoles are not now weavers. Their few wants for clothing and bedding are supplied by fabrics manufactured by white men. They are in a small way, however, basket makers. From the swamp cane, and sometimes the covering of the stalk of the fan palmetto, they manufacture flat baskets and sieves for domestic service" (MacCauley 1887, 517). Although MacCauley mentions swamp

Fig. 8.1. Cane basket, twill weave, Seminole, ca. 1826. Photograph courtesy of the Florida Museum of Natural History, Gainesville. Acc. no. H-307.

cane, southern Florida swamp cane is in fact rather flimsy. The stems of the palmetto provide a sturdier basket-making material, which was certainly favored by the Seminoles in the twentieth century. MacCauley's statement also makes reference to the most important utensils in every cooking chickee, a set of three shallow baskets used to sift corn for the Seminoles' staple food, sofke, a warm and filling corn drink (fig. 8.2). Two baskets with openings of varying widths in the center are used to sift the ground corn, while the third holds the cornmeal. To this basic set of utensils would have been added large pack or storage baskets and berry baskets, designed for the gathering and storage of food. Smaller baskets held personal items.

Rituals, taboos, and stories play an important role in basket making. Basket makers are expected to conform to special guidelines, which several Miccosukees and Seminoles, including Howard Osceola, Donna Frank, and Mary Frances Johns, discussed with me. Miccosukee-speaking Johns

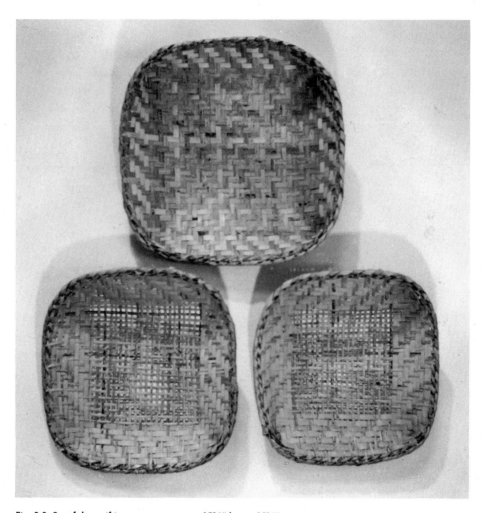

Fig. 8.2. Set of three sifting baskets, Seminole, 1970s. Made on the Big Cypress Reservation (artist unknown). Palmetto fiber. The basket at the top measures 15¾" long x 15¼" wide. The one at the bottom left is 13½" x 13½"; on the right, 13" x 12¾". Private collection.

is married to a Muskogee-speaking Seminole man and has frequent contact with Creek basket makers in Blountstown, Florida. She was thus able to provide me with additional information about Muskogee and Creek basket-making traditions, which she has discussed with the Creek anthropologist Charles Randall Daniels as well.

Basket making is basically women's work, but specific rules designate which women are eligible to make baskets for ritual use. Only grandmothers or older women who have passed menopause can make certain baskets. This rule is intended to protect the power of the medicine, if the basket is used for sacred or medicinal purposes, from the powerful force thought to be possessed by menstruating women. According to Creek tradition, artisans can work on a sacred basket only at certain times of day. This work begins in the early morning but must end by 10 or 11 A.M., because only the early morning belongs to the Upper World, whereas the afternoon is governed by the Lower World. Serious repercussions will ensue if these rules are not followed.

Corn-sifting baskets continue to have ritual significance during Green Corn Dance ceremonies, and consequently such baskets should be made only by married women (Belland and Dyen 1982b, 11). As Mary Frances Johns explained to me in 1990, three baskets are needed for the corn ritual because it is performed in four steps, only the last of which—the grinding of the corn with a mortar and pestle—does not involve a basket.

The craft was virtually abandoned in the 1950s and 1960s, except for sifting baskets made for ritual purposes or for special orders requested by collectors. Howard Osceola told me that only a very few older women still know how to make baskets. Recently, however, younger women have begun to learn the craft, largely out of a perceived necessity to keep the tradition alive. Sofke still is a favorite food, but for practical reasons modern mechanized methods are now used to prepare the cornmeal, or bags of commercially ground meal are purchased for everyday consumption.

Collecting palmetto stems for basket making could require a full day's outing. Only the longest stems are gathered. They are cut with a machete

and then split into sections with a knife. A smaller knife is subsequently used to scrape them and to make them smoother and thinner. Finally, all the stems are laid out in groups so that strips of equal width can be selected.

Analysis of a set of three baskets used for sifting, woven by an unknown basket maker in the 1970s, revealed how the weaving was done. To make the body of the holding basket—namely, the basket used to hold the sifted grain—warp and weft strips are woven in a twill plaiting technique that creates a geometric herringbone pattern. This is the pattern seen most often on Seminole plaited baskets, although weavers can produce other geometric patterns, such as diamonds, chevrons, or diagonal designs, by varying the number and sequence of the interwoven elements.

The basic twill pattern used in this set of baskets is formed by a simple two-over, two-under method, also commonly used for making mats (fig. 8.3). The bottom of the basket is woven first, with all the strips facing the same way—the slick side of the stem on the inside and the veined side on the outside. After the bottom is finished, the upturned sides are woven the same way, with special care in forming the corners. Once the sides are completed, the border is begun.

Double rims are attached to make the border. The first rim is made of a bundle of triple strips of stems as a square frame, attached by weaving it into the border. The stems are then tucked in and trimmed. The second rim, which strengthens the basket, is made of another triple bundle held by a strip that is wrapped around the bundle and woven into the frame. The two accompanying sifting baskets are woven by essentially the same technique, except that trimmed narrow strips are used for the warp and weft in the central square of the bottom of the basket to form a more open weave suitable for sifting. Wider strips are then woven to form the four turned-up sides of the basket. The rim is finished in the same manner as that of the holding basket.

Another item, not as well known but nonetheless an essential element of a medicine man's kit, was the "old little box," two envelope-shaped baskets or pouches of equal length that fitted together to hold healing

herbs (Sturtevant 1970, 159–60). Documented examples date from as early as 1857. A medicine basket dated as late as 1930s–1950s (now in the collection of the Florida Museum of Natural History) is very diminutive, some three to four inches square (fig. 8.4). The container basket opens along the top edge. The lid, which is half as deep and fits over the container, is woven in a diagonal double weave of split palmetto stems with the shiny side of the strips on the outside. These kits held medicine that had been wrapped up or put in smaller separate containers before being placed in the kit.

There are very few known examples of medicine baskets in museum collections, and such baskets have not been made for a long time. According to custom, they were made only by grandmothers or older women. One woman recalled in 1990 that her grandmothers had made them, and her mother too had learned how to make a sacred medicine basket while living with the Cherokees. But she had not been taught the correct procedure: when she returned home and showed the basket to her elders, they told her not to make them anymore because "she would not have children. The sacred baskets will take your children away."

Deaconess Harriet Bedell inspired a surge of renewed interest in basket making in the 1930s when she began encouraging the women to use the sweet grass and palmetto that grew abundantly around them to make baskets to sell to tourists. Whenever possible Bedell would endeavor to spark the memory of craft skills that had once been common but were now virtually extinct. She also emphasized the importance of high-quality workmanship, so that the people could take pride in the items they sold to boost their economy. Bedell thus urged the women to weave square or rectangular palmetto baskets that would serve a useful purpose for storage or as containers (fig. 8.5). Larger pack or trash baskets and smaller berry baskets with handles were also popular with non-Indians (see fig. 8.4). But the women also made personal items for their own use. One clever example is a baby rattle, woven of a single piece of palmetto: the stem has been used for the handle, while the fronds have been woven to hold a tiny piece of charcoal for the rattle sound.

Fig. 8.3 (right). Twill-weave technique, palmetto sifting basket, showing the outer rim, the tucked attachment, and the inner rim bundles.

Fig. 8.4 (below). Palmetto berry basket and medicine basket, Seminole. Left: Berry basket, 1943, woven in 2/2 twill pattern of split palmetto. Height without handle: 5½"; base: 3½ x 3¼"; diameter of rim: 5¼". Right: Medicine basket, ca. 1930–50. Length of lid: 4"; length of container: 3½". Photograph courtesy of the Florida Museum of Natural History, Gainesville. Acc. no. E-988.

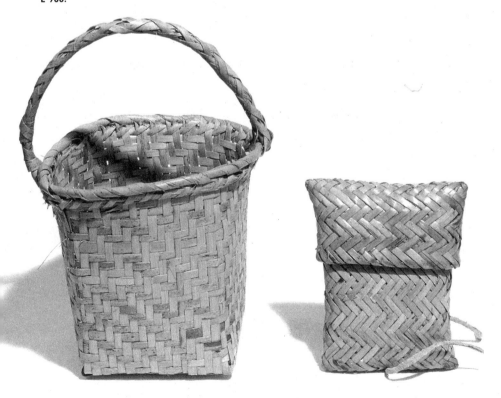

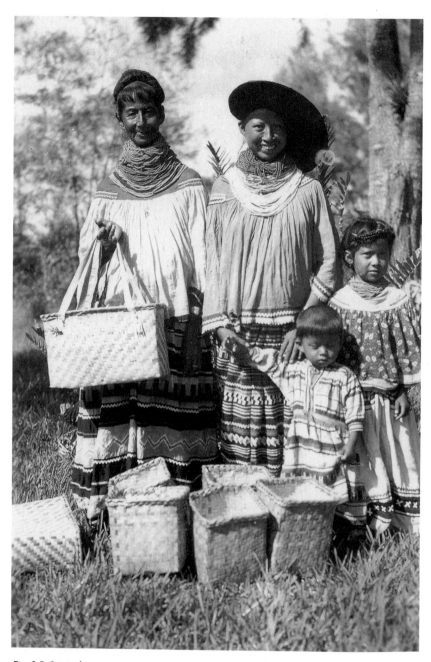

Fig. 8.5. Seminole women
with palmetto baskets, 1930s
or 1940s. Photograph by
Deaconess Harriet M. Bedell.
Courtesy of Mattie Lee McKey.

Coiled Baskets

The coiled basket-making technique is not thought to be native to the Southeast, as archaeological remains have yet to reveal any evidence of a prehistoric precedent for this method of making baskets. Some Indian people today do say that they can remember now-deceased relatives who had knowledge of the coiling technique, for which they used pine needles or sweet grass. And in his *Life and Adventure in South Florida* Andrew Canova recalled that once, while participating in a raid on an Indian camp in 1857 during the Third Seminole War, he noticed that hung "over the fire were some brass kettles, in which they were cooking dinner when we surprised them. Near by were several baskets woven of wire-grass, full of huckleberries and other wild fruit" (Canova 1906, 14). Although he did not explicitly describe the weaving technique, his mention of wire grass, rather than palmetto stalks, suggests that the coiled technique had been used.

The coiling technique might have been learned from the African slaves who lived among or near the Seminoles in the nineteenth century. Although more research needs to be done on the connection between these peoples, we know that slaves from the West African countries of Senegal and the Ivory Coast brought with them to the Southeast their knowledge of the art of making coiled baskets (Hillinger 1989). Men working on plantations, for example, made huge coiled baskets for storing and winnowing grain and for shipping cotton and indigo.

The art died out after the Civil War, however, except in rare areas such as Mount Pleasant, South Carolina (near Charleston), where black women still keep the tradition alive and are renowned for their beautiful coiled baskets made of sweet grass. The award-winning work of basket maker Mary Jackson has been featured in many exhibitions, including the annual craft show at the Smithsonian in 1984. According to Jackson, she learned the skill from her mother as a child in Mount Pleasant, where the craft had been passed down from mother to daughter through many generations. As she explained, "Our records show that this tradition has been in the community from the 1600s. It came here with the slaves, who came here

from an area along the Ivory Coast of West Africa, and it has been in continuous production up until this day. We never lost this tradition, so it's important that we hold on to it" (Young 1990, 20).

Jackson's large coiled baskets are similar to the fine work of Seminole basket maker Donna Frank done in the 1980s. Both Jackson and Frank use thick bundles of sweet grass for the coils, and the shapes of the baskets they make are often similar. The primary difference is that the coils of baskets made by South Carolina basket makers are held together by natural fibers, whereas Seminole basket makers use colored threads. Similarly, people of Creek ancestry living today in the northern Florida region of Blountstown have told me that they recall that their ancestors fashioned coiled baskets out of pine needles or sweet grass, a technique that has recently been reintroduced to them. Several Miccosukee-speaking people have also remarked that their ancestors made coiled baskets. As Howard Osceola put it, the art of basket coiling "was always around. They just didn't do much with it."

Small coiled baskets of sweet grass soon proved popular as inexpensive souvenir items (fig. 8.6). While for the most part their function was purely decorative, some were designed to hold personal belongings and those with padded lids to serve as pincushions. The baskets, which often had handles, were usually round bowls or tray-shaped with handles, although over the years the women experimented with other shapes, such as a double globular style made by coiling one basic bowl shape atop another. They have also added lids, often using doll heads for handles. Indeed, coiling sweet-grass baskets continues as an important craft today. Baskets are sometimes made for personal use, but most often they are intended for sale, even constituting a major source of income for some families. Collectors now seek out the finer baskets created by several well-known artists, who are constantly improving both their technical ability and their style.

Like other Florida Indian crafts, basket-making techniques are passed down through the family. Young girls and even a few boys have learned by watching their mothers, grandmothers, aunts, and other relatives weave. They then start small basket projects of their own. And, once

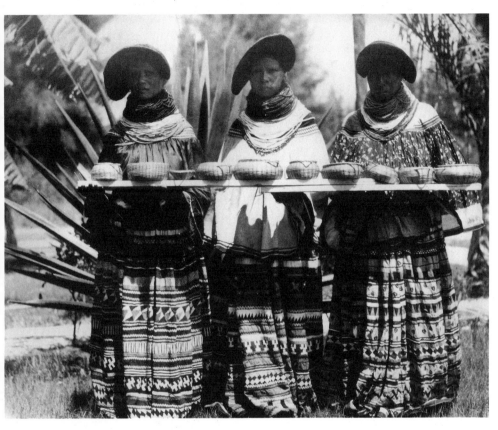

Fig. 8.6. Seminole women showing baskets they have made, 1933–39. Photographed at Glade Cross Mission by Deaconess Harriet M. Bedell.

Photograph courtesy of the National Museum of the American Indian, Heye Foundation. Neg. no. 37201.

learned, the craft is never forgotten, since it is a skill people feel they always can rely on as a source of income.

The process of making a basket begins with gathering the sweet grass. As Mary Frances Johns explained, this grass is not a true sweet grass, such as that used as incense. It grows in lengths from three to eight feet in the higher and drier regions of Florida: the Everglades are too watery, so sweet grass is not found in the region along the Tamiami Trail. Moreover, rapid land development in south Florida has created a shortage of sweet grass, with the result that people must now travel farther to find their supply. Given the time it takes to travel to and from the source, grass gathering often entails a full day's trip. The grass is more abundant in the farming district of Immokalee, and numerous basket makers live on or near that small reservation.

One can perhaps best gain a grasp on the basic techniques of basketry by examining the process used by one basket maker, although each artisan adds her own variations. In a 1986 interview on the Immokalee Reservation, Donna Frank gave me the following description of her work (Downs 1986, 18–19); see plate 28. Frank gathers her sweet grass once a month, taking care to select the best long green stalks. Even so, the grass is better during the drier times of year: it becomes spotty and brown during the rainy season. She then washes the green grass and spreads it out on two wide tables covered with tin that were specially built for drying grass. The grass is left out for four or five sunny days but is taken in each evening.

Frank has great respect for her source of supply and even finds the relationship somewhat symbiotic. As she explained, "I have been all around looking for the best grass and it was right in the pasture, practically in my backyard. It's about a quarter of a mile away. I'm so lucky to have it in walking distance. You know how you prune plants and they come out more? I feel like when I go out in this little area I'm kind of helping it" (18).

The green grass turns an attractive shade of soft yellow when dried, at which point it is ready for use. Frank's more carefully planned baskets begin with an idea of the finished size, shape, coil thickness, stitch, and

combinations of colored threads—whereas other baskets just "happen."
Not surprisingly, more time and energy are expended on the design of
larger or special baskets for collectors—time-consuming projects that com-
mand high prices. Other small baskets are made as "bread and butter"
items, sold in quantity to support the basket maker's family.

Although some basket makers prefer to begin their baskets with a coiled
bottom, Donna Frank and others start with a base consisting of a cardboard
circle or oval covered with fiber of the palmetto husk. The job of cutting
the tops off palmetto is difficult, so a male relative usually assists Frank
with this tough and messy task. She makes a number of bases at one
time so that she will not have to go back and work with the itchy palmetto
fiber too often. The smoothest fibers are selected, and a piece is sewn
onto either side of the cardboard. When the fiber refuses to lie flat, Frank
stitches it down all over the base, which also reinforces it. The excess
palmetto is then trimmed. Grass lengths are then evened out, and several
strands selected for the bundle that will form the first coil. Different
basket makers prefer various thicknesses of coils; Frank prefers fat coils,
approximately the width of her little finger. She tacks the first bundle to
the base and begins her stitching.

Coiling involves a sewing technique in which colorful thread is used
to make the chevron designs that distinguish Seminole and Miccosukee
baskets. (According to Mary Frances Johns, some women refer to these
chevron designs as "ferns" or "bird's feet.") Thread is strung on a large-
eyed needle and pulled through a lump of beeswax: this prevents the
thread from tangling as well as preserving and strengthening it. The
stitching itself is a two-step process (fig. 8.7). First, a length of the thread
is stitched into the preceding coil and wrapped around the new coil. It
is then pulled on an angle over to the next spot to be stitched, the angled
thread forming a V. Each vertical row of Vs makes a chevron design. The
work of different basket makers can be recognized by the way these
stitches have been executed.

Any color of commercial thread can be used. Some basket makers use
crochet thread, but Frank prefers embroidery thread because it is thicker
and the colors are more brilliant. The selection of colors varies with each

artist, but it has become a crucial decision. Colors were randomly chosen in the past, but recently basket makers have grown more concerned about selecting harmonious color combinations. One color is used to hold the coils of sweet grass for three, four, or more rows, after which a new color is employed for the next series of rows. Frank's choice of colors varies with her mood. Sometimes she will select a group of coordinated colors and repeat the same pattern of bands of colors. At other times she likes to work in what she calls "rainbow" colors, changing from burgundy to red, orange, and then to yellow, an idea carried over from rainbow designs on patchwork.

The basket maker knows instinctively at some point that it is time to begin finishing the basket opening, which can be worked inward or can flare out. The final coil should end so that it is even with the beginning coil, to keep the basket balanced. Frank starts reducing her coils about six rows from the top so that the last coil can be folded in without ending bluntly.

The basket can be either open or lidded. As Frank explained, there is a belief that "if you are young and not married or even if you are married and have children, you should never make a basket with a lid, because they say when you are closing it, it is just like closing a coffin"—a belief that her sister, Ethel Santiago, also voiced (Belland 1982b, 10). Nevertheless, Frank makes lidded baskets, for they are very popular with collectors. Making the lid fit the rim of the basket is tricky and so has not always been well-executed by some basket makers. The lid may just be a dome without a handle, or it may be topped with a ring or doll's head.

It was Deaconess Bedell who introduced the idea of adding the doll's

head to make the baskets more decorative and appealing. Most often, the doll's head is adorned with the headdress style popular during the 1930s and 1940s. Many strands of bead necklaces and dangling earrings enhance the dramatic effect. Heads either can be made by the basket maker or bought from someone else who is a specialist in doll making. As Donna Frank explained to me in 1986, "The doll's head with her traditional headdress represents the Seminole Tribe and also it represents the women of the tribe. Basketry is mostly women's work."

Nonetheless, a few men also have made beautiful and innovative baskets. The late Paul Billie came from a family in which basket makers, both male and female, were numerous. He sometimes combined in his baskets sweet grass and pine needles gathered at his remote camp in the high pines near Immokalee. Pine needles must also be dried for use like sweet grass, but since they are shorter, working with them is more difficult. Billie's work was to some extent inspired by the baskets made by other Native American groups, but he experimented freely with both basket shapes and different combinations of colored threads. In addition, he integrated into his baskets geometric shapes such as step designs or triangles and animal forms worked in colored threads. The thread for the designs were tightly wrapped, but the rest of the basket was coiled in the Florida chevron style. Billie also was a talented artist, and both his paintings and baskets are a tantalizing foretaste of what he might have accomplished had he not died unexpectedly around 1990 in his early forties.

Basketry Today

At present there are several basket makers producing work that wins prizes at the annual Seminole Tribal Fair. The basketry competition has inspired the people to improve their workmanship and experiment with new ideas. The baskets made by Elaine Aguilar of Immokalee Reservation are done in a clean and classic style, delicately woven in elegant shapes using narrow bundles of sweet grass (plate 29). The coils are held by tight and even stitches executed in rainbow or other refined color combinations. Aguilar also experiments with geometric designs such as diamonds and

rectangles that are wrapped into her work. A tasteful knob or doll's head tops her lidded baskets.

Mary Frances Johns is a very talented Miccosukee-speaking basket maker who lives on Brighton Reservation. Johns deviates from the customary chevron stitch by using a spiral stitch to hold her sweet-grass or pine-needle coils in place (plate 30). Johns begins her baskets with a coiled base that is more difficult to make than a fiber base. She has also devised an ingenious system that gives the artist more control by wrapping a small piece of cloth around the ends of the grass or needles of the first coil to confine them. Thread is then wrapped tightly around the cloth as the coil is twisted and stitched to form the base.

Johns should take pride in one particularly superb basket that won an award at the 1990 Seminole Tribal Fair. Spiraled black threads with a central wide band in a diamondback rattlesnake design decorate the straight sides of the basket. The designs, made of tightly wrapped threads, have been done in the traditional Seminole medicine colors of red, yellow, and black on off-white sweet grass. A cross with a blue center, representing the four directions of the logs of the sacred fire, appears in the middle of each diamond design. Black threads swirl to the center of the flat lid, which is topped with the surprise of a handle made of a small Australian pine cone. The innovative use of symbolic designs and the skill with which this small basket was woven mark a new level of achievement in Florida Indian basket making.

Mary Frances Johns is very traditional and so practices the custom of working on such a special basket only during the morning hours. Although Johns has many other artistic skills that also occupy her time, she continues to make a few baskets annually in different styles and colors, all with a carefully conceived symbolic content. But despite the work of women such as Elaine Aguilar and Mary Frances Johns, the future of Seminole and Miccosukee basket making is uncertain. Many of the basket makers are now elderly, and few young people seem interested in continuing the tradition. If we are fortunate, though, the innovative work of artists like Aguilar and Johns, as well as basket-making competitions, will inspire younger people to explore the craft anew.

CHAPTER 9

Since ancient times dolls have been made for various reasons: as play-things, as instruments of power to control supernatural forces, as puppets for performance, or for trade or sale as souvenirs (Lenze 1986, 11). Dolls were traded as souvenirs in North America even before the arrival of European explorers. Such dolls are miniature reminders of pleasant experiences, exotic places, and interesting people. In a discussion of the popularity of handcrafted dolls as souvenirs throughout the United States, Myles Libhart commented: "Undoubtedly the most widely renowned North American Indian dolls, Seminole palmetto fiber dolls, have been promoted and marketed since the 1930s as Florida tourist trade products under several craft programs directed to aiding the economic development of Indian communities. The Seminole doll is remarkable not only for its conceptual simplicity, but also for its clever integrity at depicting tribal dress" (Libhart 1989, 40).

The Seminole dolls first noticed in the late nineteenth century were relatively simple playthings made of sticks and rags (fig. 9.1). After the turn of the century, Seminole dolls took on more definable shapes and dress, though not without some reluctance on the part of their makers. As Howard Osceola explained to me, this is the result of a taboo: Seminoles and Miccosukees are hesitant to recreate the exact image of something, fearing it will bring harm to them. Wooden dolls with carved faces were dressed in the clothing style of the day. As Seminoles recognized opportunity in a booming tourist market, they began making dolls as souvenirs before 1920. Palmetto husk dolls with sewn facial features, appropriate hairstyles, and dress that reflected the changing styles in Indian clothing

became popular as souvenirs of a trip to Florida, and they remain today one of the treasures of collectors.

Clay MacCauley was the first to observe, in 1880, the games and toys of Seminole children. Even though children were expected to participate in the household chores in the camp, like all children they also found time for play—and their games of course included "playing house." MacCauley noted that "the Seminole has a doll, i.e., a bundle of rags, a stick with a bit of cloth wrapped about it, or something that serves just as well as this. The children build little houses for their dolls and name them 'camps'" (MacCauley 1887, 506).

Seminole dolls made exclusively as toys for Indian children in the first decades of the twentieth century were simple carved wooden cylinders with a round head. The face was often undecorated, but sometimes features were drawn or carved onto the head (fig. 9.2). They were dressed in calico clothes. E. F. Coe wrote in 1921:

> The Seminole boys and girls have very few playthings. The boys early in life leave off playing with toys; the girls have a few playthings. About twenty years ago a Convention of Doll Land was held in New York City and Capt. Geo. Storter was requested by the lady who was conducting same, to furnish specimens of dolls made by the Indians (Seminoles) and upon inquiry from them, they said, "Sometimes we make 'em, but thinks to make 'em dolls, Indians get sick," but Mr. Storter prevailed upon them to make specimens of Indian dolls, which were exhibited at this Doll Land Convention and they are still on exhibition there. There are only two Seminole Indians who are making these dolls—specimens of which were brought back by visitors to the camp. The body of the doll is made of a piece of cypress or other soft material and the face is sculptured out with an ordinary pocket knife. The black dye illustrates the hair, eyes and ears of the doll, and are dyes which cannot easily be removed. . . . Mr. Storter succeeded in having a Seminole Indian make a small canoe with the Indian Chief standing erect therein, properly gowned in his vari-colored shirt, with his squaw seated in the bottom of the canoe, each of whom are [sic] dressed in typical Indian garb. (quoted in Kersey 1975, 114)

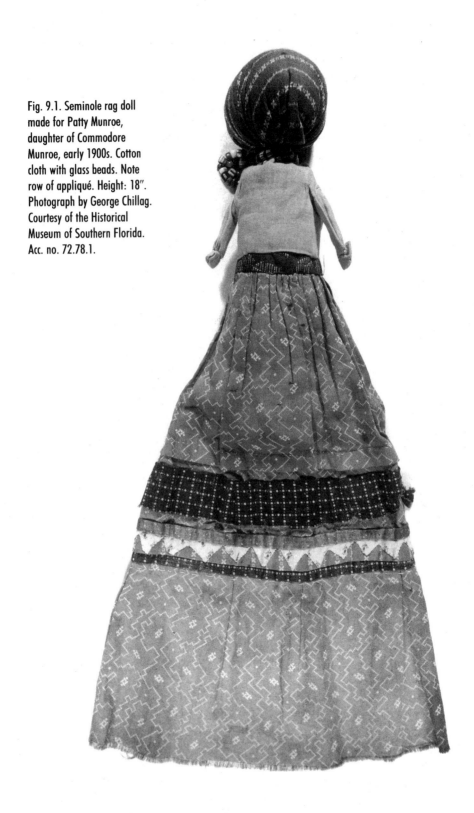

Fig. 9.1. Seminole rag doll made for Patty Munroe, daughter of Commodore Munroe, early 1900s. Cotton cloth with glass beads. Note row of appliqué. Height: 18″. Photograph by George Chillag. Courtesy of the Historical Museum of Southern Florida. Acc. no. 72.78.1.

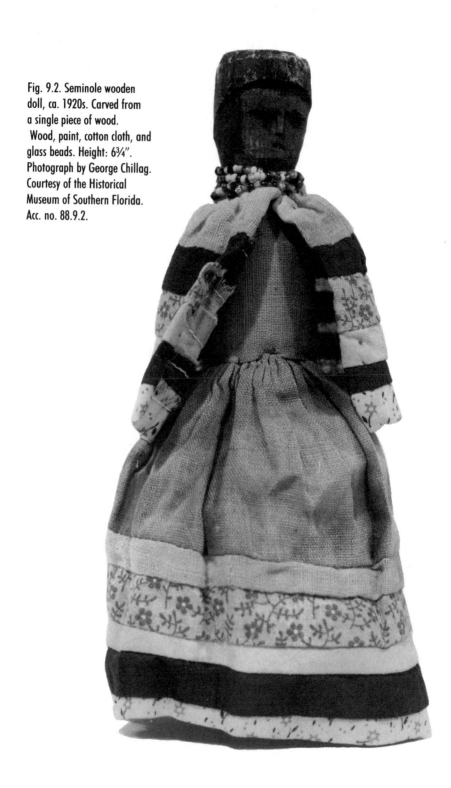

Fig. 9.2. Seminole wooden doll, ca. 1920s. Carved from a single piece of wood. Wood, paint, cotton cloth, and glass beads. Height: 6¾″. Photograph by George Chillag. Courtesy of the Historical Museum of Southern Florida. Acc. no. 88.9.2.

Coe's account of the difficulties Storter encountered in persuading the Indians to make dolls reflects the taboos surrounding the creation of such images. The same taboo probably explains why the early dolls described by MacCauley were just a bundle of rags or a stick with cloth wrapped around it.

As early as 1918, however, women had begun making dolls dressed in Indian clothing to sell from their chickees at Coppinger's exhibition village, and by 1922 they were selling dolls in gift shops at Coppinger's, Musa Isle, and elsewhere. In an article published in the *Seminole Tribune*, Betty Mae Jumper commented that "the first doll ever made was eight inches long and they sold for $.50 which was thought of to be real good money. It was sold at Willie Jumper's cold drink stand, in front of where Howard Tommie's smoke shop is today [on the Hollywood Reservation]. . . . I wonder if my mother [Ada Tiger], Rosalee Tiger Huff, and old Annie Tommie were to wake up and see the prices, what they would say, for they are the first people who started making the palmetto dolls" (Jumper 1988). The reddish cast of palmetto husk is more similar to Indian skin tones than white wood and is thus more appropriate for dolls representing Indian people.

Palmetto husk dolls thus ceased being playthings for Indian children and were made primarily to sell. Deaconess Harriet Bedell was well aware of the popularity and potential market value of Indian dolls, for she had observed their popularity as souvenirs in the Northeast and elsewhere (Lenze 1986, 82). As she did with respect to all other crafts, she encouraged high standards of quality in Seminole doll making, lamenting at one point that "Indians come sometime bringing dolls, etc., so poorly made that they cannot be sold and are destroyed." Bedell would accompany the Indians on trips deep into the Everglades to gather fiber for dolls. She found a market for the dolls in stores and by mail order and by 1937 had arranged to sell them by the thousands at ten cents a doll (Bedell 1937). By 1939 the price had jumped to fifteen cents. In the slack tourist season during summers in the 1950s, she would fill her car with dolls and other crafts to sell on her visits to her native New York.

The clothing worn by dolls, as well as their hairstyles, changed over

the years to match the styles the people were themselves wearing. Early dolls were dressed in banded calico cloth skirts, blouses, and other Seminole attire of the period. When women began to wear solid-colored cloth patchwork skirts and longer capes, dolls' dress styles changed accordingly. Cloth or yarn was used to interpret the popular hairstyles of a given period, although occasionally natural hair was used. The dress of male dolls also matched the clothing of their human counterparts, styles duly progressing from a doctor's coat to a big shirt (plate 31). Each male doll had a scarf around its neck and most wore turbans. Beginning around the 1960s, though, various older costumes and hairstyles have tended to be retained, the most popular being the classic styles of the 1940s.

Modern Miccosukee women demonstrate doll making and discuss their work at the Miccosukee Culture Center. They complain that palmetto fiber is unpleasant to work with because it is coarse and irritating to the skin, so a male relative often takes on the difficult job of collecting the fiber. Once a suitable palmetto is found, the leaves are first chopped off and the trunk cut down with a machete or ax. The palmetto fiber is then removed with a smaller knife. Smooth fiber is the most desirable, and the selected pieces are wrapped in a cloth. Four, five, or more dolls can be made from one palmetto, depending on the sizes of the dolls.

It takes a day or two for the fiber to dry, after which work begins. Pieces are cut to size for dolls that will be four, six, eight, or ten inches in height. A supply of heads is first made and the same number of bodies then cut. Scrap palmetto fiber, rather than cotton, is used to stuff the heads, because the palmetto makes it easier to sew on the facial features. The head is then tied off at the neck and facial features sewn on with colored thread, white and black being used for the eyes and bright red for the mouth.

Next the body is made. Palmetto dolls intended for quick and inexpensive production and sale have retained the same basic shape as their wooden prototype: a round head is attached to a cylindrical body without arms or legs. Since the fiber used for the body has a tendency to curl, it easily wraps around the filling of palmetto fiber or cotton. One seam is sewn down the side. The doll maker then cuts a circular cardboard base,

covers it with fiber, and sews it to the bottom of the stuffed body, after which the head is attached. Finally, the doll maker either dresses the dolls herself or else sells the bodies to other women who finish them by adding clothing.

Dolls are dressed in two-piece costumes, which also are prepared in batches. Several bands of solid-colored cloth, decorated with numerous rows of rickrack, are used for the skirt and cape. The skirt is sewn onto the body. At least one row of patchwork is usually included on the skirts of dolls eight inches or taller that sell at a higher price, while the smaller, four-inch dolls have less elaborate costumes.

At this point, cloth or yarn is added to the head to produce the desired hairstyle. The 1940s' style is conveyed by covering the doll's head with black cloth that has been pulled over a crescent cardboard frame. The ponytail—a popular hairstyle for both women and dolls in the late 1950s—is created by using black silky or wool yarn. Black wool yarn is sometimes used to make two braids. As already noted, since around 1960 it has not been easy to determine the era in which a doll was made on the basis of hairstyle and costume, because all the older styles have been used, depending on the preference of the doll maker. After the hair is added, the material used for the cape is sewn on. Beaded jewelry provides the finishing touch. All dolls are adorned with many rows of multicolored bead necklaces to complete the classic style of dress, while the better ones also have plastic pearl or dangling glass-bead earrings.

Most dolls represent women, although in the 1940s more artisans began to make pairs of male and female dolls for sale (plate 32). Male dolls have arms, legs, and flat feet for support and are dressed in big shirts with scarves around their necks and turbans on their heads. Better examples of male dolls come complete with undershorts. As Howard Osceola explained, according to another taboo only women past menopause are supposed to make male dolls.

The "man on horseback" doll—a male doll with black cloth hair dressed in a big shirt and seated on a horse made of palmetto husk—became popular in the 1940s (fig. 9.3). This style of doll probably owes its existence to the cattle-raising industry, which had proven successful on the drier

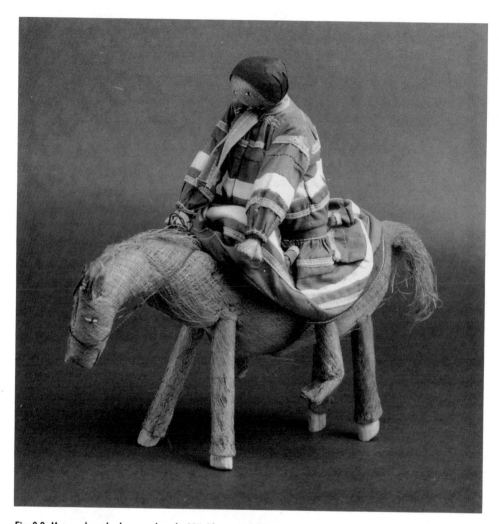

Fig. 9.3. Man-on-horseback doll, Seminole, ca. 1940s. Palmetto husk, cotton thread, and cloth. Height: 9⅞"; length: 13". Photograph by Britt Head. Courtesy of the Fort Lauderdale Historical Society. Acc. nos. X538.39 and X538.40.

land of the Brighton Reservation. In 1941 Indian leaders from the Big Cypress Reservation requested that cattle also be made available to them, and so they too were launched into the cattle business in a limited way (Kersey 1989, 129). This in turn led to admiration for cowboys. The "man-on-horseback" doll was probably devised about the same time as the patchwork design of the same name that Deaconess Bedell referred to in June 1941 (Bedell 1941).

Doll making provides an important part of the income of many families, who supply Indian arts and crafts stores or sell to people who run booths at festivals. Dolls that are to be given as gifts on special occasions are of the finest quality. There is also a doll-making competition with cash prizes at the annual Seminole Tribal Fair. Ruby Jumper Billie, a frequent prizewinner, is especially known for her fine craftmanship.

The demand for dolls far surpasses production. Collectors seek out the work of the best doll makers. Many of the women who made the dolls have since passed away, and, as was also the case with basketry, few girls have taken up the craft. In addition, palmetto fiber has become increasingly hard to find: people sometimes must drive a hundred miles or more to reach a source of supply.

It is interesting to note how doll prices—which are determined by size as well as quality of workmanship—have escalated. The tiny pin dolls that Bedell sold in volume for ten cents in the 1930s sold for two dollars in 1988. Comparably, six-inch dolls, which were once only fifty cents, sold for five or six dollars. The price of eight-inch dolls has climbed to approximately twelve dollars, and ten-inch dolls can cost twenty dollars or more. Doll making thus remains a lucrative and popular craft.

CHAPTER 10

The making of pottery was well on its way to becoming a lost Seminole art by the late eighteenth century, when William Bartram reported in his *Travels* that the Seminoles made baskets but bought their domestic utensils from the whites (1955, 168, 182). Although some women were still making a few pottery containers, durable big black kettles of cast iron had basically replaced the breakable ceramics of Seminole manufacture.

Most of the available information about Seminole pottery exists in fairly dry and technical archaeological or anthropological reports. Pottery is rarely included in exhibitions of Seminole art or even in more general written descriptions of their culture. This is not without good reason: the pottery vessels and potsherds that have been identified as Seminole are for the most part undecorated and lack aesthetic appeal. In spite of this, Seminole pottery should not go unmentioned, because variations within the ceramic arts are considered important markers of cultural diversity. In the case of the Seminoles, changes in pottery reflect the drastic new developments that were taking place in their culture during the late eighteenth and first half of the nineteenth century.

The prehistoric ancestors of the Seminoles and Miccosukees were very skilled in the ceramic arts. Ceramic vessels found at sites dating to the Mississippi Culture period come in many shapes. Some were decorated with stamped textile impressions or simple markings while others reveal an extensive iconography of well-executed designs. Imaginative ceramic figures have also been found at Mississippian sites in considerable number. The decentralization of the Southeastern cultural centers was, however, accompanied by a decline in ceramic skills, which perhaps began even before the arrival of the Europeans.

Research on carefully excavated examples of Creek pottery styles may
eventually shed light on the prehistoric origins of these people as well as
the related Seminoles and Miccosukees. Brushed pottery with notched
and fluted rim styles is now recognized as typical of Creek pottery. Archae-
ologists have determined that this ceramic technique initially appeared
in the Upper Creek area of the Coosa-Tallapoosa River around 900 to
1000 A.D. (Dickens 1979, 148). Quantities of brushed pottery sherds that
date from the middle of the eighteenth century have also been found
in the Chattahoochee River region, but precisely how this pottery type
developed in that area is unclear (Schnell 1970; DeJarnette 1975, 109,
185).

Similarities exist between Creek and Seminole ceramics, just as they
do in other art forms. Indeed, the methods of making pottery remained
similar. But as the Seminole groups drifted apart from the Creeks both
geographically and politically, variations that might distinguish their re-
spective pottery styles appeared in the clays and the tempering materials
(used to strengthen the clay) available in their natural environment.

The anthropologist John Goggin produced a definitive study of Semi-
nole pottery (1987, 180–213). Goggin and other anthropologists and
archaeologists compared examples of pottery and potsherds from excava-
tion sites in Florida that revealed multiple periods of occupation. Research-
ers thus began to distinguish characteristics of ceramics that could defi-
nitely be identified as Seminole, as opposed to those found on the
abundant potsherds left behind by indigenous people or other groups. In
northern Florida, brushed ceramic sherds indicated Seminole sites, but it
is also clear that the Seminoles had pretty well discontinued pottery
making by the time of their final move into south Florida.

The history of Seminole pottery is brief. Few written accounts mention
Seminole ceramic production in the late eighteenth century, but a fairly
early nineteenth-century account written by James Pierce refers to pottery
that still was being produced in the Alachua area. According to Pierce,
the "pottery ware is of good shape and well baked, [and] is made by
females" (Pierce 1825, 135). Sherds dating from between 1763 and 1783

that were found at Spalding's Lower Store, an important trading post on the St. Johns River, differ distinctly from previously identified prehistoric pottery types found at the same site. Some of these sherds were made with micaceous clay, which indicates an origin in West Florida or Georgia of the clay or the finished vessel. These sherds can nevertheless be considered the earliest known examples of Seminole pottery because they date from the period when "Seminoles" were first identified as a distinct group, separate from the Creeks. Samples from other sites date into the first quarter of the nineteenth century—a date that essentially marks the end of extensive pottery making among the Seminoles, although the craft continued in Florida on a very limited basis until around 1840. The Seminoles removed to Oklahoma, however, continued their ceramic traditions into the early twentieth century.

Several consistent traits identify Seminole pottery. The most important of these are the coiled method by which pots were made and the finishing techniques used. The shape or form of the vessel, including its rim and lip, and the styles of surface finish and decoration are other markers, in addition to which the texture and type of clay and the tempering materials preferred by Seminole potters have been established. Seminole women, for instance, generally used limestone and coarse or fine sand found near their camps as tempering material for their pots. Samples of Seminole pottery found in Florida have also been compared to Creek and to Oklahoma Seminole examples.

Goggin identified two styles of Seminole pottery, both of which he considered culinary ware: utilitarian vessels used for eating and pots designed for cooking (1987, 207–8) (fig. 10.1). The two styles, which were produced simultaneously, were usually tempered with fine sand and undecorated. The earliest sherds of this style of pottery have been identified at the Spalding's Lower Store site. The first style includes eating and serving dishes—small shallow open bowls with flat bottoms, finished with a smooth surface. The second category consists of vessels that are well suited for cooking on an open fire. They are described as large globular containers with a round bottom and a rough surface (fig. 10.2).

They have a constricted rim, marked only with a puctuated lip or a crude decoration. The archaeologist Brent Weisman has suggested that similar rim decorations on sherds excavated at a given site could distinguish matrilocal clan affiliation: rim styles "may have become markers of clan identity as clan membership grew in importance after the mid-1820s" (1989, 45). Pottery making was still an important female activity, and all of the women in one camp would have belonged to the same clan.

Archaeologists classify ceramics by the characteristics of their finishes, which are typically named for the archaeological sites at which they were first found and identified. The most common varieties of Seminole culinary ware, which generally has a brushed finish, are Chattahoochee Brushed, Stokes Brushed, and Winter Park Brushed. Chattahoochee Brushed ceramics were first collected and identified in 1950 by Ripley Bullen, who was working along the Chattahoochee River valley in Florida (Bullen 1950) and are now considered a cultural marker of the distribution of groups of Creek or Muskogean origin. The sherds are plain, notched, or angled at the top of the rim. Excavations at sites around the Alachua area have turned up examples of eighteenth-century Chattahoochee Brushed culinary ware as well.

Chattahoochee Brushed sherds with notched rims also have been found at Spalding's Lower Store. Some of the earliest identified forms of culinary ware from this site, dating from the eighteenth century, are classified as Stokes Brushed (or variations on it) and other sand-tempered sherds (fig. 10.3). An intact eighteenth-century Winter Park Brushed cooking vessel was recovered by Goggin and scuba divers from a major underwater site known as Oven Hill on the Suwannee River. The vessel is tempered with a mixture of limestone and quartz sand. Excavations adjacent to the river uncovered the remains of a large Seminole settlement, including an abundance of diverse sherds.

Important excavations in a region southeast of Inverness were conducted in the 1980s by University of Florida archaeologists Jerald T. Milanich and Brent Weisman. Excavations revealed camps dating from the closing years of the Second Seminole War in the 1830s. The sites are

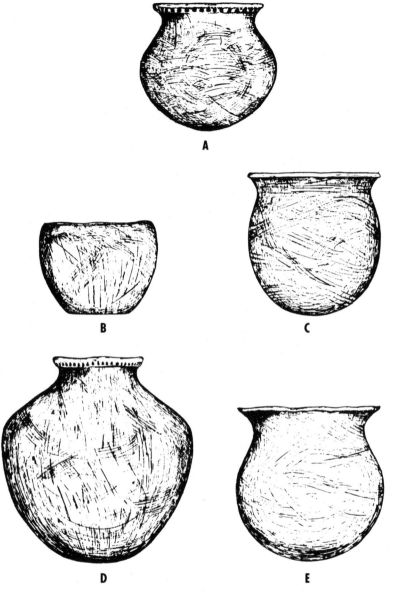

A

B **C**

D **E**

Fig. 10.1. Seminole vessels excavated from Florida sites. A: near Lake Butler, in Orange County. B: Hillis Bays, forty miles southeast of Orlando. C and D: Enterprise. E: Kissimmee River. Drawings from "Seminole Pottery," by John M. Goggin, in *Prehistoric Pottery of the Eastern United States,* 1958. Courtesy of Museum of Anthropology, University of Michigan, Ann Arbor.

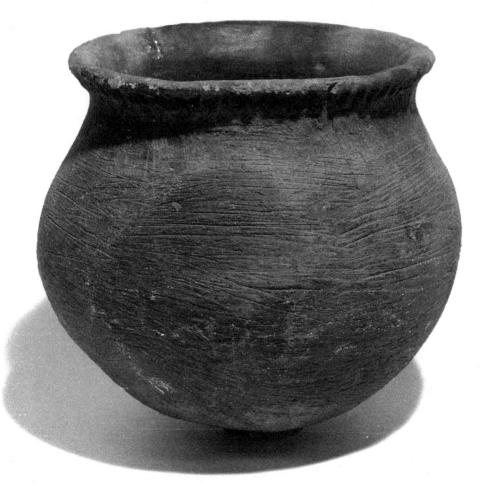

Fig. 10.2. Brushed ceramic
cooking pot, Seminole,
nineteenth century. From the
collection of the Anthropology
Department of the Florida
Museum of Natural History,
Gainesville. Cat. no. A16784.

Fig. 10.3. Stokes Brushed potsherd rims and decoration from Spalding's Lower Store. A and B: rim detail. C: profile of B. D: potsherd brushed surface texture. Drawing from "Seminole Pottery," by John M. Goggin, in *Prehistoric Pottery of the Eastern United States*, 1958. Courtesy of Museum of Anthropology, University of Michigan, Ann Arbor.

located in the southern portion of the Withlacoochee Cove, an area east of Floral City that spreads south to Lake Tsala Apopka. They were found by following maps and descriptions of the region from a diary written in 1737 by Lieutenant Henry Prince of the U.S. Army (Weisman 1989, 95). Prince referred to the inhabitants he encountered there as Upper Creek Muskogee-speaking people who called themselves Talasays and Topekay-ligays. Weisman has identified archaeological sites with traits associated with one or both of these groups, at which sherds of Chattahoochee Brushed pottery identical to specimens of that type from the Creek region are most common (1989, 145). On the basis of the distribution of sherds with a particular style of rim decoration, Weisman was able to classify the settlement pattern of these peoples as a loosely arranged group of clan camps.

The location of Osceola's village, called Powell's Town in Prince's diary, was a major find at Withlacoochee Cove. Chattahoochee Brushed sherds were not among the numerous potsherds found around the site's square ground area, although the type was found nearby. The other sherds are made of a dense, sand-tempered paste; they are undecorated and their finish is burnished or smooth. These and other ceramic remains found at Powell's Town are consistent with finds at other known Seminole sites.

As Weisman noted, an intact cast-iron cooking pot dating from the British period in Florida also found at Powell's Town suggests that the site had been occupied for some time before being abandoned.

As already mentioned, the Seminoles removed to Oklahoma continued ceramic traditions, using the coiling method to make pottery with a smooth finish until the mid-1920s, whereas among the relatively few Seminoles who remained in south Florida pottery-making skills had long since been lost. Reporting on his visit to the Florida Seminoles in 1880–81, Clay MacCauley made it clear that they were no longer engaged in making or using pottery. In MacCauley's estimation, "it was easy for the ancestors of these Indians to see that the iron kettle of the white man was better in every way than their own earthenware pots. Gradually, therefore, the art of making pottery died out among them, and now, as I believe, there is no pottery whatever in use among the Florida Indians. They neither make nor purchase it. They no longer buy even small articles of earthenware, preferring tin instead" (MacCauley 1887, 516).

The people had indeed succumbed to the availability and durability of metal utensils. Minnie Moore-Willson—a rather sentimental writer when it came to the Seminoles—also commented on the absence of earthenware in their camps in the early twentieth century, although she did notice a fine assortment of metal utensils. According to Moore-Willson, the Seminoles told her that their race made earthen pots a long time ago but found "white man's kettle 'heap good,' and they have long since ceased to work in clay. All through Florida pieces of pottery are found in sand mounds. In the pine forests where the land is good for cultivation, broken pottery is frequently dug out of the ground. These forests have grown over this evidently since it was cultivated by former races" (Moore-Willson 1920, 137; her last statement probably refers to the indigenous Indian peoples of the region).

It did not go without notice that metal containers did not break like those made of ceramic, an important consideration for mobile groups. As one informant put it in 1908, "Old pot, Indian got 'um long time ago, no good too much. Fall littly bit, break 'um" (in Harington 1908, 406). For the time being, then, the study of Seminole pottery is interesting

228 mainly to archaeologists but is less appealing than other traditional crafts. Nonetheless, as new archaeological sites are identified and excavated— frequently just a step ahead of the bulldozers of land developers—increasing information will shed more light on the dating and distribution of Seminole pottery in Florida as well as on the Seminole people themselves.

C
H
A
P
T
E
R

The women's role in Seminole and Miccosukee arts and crafts was to create decorative objects of great beauty. It was the men's role to provide for the comfort of the family camp or village. Construction of the clan camp has always been a primary responsibility of the men living there. Seminole and Miccosukee boys traditionally were taught how to work with wood by their fathers, uncles, or other family members, for construction of the family camp is the most serious of a man's duties. As boys they learned how to build the chickee, an open-sided palmetto-thatched dwelling cleverly designed to accommodate life in the warm climate of south Florida. Many consider the chickee to be a work of art.

Men also carved the dugout canoes that were essential for family transportation, as well as making decorative objects such as the large, brightly painted totem poles that stood in front of villages. Men whittled smaller objects for household use or handles for the rattles used at ceremonial functions. Today, some men make a career of carving animal or bird figures or create large numbers of inexpensive wooden toys—hatchets, knives, canoe models, alligators, decorated rattles, and drums—for the tourist trade.

Camp Construction and Community Layout

The population and size of a camp is generally determined by the number of people the group can support and feed. A comparison of eighteenth-century Creek communities and early Seminole housing and living patterns with the lifestyle of Seminoles and Miccosukees in the late twentieth century reveals the many changes that resulted from a great decrease in

population. The contrast dramatically demonstrates the hardship and loss endured by the ancestors of the Seminole and Miccosukee people of today.

The Creek Indians of the eighteenth century lived in large, populous settlements in Georgia and Alabama, organized around numerous autonomous towns that served as ceremonial centers. Family settlements included several wooden buildings for storage purposes and comfortable houses that were constructed with log walls which protected the inhabitants in cool weather (fig. 11.1). Settlement patterns and community planning were based on social organization, the essential element of which was clan association. Creek people of the eighteenth century were organized into matrilineal clans: related women and their families lived close together in matrilocal communities. A contemporary noted that these communities were made up of houses that "stood in clusters of four, five, six, seven and eight together, irregularly distributed up and down the banks of rivers or small streams; each cluster of houses contains a clan, or family of relations, who eat and live in common" (Swan 1795, 262).

William Bartram described such an arrangement when in the late eighteenth century he visited the Creeks living along the Tallapoosa River, where "every habitation consists of four oblong square houses of one story, of the same form and dimensions and so situated as to form an exact square, encompassing an area of about a quarter of an acre of ground, leaving an entrance into it at each corner" (Bartram 1955, 318). Excavations at some sites suggest that various buildings may have been used for distinctly male or female activities (Knight 1985).

These settlements were affiliated with a named town that had a plaza, council house, and sacred fire on the central square ground where the annual green corn ceremony known as the *boskita* (busk) was celebrated (Wright 1986, 22). The people were governed by town officials and a *micco*, or chief, who represented the will of the people (Sturtevant 1971, 93–104). The towns throughout the region were divided into "red" or war towns and "white" or peace towns. If busk ceremonies and kinship united the people in each town, intertribal ball games between red and white towns formed a basis for rivalry.

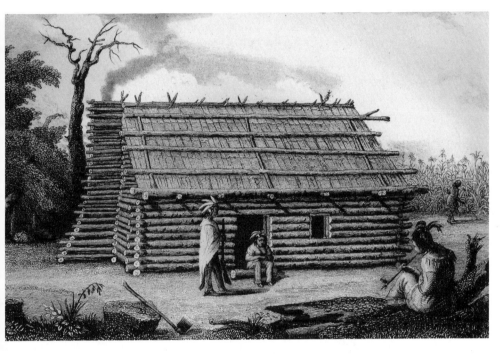

Fig. 11.1. Creek house, 1791. After a drawing by J. C. Tidball, published by J. B. Lippincott and Co., Philadelphia. Photograph courtesy of the National Anthropological Archives, Smithsonian Institution. Neg. no. 1169-A.

Early in the eighteenth century, individuals, families, and even some-times all the residents of small Creek towns began settling in vacated regions of Florida. New patterns of town organization and relations with other settlements probably developed in these communities. The fact that autonomous bands of Seminoles were breaking their traditional ties with the Creek nation was confirmed in 1757 by Cowkeeper, the leader of the town of Cuscowilla. As Cowkeeper reported to Bartram, when he visited Savannah he had neither been in the Creek nation for four years nor had he received any instruction from other Creek leaders.

Seminole towns such as Cuscowilla were in essence scaled-down ver-sions of Creek towns. Each town typically had a ceremonial square ground with a sacred fire and surrounding buildings, which served as the tradi-tional town center. The towns themselves were surrounded by various family compounds consisting of several structures. The buildings in the family compound were all grouped around a small square, and families maintained gardens near the compound as well as more distant communal plantations. Bartram noted in his description of the "Siminole" town of Cuscowilla that it had been moved from the site of the original Alachua community, near present-day Gainesville (1955, 163–70). The town was now in a far better location than it had been originally, standing on a high ridge of sand hills some three or four hundred yards from a large and beautiful lake. A brook ran through the heart of the town.

Housing and Living Arrangments in the Eighteenth Century

Cuscowilla contained about thirty compounds, each made up of two houses of nearly the same size, about thirty feet in length, twelve feet wide, and approximately the same height (Bartram 1955, 168). The living quarters of the main house were divided equally into two apartments, one side serving as the kitchen and common hall and the other for sleeping. The door was placed either in the middle of one side or on the front of the house.

The second house faced the front of the main house and was located about twenty yards from it. Two stories high, it was divided in the same way into halves but was constructed differently. There was a porch on

the end next to the main house, which was open on three sides and supported by posts or pillars. Above was an open loft or platform that was reached by a portable stair or ladder. This cool and airy space was a pleasant place where the "master or chief of the family" could retire to receive his guests or visitors in warm weather. The other half of the building, which was closed on all sides by notched logs, was used for storage. Potatoes were stored on the ground level, while the upper level was a granary, used for corn and other provisions.

Construction of the average frame house began with strong corner pillars set into the ground. Posts were placed in a line between the corners and were then strengthened by cross pieces of timber and covered with a cypress roof. The dwellings stood near the middle of a neatly swept square surrounded by a low bank of dirt. Cowkeeper's house was situated on an "eminence" and was larger than the other houses in the town. It was distinguished by a flag hoisted on a high staff at one corner. Bartram's party transacted their business with Cowkeeper openly in the public square or in the council house.

Bartram described another Seminole town some twelve miles from the trading post on the St. Johns operated by a Mr. M'Latche (1955, 250–51). Bartram's party was received and entertained in the square ground by friendly Indians, "the chief of the village conducting us to a grand, airy pavillion in the center of the village. It was four square; a range of pillars or posts on each side supporting a canopy composed of Palmetto leaves, woven or thatched together, which shaded a level platform in the center, that was ascended to from each side by two steps or flights, each about twelve inches high, and seven or eight feet in breadth, all covered with carpets or mats." Seated or reclining comfortably, the group was served refreshments.

According to Bartram, gardens and orange groves provided an abundant supply of food to Seminole towns (1955, 169–70). Little was planted close to the town, with the exception of small gardens at each compound where corn, beans, and tobacco were grown. A large plantation about two miles from Cuscowilla was maintained as a common ground and tended by the entire community. Each family had its own section of crops to care for and

harvest. The families put some of the harvest into their own granary, but a small gift or contribution was set aside for the public granary. Crops included pumpkins, squashes, peas, potatoes, melons, and peaches.

In summary, Bartram's descriptions of Seminole towns toward the turn of the eighteenth century indicate that these communities were scaled-down versions of Creek towns, enjoying times of peace and prosperity.

The Impact of the Wars

But this stable situation soon changed dramatically. During the wars of the nineteenth century, Seminole towns were under frequent threat of attack by both American and hostile Indian forces, and Seminole families were often forced to flee their homes. One such raid against a Seminole settlement occurred in October 1836 near the Withlacoochee River. The surgeon W. P. Rowles, who was serving with Creek volunteers led by Captain J. F. Lane, has given us the following description of the town: "Within a short distance from the margin of the lagoon we entered a town, consisting of huts made by planting four forks in a quadrangular form, over these poles were laid a roof of the bark . . . or boards split from the Pine or Castanea vesca, or American Chestnut. The walls were formed by bark or board . . . tied with splits or poles leaned against the evebearers. Fires were found burning and victuals cooking in several of the huts" (in Weisman 1989, 120–21). This "town" was probably a small matrilineal camp used only for a brief period of time by people who were of necessity frequently on the move. Excavated sites indicate that such towns no longer had a central square ground. Under such conditions, religious ceremonies were conducted on temporary busk grounds with makeshift arbors.

By the late nineteenth century, after a long period of isolation following the wars, Seminoles were once more found in settled but small communities. Richard Henry Pratt indicated in his report on the few Seminoles still living in Florida that he had located four distinct communities, which he listed by the name of their headman. These communities were made up of remote, scattered camps. Pratt visited the camp of Chipco, the old veteran of the wars, which was located on an elevation in piney woods near lakes

that held an abundant supply of fish. It consisted of ten sturdy buildings,
not arranged in any particular order. Pratt included drawings made by Lieu-
tenant E. T. Brown of several of the structures, commenting that "although
rude in their construction, they are quite ample for the climate, show as
much mechanical skill and are quite equal to those of many of their white
neighbors. The timbers for beams, rafters, posts and floors are neatly hewn;
while the clapboards were rived out as evenly as possible" (in Sturtevant,
ed., 1956, 6). A large garden was maintained, in which corn, sugarcane,
rice, sweet potatoes, tobacco, and melons were raised.

White settlers living in the area told Pratt that four or five years earlier
all the Seminoles, of necessity, lived in frail houses thatched with palmetto
leaves. They had been able to construct suitable housing only recently,
since they had become fairly prosperous from profits earned by hunting,
selling excess produce from their gardens, and doing odd jobs. One house
even had the luxury of windows. Pratt was also told that some of the
other Seminole villages, which he did not have an opportunity to visit,
were built around squares.

Clay MacCauley's report on the Seminoles in 1880 included a descrip-
tion of the hidden camp of "Charley Osceola," located farther south in
the so-called Bad Country on the edge of the Big Cypress swamp (Mac-
Cauley 1887, 499–501). The camp was situated on a hammock, a high
and dry island surrounded by a swamp of saw grass, and was well hidden
from view by a jungle of dense foliage, giving the appearance that no
one lived there. He estimated the island to consist of approximately two
acres of rich land. To his surprise, MacCauley entered a "small, neat
clearing, around which were built three houses, excellent of their kind
and one insigificant structure" (499). A fenced garden lay beyond the
structures. Looking around the camp, he found a cow's horn, which was
used to call from camp to camp.

The Chickee

MacCauley said that dwellings throughout the Florida Everglades were
virtually all the same as Charley Osceola's, and he included a drawing
and thorough description of the chickee style of architecture (fig. 11.2).

236 Charley Osceola's three houses were exactly alike, with the exception of the chickee used for cooking. They were located at the three corners of a rectangular clearing some thirty by forty feet. At the fourth corner was the entrance to the elliptical-shaped garden. The chickee he described measured approximately sixteen by nine feet. Its main feature was a platform raised some three feet off the ground that covered the entire interior floor space. This provided the family with a dry living space during high water and protected them from snakes and other creatures. The platform, which rested on beams that ran the entire length of the building, was made of split logs, flat side up, that were tied to the support uprights with palmetto rope, hide thong, or trade rope.

The palmetto-thatched roof reached some twelve feet above the ground at the central ridge pole and seven feet at the eaves. Eight cypress logs supported the roof. Numerous rafters held the palmetto thatching, which MacCauley described as a work of art: "Inside, the regularity and compactness of the leaves displays much skill and taste on the part of the builder; outside—with the outer layers there seems to have been less care taken than with those within—the mass of leaves [of] which the roof is composed is held in place and made firm by heavy logs, which bound together in pairs, are laid upon it astride the ridge" (500).

The chickee was open-sided and had no separate rooms: thin cotton or calico cloth could be pulled down for protection from insects or for privacy. The rafters were used for the storage of prized possessions and gaily ornamented clothing, as well as household goods and food. MacCauley considered this style of housing perfectly adequate for the Indians' needs and well suited to the south Florida climate. It offered sufficient protection from the hot sun, frequent rains, and high water. The sturdy roof was watertight and capable of withstanding strong winds, even of hurricane force.

The cooking chickee served as a gathering place for the family. Unlike the main chickee, it had only half a platform, in order to allow space on the ground for a cooking fire that was always burning. (Maintenance of the clan campfire held a religous significance, and it was always set with four large logs pointing to the four directions.) Sometimes the cooking

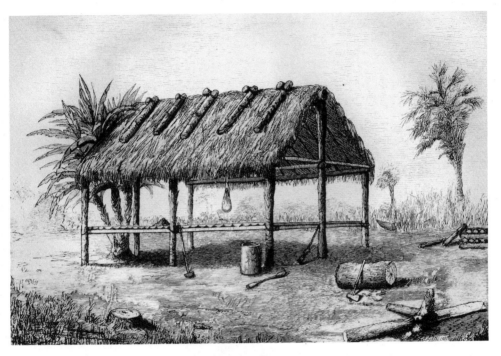

Fig. 11.2. Seminole dwelling, 1880. Drawing published in Clay MacCauley's 1887 report to the Bureau of Ethnology (MacCauley 1887). Photograph courtesy of the National Anthropological Archives, Smithsonian Institution. Neg. no. 1178-N-8-1.

chickee did not have a platform at all, and occasionally open-air fires were used as well. Cooking utensils and a bag of corn hung from the uprights of the building. MacCauley mentioned the essential household items of mortar and pestle, baskets for sifting corn, an iron kettle, and tools.

Some Seminole houses in the region were exceptional. The progressive "Key West Billy" built a two-story house for his wife and three children. This nuclear family arrangement was unique, as opposed to the traditional extended matrilineal family. The house, which was made of cypress boards, boasted doors, windows, partitions, floors, ceilings, and a balcony on the upper floor. MacCauley also mentioned five other Seminole houses that were enclosed; these probably included ones in Chipco's settlement mentioned by Pratt. They were covered with cypress planks, slabs, or logs.

MacCauley also visited two temporary camps farther south and found the lodging there much simpler and less comfortable than the Indians' permanent housing. One of the camps was located beside a sugarcane field and hidden by tangled vegetation. Once inside the camp, he found a large clearing with randomly scattered lodges housing some fifty Indians. Their shelter was provided by tents of white cotton cloth that was stretched over ridge poles and tied at the four corners. MacCauley also encountered a northern group from Cat Fish Lake who were encamped at a coontie grove near Horse Creek. He saw that their temporary lodges offered more protection from the elements than the cotton tents of the southern Seminoles. Some shelters were shaped like a walled tent but were covered with palmetto leaves, while others were like a single-roofed shed.

Twentieth-Century Camps

As we have seen, the isolated camps in the Everglades, Big Cypress, and elsewhere were well hidden from outsiders (figs. 11.3 and 11.4). The camps visited by Alanson Skinner in 1910 were all equally as remote. Skinner and his guide, Frank Brown, whose father had been an Indian trader for thirty years, visited the camp of a friend of Brown's, "Little Billy" Koniphadjo, also referred to as Billy Conapatchee. Skinner's party

came upon a well-marked trail among the cypress, about three feet wide and dug out to permit the passage of canoes. "After a short journey we saw the yellow glint of the palmetto-thatched lodges of an Indian village. As we drew near, the effect was charming. On a little 'hammock,' or meadow island, surrounded by dark cypress trees that stood in the glass clear water, were clustered eight or ten Seminole lodges. The palmetto fans with which they were thatched had faded from green to old gold in color and above them the sky formed a soft background" (Skinner 1913, 68–69). Skinner was so impressed by Seminole houses that he included in his report photographs of an exterior view of a house, the artistic patterning of the interior thatching, and a cookhouse.

In 1914 Henry Coppinger was the first to open the camp of an Indian family, who were living on property he owned on the Miami River, as a tourist attraction. Non-Indians were fascinated by the unique way the Florida Indians lived in open-sided chickees: soon other exhibition villages patterned after traditional matrilocal camps were set up as tourist attractions. These exhibition villages, which operated until about 1960, did retain a good many aspects of the traditional camps. Families who were matrilineally related often worked in the same village. Cousins would romp and play together, chattering to one another in Miccosukee. The chickees that were used for sleeping at night served during the day as the place where the women did their sewing and exhibited other crafts. Family meals continued to be prepared in a communal cooking chickee. The people were thus basically able to maintain a reasonably traditional lifestyle, even under the watchful eyes of tourists.

Deaconess Bedell, however, deplored the exhibition villages, far preferring to visit the people in their wilderness camps or at their own village enterprises along the Tamiami Trail. She shared an intimate look at village life in her letters:

There are usually three or more families in each village. When the daughter marries, a new cheekee or dwelling is built as they continue to live with the wife's parent [i.e., mother] for four months or more. Each family has a separate sleeping cheekee; there is the common eating platform; and the

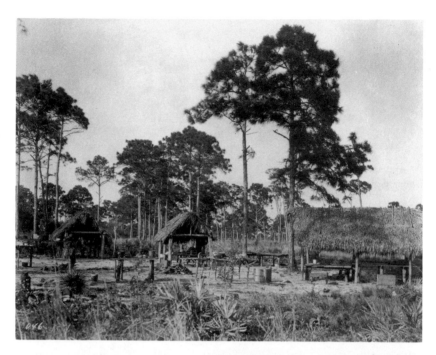

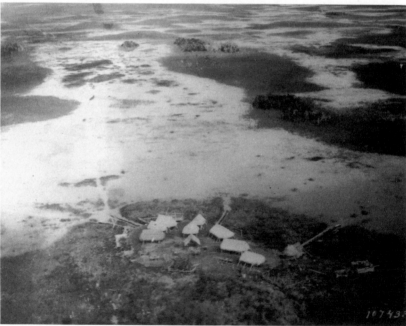

Fig. 11.3 (top). *Camp at Fort Lauderdale, Mikasuki Seminole,* ca. 1917. Photograph by Frank A. Robinson. Courtesy of the National Anthropological Archives, Smithsonian Institution. Neg. no. 45, 837-A.

Fig. 11.4 (bottom). Camp in the Everglades, taken from the Goodyear zeppelin, 1929. Photograph by Claude C. Matlack. Courtesy of the Historical Museum of Southern Florida. Neg. no. 189-30.

common cooking place is under a palmetto roof. The women remain at the fire for eating and the men gather on the platform around the food though now the families are beginning to eat together. . . . The beds are made by spreading pieces of canvas on the platform and using clothing or anything they may have to sleep on, but they are buying blankets and comforters for pallets more and more. (Bedell, n.d.)

Deaconess Bedell had great respect for chickee architecture, describing one chickee as a "real work of art—the regularity in putting on the palmetto fans resulting in a woven design on the inside. It sheds water and does not leak."

By the early 1960s, though, all but a few of the people had settled on reservation land, where the government hired the men to help construct modern cement-block houses with electric kitchens. The first government houses built, after World War II, were ill-conceived for the simple reason that the planners failed to take into account the traditional Florida Indian living arrangement, which is based on the extended matrilineal family. The floor plans were designed with small living, dining, and sleeping rooms such as would be found in a non-Indian dwelling and were not suitable for the needs of Indian families. Moreover, the houses had few windows and were not as cool as the open-sided chickees. Fortunately, later housing planners did remember to consider customary family arrangements and also included large banks of windows for ventilation.

The early exhibition villages were the models for similar tourist attractions that are still operated by both the Seminole and Miccosukee tribes. The men are hired to build the chickees and do any other necessary construction work in these villages. The Miccosukee tribe also maintains a camp in the Everglades that tourists can reach only by airboat. A few families along the Tamiami Trail continue to open their own camps to visitors and sell crafts made by the family in their small gift shops facing the busy highway.

A visit in the 1990s to the camp of Frances and Bill Osceola located along the Tamiami Trail in the Big Cypress preserve gives one the feeling of stumbling across life in a bygone era. Frances belongs to the Otter clan

and Bill to the Bird clan, so other Indians know the camp as an "Otter and Bird camp." Frances and Bill share the camp with their unmarried sons, their daughters, and their families. Tourists are lured inside the village by a sign that politely states, "Admission $1.00; any size person." Bromeliads gracefully drape the trees in this tranquil setting surrounded by pines, cypress, and palmettos. Frances talks with visitors in her open-sided sewing chickee as she works on her commercial electric sewing machine, watches television, and baby-sits her grandchildren. A profusion of colors—skirts, jackets, bolts of cloth, and giant spools of thread—vibrate in the room.

The Osceolas' living or sleeping chickees, which are walled for privacy, surround a large open square. Fragrant smoke from a slow-burning fire drifts lazily from the tidy cooking chickee in the center of the square. Various other open chickees positioned around the square serve as storage and work space for Bill, who is involved in many crafts projects. A giant wild boar and several alligators are penned in at the back of the property. Handmade items crafted by the family and their friends are sold in the store in front of the camp.

In 1992 the camp managed to withstand the wrath of Hurricane Andrew. Although the rest of the family went to stay with relatives on the reservation, Bill weathered the storm alone in the camp. As he later explained to me, "I've lived through hurricanes here all of my life. Why would I leave for this one?" Even though he saw trees bent almost to the ground, the chickees, except for minor damage, held up.

This pleasant way of life is vanishing because most of the people now live on reservations in modern housing and prefer the nuclear family arrangement. However, many of these families still build a separate chickee somewhere on the property for sewing or other purposes. Chickee builders also are kept busy in south Florida by jobs quite apart from those for their own people. There is now an active market of non-Indians who contract chickees to be built as decorative huts or for shelter from the sun near swimming pools and tennis courts on the grounds of homes, resorts, or businesses. By way of further testimony to the durability of chickees, Pete Osceola, who owns a chickee-building business, told me

that after Hurricane Andrew he received a phone call from a client in Miami. The caller said, "My house was blown away but the chickee you built for me is still standing, and we are living in it!"

Chickee builders can be seen scraping the bark off of poles in work huts along the Tamiami Trail and on the reservations. The dwindling supply of palmetto and cypress trees now endangers the business, though, just as the loss of indigenous materials threatens the demise of other crafts. Nonetheless, basic chickee construction has changed very little over the years. With the exception of the use of some stronger commercial materials and nails, chickees are essentially built in the same way described by Clay MacCauley in 1880. Even the palmetto fronds on the interior roof are as carefully placed as they were over a century ago.

Dugout Canoes

The men took the same pride in their canoes as we take in our automobiles. According to the earliest accounts written by European explorers, the original inhabitants of Florida told of large oceangoing canoes that could make crossings to Cuba, the Bahamas, and other distant locations. In the late eighteenth century, William Bartram commented on the large canoes he had seen on the Gulf Coast of Florida, saying that they were made of cypress and held as many as twenty or thirty warriors (Bartram 1955, 193).

Seminole and Miccosukee dugout canoes provided transportation through south Florida swamps, along rivers, and in bays. Somewhat more shallow canoes with pointed bows, which were propelled by poles, were used to glide through the Everglades on hunting and fishing expeditions. Entire families with their trade and household goods could be loaded into canoes for outings up the rivers. Sometimes a sail was added to take advantage of the prevailing southeast winds, especially on return trips from Miami to the Everglades (fig. 11.5). Travel in Biscayne Bay or the Gulf of Mexico between the mainland and islands nearby was more treacherous (Densmore 1972, 30–31). Both sails and oars were used in the bay. Some of the Indians may have acquired their sailing skills from

Fig. 11.5. Seminole woman in sailing canoe, 1920s. Photograph by Claude C. Matlack. Photograph courtesy of the Historical Museum of Southern Florida. Neg. no. 101-30.

the Spanish fishermen living near Charlotte Harbor (Neil 1956, 80). But even though Seminole sailors were considered quite skilled, solo trips in open water were thought to be risky.

Making a dugout canoe was both difficult and time-consuming. Only through experience could one learn how to treat and carve the wood so that it would not warp or split. In 1953 an elderly Seminole named Charlie Cypress, who was living in the Florida tourist attraction at Silver Springs, discussed the way he made a dugout canoe (Neil 1953). His canoes were carved of bald cypress, which was the preferred tree for canoe making throughout the Southeast because it grew very tall and had high branches. The straightest trees were always selected.

First, the shape of the canoe was roughed out with an ax, after which an ax and a hatchet were used to chop two hollows on either side of a stabilizing central block of wood on the inside of the canoe. This central block, which prevented warping, was cut out last. Numerous small holes were then cut in the bottom of the canoe to judge its thickness; these were patched when the canoe was completed. An adze was used to finish hollowing out the canoe and to shape the prow. Canoes were designed with a pointed prow and a shallow draft so that they could function even at low tides and slice though the thick saw grass of the Everglades. A hole was often cut in the prow for a docking line, and seats were sometimes added at prow and stern.

Great pride was also taken in decorating canoes, which were often painted in bright colors and covered with bold designs that identified the families that owned them (fig. 11.6). The outsides of canoes were generally ornamented with lines of color or diamond or sawtooth patterns, while stripes of alternating colors or designs following the line of the canoe were painted on the inside.

After the opening of the Tamiami Trail, the automobile—and, more recently, airboats—replaced the dugout canoe as the main mode of transportation. Nevertheless, the historical importance of the canoe in the Florida Indian way of life was emphasized in a moving moment during the induction of Sonny Billie as chairman of the Miccosukee Tribe in 1985. As Barbara Billie reported in the *Seminole Tribune:* "To honor Mr.

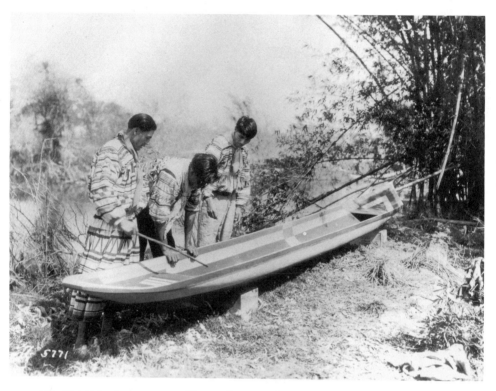

Fig. 11.6. Painted canoe,
Seminole, 1920s. Photograph
by Claude C. Matlack.

Photograph courtesy of the
Historical Museum of Southern
Florida. Neg. no. 169-30.

Billie . . . in a traditional ceremony of gift presentation and wishing, Seminole chief, James E. Billie, dressed in traditional dress of the long shirt, leggings, and turban, poled his dugout from deep in the Everglades to the Miccosukee Reservation where he arrived before hundreds of tribal members, employees, dignitaries, and honored guests" (B. Billie 1985).

Totem Poles

Although Seminole and Miccosukee people consider twentieth-century totem poles a recent introduction to the region, there is evidence of prehistoric precedents for carved wooden animal effigy figures in the Southeast. These include an eagle pole dating from somewhere between 500 and 800 A.D., which was excavated from Fish Eating Creek in 1926 ("Totem Pole from Florida," 1933). In 1895, Frank Hamilton Cushing led the excavation of a west coast site at a Calusa Indian town on Key Marco. He recovered, among other carved wooden objects, a small, graceful wooden figure with the body of a human and a feline head, which has been dated no later than the fifteenth century (Gilliland 1975, 116, 38). In 1955, a large owl totem was dragged from the muck of the St. Johns River near Deland, Florida. It appears to have been made prior to 1500 A.D. because nonmetal tools were used for carving it (Bullen 1955).

Late in the eighteenth century, a Creek precedent for totemic clan animal sculpture was observed by William Bartram, who commented that the pillars and walls of the houses on the square in the Creek town of Tuccabache were decorated with various "paintings and sculptures." Some of the paintings were of men with the head of an animal such as a "duck, turkey, bear, fox and wolf, buck &c, and again those kinds of creatures are represented having human heads." He also noted that the "pillars supporting the front or piazza of the council house are ingeniously formed in the likeness of vast speckled serpents ascending upwards; the Otassees being of the snake family or tribe" (Bartram 1955, 361). Other travelers observed wood carvings of birds, which designated an affiliation with the Bird clan, at the site of other camps along various rivers. A panther carved into the bark of a pine tree photographed near a Seminole

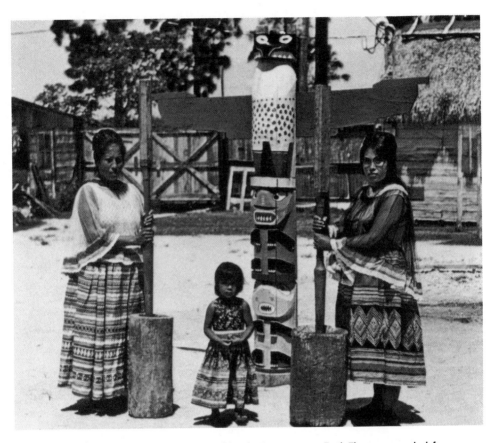

Fig. 11.7 (facing page). Bark carving of a panther, Seminole, 1908. Photograph by M. R. Harrington. Courtesy of the National Museum of the American Indian, Heye Foundation. Neg. no. 2940.

Fig. 11.8 (above). Women in front of totem pole, ca. 1970. These Miccosukee-speaking women are pounding corn in front of totem pole adorned with three figures, located in a village along the Tamiami Trail. The woman on the left wears a long skirt with many bands of design, while her companion's skirt is calf-length with one complex design. Both women wear net capes.

camp in 1908 suggests a modified continuation of this tradition (fig. 11.7). Even today, the Panther clan continues to be one of the largest Seminole and Miccosukee clans.

Brightly painted totem poles decorated Seminole exhibition villages in the twentieth century, but the people say the idea of setting up such poles came from outside sources: they were designed for "show" in tourist villages, presumably to give them an easily recognizable "Indian" flavor. Even so, well into the 1970s totem poles marked the entrances of some family camps that were open to tourists along the Tamiami Trail. One matrilineal camp where the women and their children belonged to the Bird clan had a pole topped by a bird, with a panther and then an otter below it (fig. 11.8). This identified the village as a Bird clan camp that had members of the Panther and Otter clans—namely, the husbands of the women—living there as well. At that time, because of a fear that outsiders would misunderstand the tradition, clans were not as openly discussed as they are now. The owners of the village were thus reluctant to attribute any significance to the images on the pole.

While some of the poles were quite attractive, others were poorly carved and painted, depending on the skill and taste of the carver. Today, though, there is little interest in carving large totem poles, and the elements have taken their toll on the few still standing. Occasionally collectors will commission a carver living on the Hollywood Reservation to make a large totem pole. But miniature totem poles are still carved and sold as souvenirs.

Ritual Rattles

Men carve ritual rattles and other items used in dances and activities at ceremonial events, including the long-handled wooden racquets with hide webbing that are used in the ball games played during Green Corn Dance ceremonies (fig. 11.9). The hypnotic sound of the rattle shaken by the dance leader is usually the only musical accompaniment to the human voice during the dances, although a water drum is used as well during the Buffalo Dance (Sturtevant 1954, 59). Ritual rattles and other ceremonial

objects are made of natural materials such as coconut or turtle shell and are themselves undecorated. But rattles are supported by hand-carved handles, to which a hide wrist strap is attached (fig. 11.10).

The only opportunity for non-Indians to experience Seminole dances and hear their musical instruments being played occurs at the Seminole Tribal Fair or other such events that are open to the public. A stomp dance team of men and women goes through the motions of a meandering "social dance" that has no ritual significance. The steady beat of a hand rattle is joined by the rhythmic effect produced by the women's leg rattles, the repetitive but stirring sound establishing both the balanced mood and pace of the dance. The overall effect is quite impressive in spite of the confusion and noise of the crowd.

The male dance leader most commonly uses a coconut shell rattle. To make such a rattle, a hole is first drilled in the shell at the end opposite the eye and the coconut milk drained. The hole is then enlarged to about half an inch in diameter so that the meat can be scraped out, and the outside of the shell is scraped and polished with a piece of broken glass. The shell now prepared, regular rows of small holes are drilled in it to provide sound amplification; some thirty or more canna seeds or beads are placed inside the coconut to give the rattle its voice. Another hole is then made in the eye of the shell. A stick approximately twelve inches long, which has been tapered at the upper end to fit through the two bigger holes, is inserted. It projects out of the top and the bottom to serve as a handle, which is firmly attached to the rattle with hide. Around the base of the handle a hide thong is tied, which can be wrapped around a man's wrist. Only one hand rattle is used: it is shaken or hit against the other hand.

Turtle shells are used to make the rattles the women wrap around their legs, and sometimes to make the hand-held rattles. (see fig. 12.1). The head, tail, legs, and as much meat as possible are removed from turtles used to make rattles. The shells are set out in the sun to dry, and ants complete the job of removing the meat. Once dry, the shells are cleaned and holes drilled in several places in the top, again to amplify the sound produced by the seeds that are placed in the shell. The underside of the

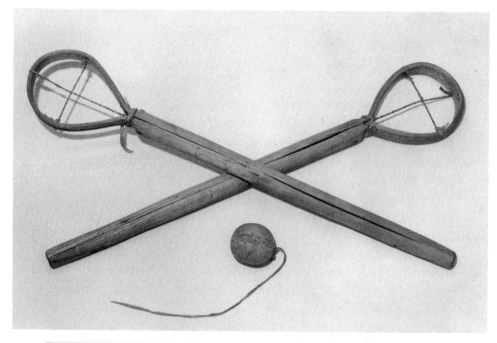

Fig. 11.9 (top). Racquets and ball used in ball games, Seminole, twentieth century. Wood, leather, and moss. Photo courtesy of the Florida Museum of Natural History, Gainesville. Acc. nos. E1001 (racquets) and E990 (ball).

Fig. 11.10 (bottom). Coconut-shell rattle, Seminole, twentieth century. Coconut shell, wood, and leather. Courtesy of the Crane Collection, Denver Museum of Natural History. Acc. no. 8227.

shell is then bent in to close the rattle. A wooden handle is inserted to produce a hand-held rattle; for leg rattles, the turtle shells are laced to a piece of soft leather, hide thongs serving as ties. Turtles are, however, becoming more difficult to find, with the result that turtle-shell rattles are growing less common.

Occasionally feathers or a few beads might be added to hand rattles that are made for sale. For example, some men who have admired the musical instruments of other Native American dance groups now make coconut or turtle-shell rattles with carved, painted, or beaded decoration. Eugene Bert produces exceptionally handsome turtle-shell rattles with carved handles resembling eagles and decorations fashioned out of hide and feathers, which he sells at festivals. Although decorated rattles are out of character with Seminole and Miccosukee tradition, they are popular with collectors.

Household Items and Souvenirs

The most important carved household items were the mortar and pestle used for grinding corn. To make the mortar, a log was cut to approximately knee height and a hole carved in the top of it to hold the corn. A heavy pole, carved smooth in the middle for easier handling, formed the pestle for pounding the corn. Often two women, each armed with a pestle, would alternately pound the corn.

A big wooden spoon with a crook in the handle was used for stirring the ever-present kettle of sofke (fig. 11.11). In 1830 George McCall remarked that it "is a pleasing sight to see four or six stalwart warriors sitting round a large kettle of hot saufke, with but one large wooden spoon between them. The chief, if he be of the party, or the oldest man,— for great deference is paid to both rank and age, takes the spoon, and with a modest and at the same time studied and graceful motion of the arm bends forward and takes a spoonful of this favorite viand, then having disposed of, he then, with the most respectful air, hands the spoon to his neighbor on the left. Thus it goes round till the kettle is emptied. During

the meal, the conversation is cheerful and unwearied" (McCall 1974, 221–22).

Another important carved item was the bow and arrow. In 1879 Lieutenant Pratt reported on one man's demonstration of his archery skills, which the lieutenant had witnessed while visiting an Indian village. In Pratt's description, the "bow was nearly six feet and the arrow nearly four feet in length, and without feathers, but having a pointed cone shaped cap of iron at the butt [i.e., distal] end. He asked what to shoot at, and a large pine tree was indicated, farther than I supposed he could send the arrow. He shot and struck the tree. The trajectory was equal to the height of the tree, and the arrow struck about as high as a man's head. I stepped the distance and found it quite one hundred and ninety yards. I removed the arrow with difficulty" (in Sturtevant 1956, ed., 9).

Although hand-carved bows and arrows had by that time been replaced by the rifle as the necessary weapon of choice for war, archery skills clearly had not been lost. In fact, bows and arrows were sometimes used for hunting even during the wars when the loud noise of a rifle would attract the enemy's attention. Indian boys have always played with bows and arrows (fig. 11.12): they practiced shooting at small animals or fish so that they would become good hunters as they grew older.

Today, toy bows and arrows have become popular tourist souvenirs for non-Indian boys as well. Like other Indian groups, Seminoles and Miccosukees were quick to recognize that tourists were attracted to miniature carved wooden items, with the result that hand-carved souvenirs became an important market item early in the twentieth century. The first miniature toy canoes, carved of cypress, were sold in 1918. "Tom-toms" were introduced at Musa Isle in the 1930s by an Indian employee from Arizona (West 1981, 208). He also taught the Indians how to paint Indian chiefs wearing war bonnets and designs typical of southwestern tribes on the drums, to give the souvenirs an "Indian look."

Not surprisingly, the enterprising Deaconess Bedell also encouraged the men to carve objects to sell to tourists. She reported to Bishop Wing in 1941 that the "men and boys are showing much talent in woodcarving—busts, statuettes, bag handles, book-ends, plaques, bowls, wooden

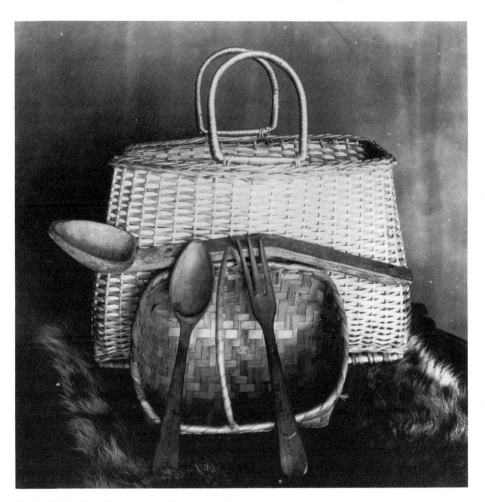

Fig. 11.11. Wooden sofke spoon, salad servers, and souvenir baskets, Seminole, 1920s. Photograph by Claude C. Matlack. Courtesy of the Historical Museum of Southern Florida. Neg. no. 157-30.

Fig. 11.12. Seminole boys shooting bows and arrows, 1920s. Photograph courtesy of the Historical Museum of Southern Florida. Neg. no. 75-66-9.

Fig. 11.13. Wooden bowls, Seminole, ca. 1940. Note incised diamond designs. Photograph courtesy of the National Museum of the American Indian, Heye Foundation. Acc. no. 20-3631; neg. no. 2862 C.

plates, forks and spoons, miniature canoes, etc." (Bedell 1943). Attractive diamond designs were incised on both large and small wood bowls (fig. 11.13). Some articles were carved with an ordinary pocket knife, while for others the men used a special kind of knife with a curved blade that they had made themselves.

In the 1990s Buffalo Tiger and Howard Osceola continue making the craft items they learned to make as children at Musa Isle. They produce large quantities of small drums and rattles, as well as toy knives, spears, and bows and arrows for sale to tourists. These souvenirs are often decorated with bright paint, natural or colored feathers, and beads—to appeal to the tourist conception of what looks "Indian." Buffalo Tiger, who signs his work, continues painstakingly to decorate the drums and other items he makes with the war-bonneted Indian chiefs and southwestern motifs that he learned to paint as a boy. Howard Osceola makes large numbers of drums and rattles that are sold to tourists as inexpensive souvenirs. He uses plastic plumbing pipe, which he cuts into short lengths and spray paints in bright colors. Cow hide is stretched over the openings and, for a rattle, a carved wood handle is added. But Osceola also makes large drums by special order for other Indians or collectors, using hollowed-out cypress logs for the body and hide for the drumhead. Deer hide is preferred, but since it is not always available cow hide is often used as a substitute.

Carving or whittling has, however, remained a folk art or craft for the Seminoles and Miccosukees, rather than becoming a serious sculptural art form. Some men simply take pleasure in carving small animal, bird, and alligator figures or totem poles. The more competent carvers win prizes at tribal competitions and sell their work in gift shops. Occasionally, large-scale works—such as totem poles or canoes—are commissioned by collectors, but otherwise such work is rarely done. Rather, most of the carvers make a living from the bulk sale of inexpensive toys. With the decrease of natural materials for making chickees and little interest in making large totem poles and canoes or finer sculpture, it appears that Seminole and Miccosukee woodwork is becoming another lost art.

C
H
A
P
T
E
R

12

The continuity of the Seminole and Miccosukee culture is affirmed by the fact that the finest artwork of all is reserved for the Green Corn Dance. The ongoing, though modified, ceremonials are an annual reminder to the people of their ties with Breathmaker. It is a time of renewal celebrated by the wearing of beautiful new clothes, just as Christians put on new outfits at Eastertime.

Green Corn Dance ceremonials are conducted at three locations in south Florida. They take place in the heat of late May or June, on dates determined by the medicine men. This usually is the rainy season and is also a time when mosquitoes start their annual attack. Non-Indians are rarely invited to attend the Green Corn Dance, and what we know about the activities primarily comes from the studies of several researchers (MacCauley 1887, Capron 1953, and Sturtevant 1954 and 1970).

Many different ritual and social dances are performed over the four-day period, although the events of the fourth and final day are considered the most important. These include a meeting of the tribal court council, the lighting of the medicine fire, the presentation of the new corn, storytelling, and dances that continue through the night (Capron 1953, 188–205). The activities begin at dawn when the medicine man and his assistant bring out the sacred medicine bundle in its soft hide covering and open each individually wrapped package inside. The tribal court council convenes at noon. After court deliberations are completed, men and women gather for a ball game. The dance ground is prepared by assistants to the medicine man. At dusk the medicine man starts the sacred fire on the clean sand in the center of the dance circle. Four ears of corn are placed by the logs that point in the four cardinal directions. Dancing begins, and the air fills

with the haunting sound of turtle-shell leg rattles. Men, women, and children wear their finest new clothes for the all-night dances.

J. R. Motte, an army surgeon, romantically described the magic of the moment at a dance he witnessed during the Second Seminole War in 1838. "The scene presented to our eyes appeared that of some dark enchantment. Near the middle of their camp, in the center of a cleared circle some fifteen feet in diameter, was blazing a large fire, whose flame threw its fitful gleam on the dark trees and glaring visages of the younger savages, who, dressed in all the . . . paraphernalia, flitted to and fro before the blaze; their gaudy dress and animated figures . . . forming a lively contrast to the more sober garb of the elderly ladies and gentlemen" (Motte 1953, 214–16).

Wearing new clothes is an important aspect of renewal in these rituals. Like a snake shedding its skin, men, women, and children put aside old clothes; their beautiful new outfits are the primary form of artistic expression. All other ritual paraphernalia used for this ceremonial are without decoration. Unadorned, natural materials are used, such as the egret feathers carried as dance wands in the Feather Dance.

Men use hand rattles made of turtle shells or coconuts, but the most dramatic sound is that of the heavy turtle-shell leg rattles worn by the women (fig. 12.1). Leg rattles are sometimes made out of condensed-milk cans, which produce a sound both lighter and louder than the traditional turtle-shell rattles described in the preceding chapter. A nail is used to puncture many holes in the sides, top, and bottom of a clean, empty can, and canna seeds or BBs are poured in. (Riverbed pebbles were used in northern Florida, but they are not available in south Florida.) Rows of cans are then tied to strips of leather with hide laces.

To provide padding, the women wrap soft towels around their lower legs. They then tie the rattles onto the inside of their legs with hide laces. Dancers wear many bulky rattles that make walking and dancing difficult, and the long and heavy patchwork skirt worn over the rattles adds to the weight: these ritual objects are made to be heard and not seen. Some dancers are in their fifties and sixties, and it takes tremendous energy and skill to participate in the series of dances.

Fig. 12.1. Turtle-shell leg
rattles, Seminole, twentieth
century. Photograph courtesy
of the National Museum of the
American Indian, Heye
Foundation. Acc. no. 1/8239;
Neg. no. 29144.

Seminole and Miccosukee creativity is best exemplified in the clothing worn for the Green Corn Dance. Dress designers often adapt or copy older styles to renew their ties with the past. But they also create new trends, thereby confirming their commitment to the present and strengthening their dedication to preservation of their culture for the future. Today, the busy Corn Dance schedule requires many new outfits for each family member: individuals tend to change their clothes several times a day in order always to look their best. Each day of the ceremonials can require two daytime outfits and an evening dance outfit.

Sewing the many family outfits for the Corn Dance begins at least six weeks before the festival, by early May at the latest. Women vanish from tribal offices to devote themselves to their sewing machines: it is accepted that little besides sewing will get done before the Green Corn Dance. During the ceremonies, the family camps along Tamiami Trail are vacant, and "Closed" signs hang in the windows of souvenir stores. Although not every family can afford the expense of many outfits, those who can try to outdo one another. This is a time for eligible young men and women to impress each other. Girls and women compete against boys and men in energetic ball games—and many a skirt or jacket made of expensive materials worth several hundred dollars has been ruined in the mud after summer rains. Not surprisingly, following a particularly wet Green Corn Dance, considerable sums of money are spent at dry cleaners in Miami to clean fancy fabrics that cannot be washed.

Frances Osceola and her daughters Debbie Osceola and Tina Osceola Clay showed me the beautiful outfits they made for their families to wear at the 1991 Green Corn Dance, of which they are justifiably proud. The family continues the tradition of living in a matrilineal camp and operates a tourist village and store along the Tamiami Trail. They also sell their work in booths at art festivals and take orders for custom outfits they make for other families. At the turn of the century, the Osceolas' ancestors would travel by canoe to downtown Miami to shop for fabrics. By the 1930s they were driving Model A Fords, and now Frances and her daughters have taken a trip downtown on the speedy Metrorail to purchase supplies.

Seminole and Miccosukee women discovered the great variety of expensive fabrics now found in the many Latin, primarily Cuban, fabric shops in malls or in downtown Miami, which in many way resembles the capital city of any Latin American country. The Latino population is highly fashion conscious, and their fabric stores are stacked with imported lamés, rich satins, brocades, and flashy prints. Also available are sheer fabrics with metallic threads and laces, which the Indian women can use to make capes that are more dramatic than ever before. Cotton fabric in solid colors continues to be used to make the patchwork designs, but owing to the almost dizzying array of choices there is now more emphasis on the selection and coordination of colors and fabrics.

There are no rules or traditions that must be followed for the selection of outfits worn for various Green Corn Dance events: it is primarily a matter of personal choice. We have seen in this study how dress styles have evolved over time. In the past, the people would all have been similarly dressed for Green Corn Dance activities in the styles of that particular period. Today, the situation is very different. People have seen portraits or archival photographs of the old styles of clothing and have either copied these styles or adapted them to contemporary taste—a trend that has also been encouraged by dress competitions at tribal fairs. Or they may wear completely new styles, with the result that an exciting variety in Green Corn Dance dress now exists.

Some women like to wear at least one outfit that has been adapted from late-nineteenth-century styles (plate 17), although there is no special time during the festival at which such clothing should be worn. The outfit might consist of a long skirt and a blouse with a shoulder ruffle made of one or more printed fabrics with a row of appliqué. As MacCauley pointed out, the nineteenth-century blouse was notoriously short; the modern version is longer and tucks into the waistband, and instead of appliqué a row of patchwork is used on the skirt. Girls also wear the older style of calico dress, a one-piece version with skirt and top attached. Debbie Osceola specializes in creating modern interpretations of older styles for women and girls.

Long skirts of metallic fabrics that glisten in the firelight are worn with

glamorous capes decorated with laces and expensive trim for the dances on the final evening, when everyone tries to look their best. Metallic fabrics have a tendency to catch on rough surfaces, so one wearing can be hard on an expensive skirt. Even so, girls are lavished with beautiful wardrobes made by adoring mothers and grandmothers (plate 18). Older girls wear long skirts, blouses, and capes like their mothers, while younger girls' outfits are sometimes made in one piece for ease of dressing. The long patchwork skirt is joined to a solid-colored top that is tied in the back, over which a cape is worn.

Many women still prefer long skirts with numerous rows of the older traditional patchwork designs for Corn Dance wear (see plate 14). Some of these skirts are heirlooms, which are brought out only at this special time. As Delores Billie told me in 1991, she buys older skirts in this style from her mother, Lois Tiger Billie, which have sentimental value to her because they were made and worn by her mother. Younger women, though, prefer to wear calf-length skirts with a wide row of patchwork for daytime events (see plate 13). A Green Corn Dance wardrobe would include several of these skirts decorated with designs sometimes bought from a favorite patchwork maker. They are worn with a plain blouse or a blouse decorated with matching patchwork. Depending on the occasion, high heels, flat shoes, or socks and sneakers are worn with calf-length skirts.

Most men and boys wear trousers or jeans with a nice jacket that might sometimes have a zipper and lining. A 1988 innovation was the "James Billie sport shirt," so named for the chairman of the Seminole Tribe who was the first to wear one. It is made like a jacket but has short sleeves. Shirts trimmed with ribbons, a style copied from other Indian groups, and short-sleeved sport shirts in bright prints with complementary-colored patchwork are also worn for comfort and coolness. The Miccosukee medi-cine man Pete Osceola told me in 1990 that he prefers a 1930s-style big shirt with many small rows of patchwork that his wife Mary Tiger Osceola made him expressly for the Green Corn Dance. He has collected an exten-sive wardrobe of outfits, including wide, loom-beaded sashes with long yarn tassels.

Some of the men and boys wear doctor's coats: these are chosen primarily for their traditional styling and thus do not necessarily designate that their wearer has any particular role in the Green Corn Dance. Most men and boys wear turbans during Corn Dance. A few men, such as Chairman James Billie, like to wear complete outfits copied after nineteenth-century styles, replete with a banded turban with feathers, arm bands, a doctor's coat, beaded straps, and hide leggings. Outfits like these can be seen in Seminole clothing competitions (plate 19). For James Billie's outfit, a set of crescent gorgets and a silver belt buckle were made by the craftsman Bill Osceola.

It is fitting that James Billie and other men, as well as many women, revert to traditional dress on such ceremonial occasions. Throughout their long history, distinctive clothing styles have identified the Seminoles and Miccosukees. As we have seen, the women have taken pride in the elaborate and painstakingly crafted clothing they have created for their leaders even during times of hardship. Despite the changes brought by the twentieth century, the concern with both preserving and enhancing their traditional styles of dress continues to identify the men, women, and children who are proud to say they are Seminole and Miccosukee Indians of Florida.

Although European contact had a somewhat different impact on the artistic traditions of each Native American group, the results were for the most part devastating. Despite this, a concern with the preservation of ongoing artistic traditions and the ability and desire to create remain characteristic of the Indian people. The most isolated tribes, who were relatively immune to European products and ways, have best been able to keep their indigenous traditions alive. The Seminoles and Miccosukees, however, were less fortunate: they underwent many hardships during the nineteenth century. But even so, new artistic skills evolved in the face of acculturation. Likewise, in the twentieth century, as the dominant society has intruded yet further into their customary way of life, they have gone on to create a fresh art form—patchwork.

Seminole and Miccosukee elders tell stories about the long migrations undertaken by their ancestors that reveal the basically seminomadic nature of their people. As we have noted, nomadic people in other cultures, such as various African tribes, have tended to find their primary forms of artistic expression in personal adornment and body decoration, and much the same has proved true of Native American groups. Among the Seminoles and Miccosukees, their inherited appreciation of colorful costume survived the many cataclysmic changes of the eighteenth and nineteenth centuries, even as the people developed new modes of expression inspired by the enticing foreign materials and techniques introduced by the Europeans. Their close contact with African slaves, which led to the sharing of skills and artistic traditions, almost certainly provided another impetus toward change, although the full extent of these influences has yet to be determined.

The reports of William Bartram and Clay MacCauley have been crucial to this study because their work documented the people at critical stages of their history. For his part, Bartram has left us a detailed description of the lifestyles and creative efforts of both the Creeks and the emerging Seminoles in the late eighteenth century. MacCauley's thorough investigation of the Seminoles in 1890 confirmed that, after a long period of isolation, most of their traditional design elements, arts, and crafts had been lost. Their artistic renascence in the twentieth century, as evidenced by the creation of a new art form and a new design iconography, is thus all the more impressive.

Role definition for men and women is another important factor that has been evaluated. Men's and women's roles once were clearly defined. Men were the hunters, providers, and warriors. They held positions of leadership in dealing with Europeans and then the Americans who sought their land and planned the removal of their people. Women not only cared for the family but also continued artistic endeavors in spite of the chaos of the wars of the nineteenth century. Old crafts were abandoned, but the women innovated art forms of their own using new materials and skills introduced by Europeans and others. The imagination and creative ability of the women cannot be underestimated even though these art forms resulted from acculturation.

Art can serve a community on many levels during a time of crisis. It can function as a unifying device by identifying a group of people and reflecting their dignity under duress. For example, the distinctive outfits that the women fashioned for chiefs during the wars not only identified these men as Seminole leaders but duly impressed their enemies. In addition, Seminole women found artistic fulfillment, emotional release, and distraction from problems during a period of chaos. They were able to keep their minds and hands busy by creating outfits for their men at a time when there was little else they could do to contribute to the war effort. Far from collapsing in the face of adversity, their creativity could not be conquered.

The women's most noteworthy achievements are visible in the bead designs they embroidered on shoulder bags, and later in patchwork de-

signs. Traces of traditional iconography mentioned in written accounts and preserved in visual images reveal that some of these designs have provided artisitic continuity while others were clearly innovative departures from tradition. The designs that proved most durable were used initially for body decoration but then transferred to bead embroidery, while many of the patchwork designs integrate both old and new elements of the people's environment. As a textile art, patchwork relies on the artist's skills at the creation and execution of designs as well as an innate feeling for color and fabric. These are no small accomplishments—as the explosion of colors and unlimited new designs found in the brilliant and distinctive patchwork clothing of this century readily demonstrate.

In understanding the art of the Seminoles and Miccosukees, however, we must not fail to take economics into consideration as well. Until the arrival of the Europeans, the Indians of the Southeast knew of no ownership of land and had few wants that were not provided for by their natural environment. They found the materials they used for artistic expression, in the form of fibers, feathers, fur, hide, and natural dyes. Granted, Southeastern Indians had also developed an affection for exotic goods such as shells and metals that had to be traded from great distances. But when the Europeans introduced commercially manufactured cloth and shiny glass beads, these rapidly became the necessary materials for new arts, while hides became the medium of exchange. The economy of these Indians was changed forever. The people moved from a hunting-gathering and small-garden economy to one of barter and trade, and ultimately to an economy based on currency. As they became more acquisitive and turned increasingly to hunting to supply the hides they needed to generate income, their once bountiful supply of game dwindled, forcing them to find new ways to acquire the objects they desired. In the twentieth century, arts and crafts have been a principal factor in their economic survival.

As we have seen, many Seminole and Miccosukee families of today derive their income primarily from the sale of baskets, dolls, beadwork, and wooden toys, largely to tourists. At the same time, the best artisans continue to create innovative designs, whether in patchwork or in basketry, and their work often commands high prices from collectors. Jennie

O. Billie, a Miccosukee schoolteacher, explained to me that she advises girls to learn to sew and do other crafts: "I tell them if they know those skills, they can always survive. Even if they have no education, they always have the crafts to fall back on."

But the economic importance of the arts and crafts may be waning. For example, an exhibition village and arts and crafts center were operated by the tribe living on the Hollywood Reservation but met with only limited success—although plans have been drawn up for a major museum and culture center on the Big Cypress Reservation. Perhaps more to the point, though, over the years the Seminole Tribe has established many other businesses, including cattle, catfish, and citrus industries. "Smoke Shops," where tax-free cigarettes are sold by tribal members, now flourish on the reservations—but it is bingo that has become the big financial winner for the Seminole Tribe. There are large bingo halls on the Hollywood, Big Cypress, and Tampa Reservations, in addition to which the tribe owns a Sheraton hotel on the Tampa Reservation that can accommodate both tour groups and conventions. Gambling casinos have also been considered, but the venture must first win government approval.

Until recently, however, tourism has remained the mainstay of the Miccosukee Tribe, primarily because of their scenic location on the fringe of the Everglades and their concern for arts and the environment. During his administration, which lasted for over twenty years (from 1962 to 1984), Chairman Tiger proved to be an effective and dedicated leader. Not only did he fight for the retention of tribal land and for housing, public safety, and firefighting equipment, but he was acutely sensitive to environmental issues. Thus he was actively involved in negotiations for the preservation of vast tracts of wilderness for recreation, hunting, and fishing. The tribe also built beautiful schools providing quality education, as well as offering health and other services to the people living on the reservation—which is located over forty miles from facilities in Miami.

The tribal restaurant, exhibition village, and museum are frequented by tour buses from Miami. The tribe also retains its oil rights on certain lands and has built a large service-station plaza near its reservation, on Alligator Alley. Under the leadership of Chairman Billy Cypress, the Mic-

cosukees have also entered the bingo business. In 1990 the tribe entered into a partnership with investors and built a four-million-dollar bingo hall on tribal land at the junction of the Tamiami Trail and Krome Avenue. By 1993, however, problems developed, with the result that the tribe terminated their partnership with the investors and simply began operating their own bingo business.

When Buffalo Tiger addressed the annual conference of the Florida Library Association in 1992, he was asked his reaction to some of the economic ventures the tribe is now engaged in, such as oil drilling on tribal land and bingo, with the future possibilty of casinos. His response was eloquent and impassioned. Although he now earns a large part of his personal income from making and selling crafts, he said that the Indians cannot be expected to continue living just on the money made from selling trinkets. If they are to survive, they have to be able to compete economically in this world on an equal footing with everyone else, which means they must be free to explore new sources of profit. He acknowledged that many of the Indians dislike having to do so, because it is not the Indian way, but that is the position in which they now find themselves.

They also fear that their people are on the verge of losing touch with their cultural heritage—their religion, language, and arts. They thus recognize an urgent need for expanded cultural programs for Seminole and Miccosukee children. Many of the people are now expressing a desire to trace their ancestry and amass whatever information is available about their family history. There is also a growing interest in oral history—writing or preserving on audiotape or videotape reminiscences, stories, folklore, or anything else pertaining to the culture's past before the elders are gone and with them the last living link to tribal history. Consequently, more people are now willing to share or exchange knowledge with serious scholars—an atmosphere that provides the opportunity for a real breakthrough in the understanding of these people and their art.

Art reflects the society in which it was created. Pressured by the complexity of an encroaching modern world, patchwork designs, like Seminole and Miccosukee society, have become more fragmented and complex—an effect visible in the twentieth-century art of non-Indians as well.

As we explore the artistic accomplishments of the people we know as
Seminoles and Miccosukees and the effects of cultural turmoil on their
creativity, we must inevitably come to wonder whether they will ulti-
mately be able to retain their ethnic identity and beliefs. Only time will tell.
The Indians must deal with the same social, educational, and economic
problems as non-Indian groups. They too must cope with alcohol and
drug abuse and with all the other ills currently besetting American society
at large. Television has had a major impact on the values of Indian chil-
dren, for it thrusts into the immediacy of the family chickee the realities
of a very different world—one in which they must again learn to adapt
if their culture is to survive. We can only hope that the courage and
creativity the Seminole and Miccosukee people have manifested in the
past will continue to serve them, enabling them to find ways to deal
with the uncertainties of the future without entirely losing their sense of
connection to the past.

Conversations and Interviews

Billie, Delores. 1989. Interviewed for *Patterns of Power.* Video documentary. Miami: WLRN-TV/Dade County Public Schools, 1990.

———. 1991. Personal conversations with author, Miccosukee Reservation.

Billie, Jennie Osceola. 1989. Interviewed for *Patterns of Power.* Video documentary. Miami: WLRN-TV/Dade County Public Schools, 1990.

Clay, Tina Osceola. 1989. Interviewed for *Patterns of Power.* Video documentary. Miami: WLRN-TV/Dade County Public Schools, 1990.

Coppinger, Francis "Sonny." 1981. Interview with author, Miami.

Cypress, Carol. 1989. Interviewed for *Patterns of Power.* Video documentary. Miami: WLRN-TV/Dade County Public Schools,1990.

Jim, Annie. 1984. Personal conversations with author, Miccosukee Reservation.

Johns, Mary Frances. 1990. Personal conversations with author, Brighton Reservation.

Miller, Polly G. 1993. Telephone interview with author, July 14.

Osceola, Bill. 1988–93. Personal conversations with author, Tamiami Trail.

Osceola, Debbie. 1988–93. Personal conversations with author, Tamiami Trail.

Osceola, Effie. 1989. Interviewed for *Patterns of Power.* Video documentary. Miami: WLRN-TV/Dade County Public Schools, 1990.

Osceola, Frances. 1989. Interviewed for *Patterns of Power.* Video documentary. Miami: WLRN-TV/Dade County Public Schools, 1990.

Osceola, Howard. 1975–93. Personal conversations with author, Tamiami Trail.

Osceola, Pete. 1990–93. Personal conversations with author, Tamiami Trail.

Poole, Virginia. 1989. Interviewed for *Patterns of Power.* Video documentary. Miami: WLRN-TV/Dade County Public Schools, 1990.

Tiger, William Buffalo. 1975–94. Personal conversations with author, Miami and Tamiami Trail.

274 **Books, Articles, and Papers**

Adair, James. 1930 [1775]. *History of the American Indians.* Ed. Samuel Cole Williams. Reprint, New York: Promontory Press.

Alexander, John. 1839. Unpublished diary. Transcribed by Linda Wickert, 1978. Seaver Center for Western History, Natural History Museum of Los Angeles County.

American Antislavery Almanac. 1839. New York: Webster and Southard.

Barbeau, Marius. 1976. *Assomption Sash.* Department of Mines and Resources, National Museum of Canada, Anthropological ser. 24, Bulletin no. 93 (facsimile of 1937 edition). Ottawa: National Museums of Canada.

Bartram, William. 1955 [1791]. *Travels of William Bartram.* Ed. Mark Van Doren. Reprint, New York: Dover Publications.

Bearss, Edwin C. 1968. *Osceola at Fort Moultrie, Sullivan's Island, South Carolina, Fort Sumter National Monument.* Washington, D.C.: Division of History, Office of Archaeology and Historic Preservation, National Park Service.

Bedell, Harriet M. 1933–1943. Bedell Papers. Historical Museum of Southern Florida, Miami, Florida.

Belland, Merri, and Doris Dyen. 1982a. *It's Our Way: Seminole Designs.* White Springs, Fla.: Bureau of Florida Folklife Programs, Florida Department of State.

———. 1982b. *Palmetto and Sweetgrass: Seminole Basketry Traditions.* White Springs, Fla.: Bureau of Florida Folklife Programs, Florida Department of State.

Billie, Barbara. 1985. "Miccosukee Swearing in Ceremony Held." *Seminole Tribune* [Hollywood, Fla.]. December 14.

"Billy Bowlegs in New Orleans." 1858. *Harper's Weekly.* June 12.

Blackard, David M. 1990. *Patchwork and Palmettos.* Ft. Lauderdale: Historical Museum.

Britt, Albert S., and Lilla M. Hawes, eds. 1976. "The Mackenzie Papers." Reprint of selected papers from vol. 18 of *Collections of the Georgia Historical Society.* Savannah: The Society.

Brown, James A., and David W. Penney. 1985. "The Mississippian Period." In *Ancient Art of the American Woodland Indians,* ed. David S. Brose. New York: Harry N. Abrams.

Bullen, Ripley. 1950. "An Archaeological Survey of the Chattahoochee River Valley in Florida." *Journal of the Washington Academy of Sciences* 40: 101–25.

———. 1955. "Carved Totem, Deland, Florida." *Florida Anthropologist* 8: 61–73.

Burnham, Dorothy K. 1981. *The Comfortable Arts: Traditional Spinning and Weaving in Canada.* Ottawa: National Museums of Canada.

Campbell, Richard. 1975. *Historical Sketches of Colonial Florida*. Gainesville: University Presses of Florida.

Canova, Andrew P. 1906. *Life and Adventure in South Florida*. Reprint, Tampa: Tampa Tribune Printing Company.

Capron, Louis. 1953. "The Medicine Bundles of the Florida Seminole and the Green Corn Dance." *Bureau of American Ethnology Bulletin* 151: 155–210. Washington, D.C.: Government Printing Office.

Carr, Robert S. 1981. "The Brickell Store and Seminole Indian Trade." *Florida Anthropologist* 34: 180–99.

———. 1989. "Archaeological Excavations at the Stranahan House (8Bd259), Fort Lauderdale, Florida." *Florida Anthropologist* 42: 17–33.

Catlin, George. 1973 [1844]. *Letters and Notes on the Manners, Customs, and Conditions of the North American Indians*. 2 vols. Reprint, New York: Dover Publications.

Cline, Howard F. 1974. *Florida Indians*. 2 vols. New York: Garland Publishing.

Coe, Ralph T. 1976. *Sacred Circles*. London: Arts Council of Great Britain.

———. 1986. *Lost and Found Traditions: Native American Art, 1965–85*. Seattle: University of Washington Press.

Collections of the Georgia Historical Society. Vol. 3. 1873. Savannah: Morning News Office.

"Commission to View Seminole Villages." 1930. *Miami Herald*. November 11.

Conn, Richard. 1979. *Native American Art in the Denver Art Museum*. Seattle: University of Washington Press.

Cory, Charles B. 1896. *Hunting and Fishing in Florida*. 2d ed. Boston: Estes and Lauriat.

Cotterill, Robert S. 1954. *The Southern Indians: The Story of the Civilized Tribes before Removal*. Norman: University of Oklahoma Press.

Covington, James W. 1960. "English Gifts to the Indians, 1765–66." *Florida Anthropologist* 13: 71–75.

———. 1982. *The Billy Bowlegs War: 1855–1858*. Chuluota, Fla.: The Mickler House Publisher.

———. 1985. "Formation of the State of Florida Indian Reservation." *Florida Historical Quarterly* 64: 62–75.

Cypress, Billy. 1991. *Seminole Medicine Project*. Video documentary. Hollywood, Fla.: Seminole Tribe of Florida.

Daniels, Charles Randall-Sakim. 1989. *Muskogee Words and Ways*. Tallahassee: The Muskogee Press.

Dark, Phillip. 1967. "The Study of Ethno-Aesthetics: The Visual Arts." In *Essays*

on the Verbal and Visual Arts: Proceedings of the 1966 Annual Spring Meeting of the American Ethnological Society, ed. June Helm. Seattle: University of Washington Press.

Davis, Hilda J. 1955. "The History of Seminole Clothing and Its Multi-Colored Designs." *American Anthropologist* 57: 974–80.

Deagan, Kathleen. 1977. "An Early Seminole Cane Basket." *Florida Anthropologist* 30: 28–33.

DeJarnette, David L. 1975. *Archaeological Salvage in the Walter F. George Basin of the Chattahoochee River in Alabama.* University, Ala.: University of Alabama Press.

Densmore, Frances. 1972. *Seminole Music.* New York: DaCapo Press.

Dickens, Roy S., Jr. 1979. *Archaeological Investigations at Horseshoe Bend.* Special Publication no. 3. University, Ala.: Alabama Archaeological Society.

Dockstader, Frederick J. 1978. *Weaving Arts of the North American Indians.* New York: Thomas Y. Crowell.

Dowling, Dan. 1836. *Sketch of the Seminole War by a Lieutenant of the Left Wing.* Charleston: J. P. Beile and W. H. Berrett.

Downs, Dorothy. 1976. *The Art of the Florida Indians.* Coral Gables, Fla.: Lowe Art Museum.

———. 1979. "Patchwork Clothing of the Florida Indians." *American Indian Art Magazine* 4: 32–41.

———. 1980. "British Influences on Creek and Seminole Men's Clothing, 1733–1858." *Florida Anthropologist* 33: 46–65.

———. 1981. "Coppinger's Tropical Gardens." *Florida Anthropologist* 34: 225–31.

———. 1982. *Miccosukee Arts and Crafts.* Miami: Miccosukee Tribe of Indians of Florida.

———. 1986. "Donna Frank: Seminole Basketmaker." In *Arts and Friends* 4: 18–19. Lowe Art Museum, Coral Gables, Fla.

———. 1990. "Contemporary Florida Indian Patchwork and Baskets." *American Indian Art Magazine* 15: 56–63.

Downs, Dorothy, and Clay Stafford. 1990. *Patterns of Power.* Video documentary. Miami: WLRN-TV/Dade County Public Schools.

Drooker, Penelope Ballard. 1992. *Mississippian Village Textiles at Wickliff.* Tuscaloosa: University of Alabama Press.

Dunbar, John Telfar. 1962. *History of Highland Dress.* Edinburgh: Oliver and Boyd.

Florida State Museum. 1976. "The Gift of Winston B. Stephens, Jr." *Florida State Museum Newsletter* 5 (January–February). Gainesville: University of Florida.

Forge, Anthony. 1973. *Primitive Art and Society.* London: Oxford University Press.

Francke, Arthur E., Jr. 1977. *Fort Mellon, 1837–42*. Miami: Banyan Books. **277**

Fundaburk, Emma Lila, ed. 1957. *Sun Circles and Human Hands*. Luverne, Ala.: by the author.

———. 1969. *Southeastern Indians: Life Portraits*. Metuchen, N.J.: Scarecrow Reprint Corporation.

Giddings, Joshua R. 1964 [1858]. *The Exiles of Florida: The Crimes Committed by Our Government against the Maroons, Who Fled from South Carolina and Other Slave States, Seeking Protection under Spanish Laws*. Columbus: Follett, Foster and Company. Reprint, Gainesville: University Presses of Florida.

Gilliland, Marion Spjut. 1975. *The Material Culture of Key Marco Florida*. Gainesville: University Presses of Florida.

Gleason's Pictorial Magazine. 1852. May 2.

Goggin, John M. 1940. "Silver Work of the Florida Seminole." *El Palacio* 47: 25–32.

———. 1949. "Plaited Basketry in the New World." *Southwestern Journal of Anthropology* 5: 165–68.

———. 1951. "Beaded Pouches of the Florida Seminole." *Florida Anthropologist* 4: 2–17.

———. 1958. "Seminole Pottery." In *Prehistoric Pottery of the Eastern United States*. Ann Arbor: Museum of Anthropology, University of Michigan.

———. 1967. "Style Areas in Historic Southeastern Art." In *Indian Tribes of Aboriginal America*, ed. Sol Tax. Proceedings of the Twenty-ninth International Congress of Americanists. New York: Cooper Square Publishers.

Greenlee, Robert F. 1944. "Medicine and Curing Practices of the Modern Florida Seminole." *American Anthropologist* 46: 317–28.

———. 1945. "Folktales of the Florida Seminoles." *Journal of American Folklore* 58: 138–44.

Gregor, Jack, and Rennard Strickland. 1971. *Creek and Seminole Spirit Tales: Tribal Folklore, Legend, and Myth*. Pensacola: Indian Heritage Association.

A Guide to the Miccosukee Language. 1978. David West and Nellie Smith, consultants. Miami: Miccosukee Tribe of Indians of Florida.

Harington, M. R. 1908. "Catawba Potters and Their Work." *American Anthropologist* 10: 406.

Hartley, William, and Ellen Hartley. 1973. *Osceola*. New York: Hawthorn Books.

Hillinger, Charles. 1989. "Weaving Is Link to African Ancestors." *Miami Herald*, August 20.

Horan, James D. 1972. *The McKenney-Hall Portrait Gallery of American Indians*. New York: Crown Publishers.

Howard, James, and Willie Lena. 1984. *Oklahoma Seminole Medicine, Magic, and Religion*. Norman: University of Oklahoma Press.

278 Hudson, Charles. 1976. *The Southeastern Indians.* Knoxville: University of Tennessee Press.

Hudson, Charles, Chester B. DePratter, and Marvin T. Smith. 1989. "Hernando de Soto's Expedition through the Southern United States." In *First Encounters: Spanish Exploration in the Caribbean and the United States, 1492–1570,* ed. Jerald T. Milanich and Susan Milbrath. Gainesville: University of Florida Press/Florida Museum of Natural History.

Ivers, Larry. 1974. *British Drums on the Southern Frontier.* Chapel Hill: University of North Carolina Press.

Johnson, Byron A. 1976. "Florida Seminole Silver Work." *Florida Anthropologist* 29: 93–104.

Jumper, Betty Mae. 1988. "Seminole Palmetto Dolls." *Seminole Tribune* [Hollywood, Fla.]. January 11.

Kersey, Harry A., Jr. 1975. *Pelts, Plumes, and Hides.* Gainesville: University Presses of Florida.

———. 1978. "Private Societies and the Maintenance of Seminole Tribal Integrity, 1899–1957." *Florida Historical Quarterly* 56: 297–316.

———. 1989. *The Florida Seminoles and the New Deal: 1933–1942.* Boca Raton: Florida Atlantic University Press.

Kidd, Kenneth E., and Martha Ann Kidd. 1970. "A Classification System for Glass Beads for the Use of Field Archaeologists." In *Canadian Historic Sites Occasional Papers in Archaeology and History,* no. 1. Ottawa: National Historic Sites Service, National and Historic Parks Branch, Department of Indian Affairs in Northern Development.

Kimber, Edward. 1976 [1744]. *A Relation of a Journal of a Late Expedition.* Gainesville: University Presses of Florida.

Klos, George. 1989. "Blacks and the Seminole Removal Debate, 1821–1835." *Florida Historical Quarterly* 68: 55–78.

Knight, Vernon J., Jr. 1985. "Tuckabatchee: Archaeological Investigations at an Historic Creek Town, Elmore County, Alabama, 1984." In *Report of Investigations* 45: 109–18. University, Ala.: Office of Archaeological Research, University of Alabama.

Kuttruff, Jenna Tedrick. 1990. "Charred Mississippian Textile Remains from Wickliff Mounds, Kentucky (15BA4)." Paper presented at the 1990 Southeastern Archaeological Conference, Mobile, Alabama.

Lefferts, Lt. Charles M. 1926. *Uniforms of the American, British, French and German Armies in the War of the American Revolution, 1775–1783.* Old Greenwich, Conn.: WE, Inc.

Lenze, Mary Jane. 1986. *The Stuff of Dreams: Native American Dolls.* New York: **279** Museum of the American Indian.

Libhart, Myles. 1989. "To Dress with Great Care: Contemporary American Indian and Eskimo Doll Artists of the United States." *American Indian Art Magazine* 14: 38–51.

McCall, Maj. Gen. George Archibald. 1974 [1868]. *Letters from the Frontiers.* Reprint, Gainesville: University Presses of Florida.

MacCauley, Clay. 1887. "The Seminole Indians of Florida." In *Fifth Annual Report of the Bureau of Ethnology* (1883–84): 469–531. Washington, D.C.: Government Printing Office.

McPherson, Robert G. 1962. *The Journal of the Earl of Egmont.* Athens: University of Georgia Press.

Mahon, John K. 1967. *History of the Second Seminole War: 1835–1842.* Gainesville: University Presses of Florida.

Miccosukee Tribe of Indians of Florida. 1966. "History of the Miccosukee Tribe of Indians of Florida." Unpublished paper.

Milanich, Jerald T., and Charles H. Fairbanks. 1980. *Florida Archaeology.* Orlando, Fla.: Academic Press.

Milanich, Jerald T., and Susan Milbrath, eds. 1989. *First Encounters: Spanish Explorations in the Caribbean and the United States, 1492–1570.* Gainesville: University of Florida Press/Florida Museum of Natural History.

Milanich, Jerald T., and Samuel Proctor, eds. 1978. *Tacachale: Essays on the Indians of Florida and Southeastern Georgia during the Historic Period.* Gainesville: University of Florida Press.

Mitchem, Jeffrey M. 1989. "Artifacts of Exploration: Archaeological Evidence from Florida." In *First Encounters: Spanish Explorations in the Caribbean and the United States, 1492–1570,* ed. Jerald T. Milanich and Susan Milbrath. Gainesville: University of Florida Press/Florida Museum of Natural History.

———. 1991. "Beads and Pendants from San Luis de Talimali: Inferences from Varying Contexts." *Florida Anthropologist* 44: 2–4, 307–15.

Mooney, James. 1900. "Myths of the Cherokee." In *Nineteenth Annual Report of the Bureau of American Ethnology,* part 1, 3–576. Washington, D.C.: Government Printing Office.

Moore-Willson, Minnie. 1920. *The Seminoles of Florida.* New York: Moffat, Yard, and Company.

Motte, Jacob Rhett. 1953. *Journey into Wilderness: An Army Surgeon's Account of Life in Camp and Field during the Creek and Seminole Wars, 1836–38.* Ed. James F. Sunderman. Gainesville: University of Florida Press.

Neil, Wilfred T. 1953. "Dugouts of the Mikasuki Seminole." *Florida Anthropologist* 6: 77–84.

————. 1956. "Sailing Vessels of the Florida Seminole." *Florida Anthropologist* 9: 79–86.

Nunez, Theron, Jr. 1958. "Creek Nativism and the Creek War of 1813–14." *Ethnohistory* 5: 1–48, 131–75, 292–301.

Orchard, William C. 1975. *Beads and Beadwork of the American Indian.* New York: Museum of the American Indian, Heye Foundation.

"Pair of Beaded Red Trade Cloth Leggings." 1988. *Important American Indian Art.* Auction catalog, November 29. Lots 45, 46. New York: Sotheby's.

Parker, Arthur C. 1910. "The Origin of Iroquois Silversmithing." *American Anthropologist* 12: 349–57.

Partons, James. 1860. *Life of Andrew Jackson.* 3 vols. New York: Mason.

Penney, David W. 1992. *Art of the American Indian Frontier.* Seattle: University of Washington Press.

Pickett, Albert James. 1900. *History of Alabama.* Birmingham: The Webb Book Company.

Pierce, James. 1825. "Notices of the Agriculture, Scenery, Geology and Animal, Vegetables and Mineral Productions of the Floridas, and of the Indian Tribes, Made during a Recent Tour in These Countries." *American Journal of Science,* ser. 1: 9.

Piper, Harry M., and Jacquelyn G. Piper. 1982. *Archaeological Excavations at the Quad Block Site 8Hi998.* St. Petersburg, Fla.: Piper Archaeological Research.

Porter, Kenneth. 1967. "Billy Bowlegs, Holata Micco in the Seminole Wars." *Florida Historical Quarterly* 45: 219–42.

Porzio, Domenico, and Marcos Valsecchi. 1973. *Understanding Picasso.* New York: Newsweek Books.

Potter, Woodburne. 1966 [1836]. *The War in Florida: Being an Exposition of Its Causes, and an Accurate History of the Campaigns of General Clinch, Gaines, and Scott.* Reprint, Ann Arbor, Mich.: University Microfilms.

Quimby, George Irving. 1966. *Indian Culture and European Trade Goods.* Madison: University of Wisconsin Press.

Ramsey, Dr. Andrew Boggs. n.d. "The Group That Was Left Behind." Unpublished history of Florida Creek Indians. Blountstown, Florida.

Rubin, William. 1984. "Picasso." In *"Primitivism" in 20th Century Art.* 2 vols. New York: Museum of Modern Art.

Rush, Beverly, with Lassie Wittman. 1982. *The Complete Book of Seminole Patchwork: From Traditional Methods to Contemporary Uses.* Seattle: Madrona Publishers.

Schneider, Jane. 1989. "Rumpelstiltskin's Bargain: Folklore and the Merchant

Capitalist Intensification of Linen Manufacture in Early Modern Europe." In
Cloth and Human Experience, ed. Annette B. Weiner and Jane Schneider. Washington: Smithsonian Institution Press.

Schnell, Frank T. 1970. "A Comparative Study of Some Lower Creek Sites."
Southeastern Archaeological Conference Bulletin 13: 133–36.

"Seminole Beaded Cloth Shoulder Bag." 1988. *Important American Indian Art.*
November 29, Lot 48. New York: Sotheby's.

Shaw, Helen Louise. 1931. *British Administration of Southern Indians, 1756–1783.*
Lancaster, Pa.: by the author.

Skinner, Alanson. 1913. "Notes on the Florida Seminole." *American Anthropologist*
15: 63–77.

Smith, Hale G., and Mark Gottlob. 1978. "Spanish-Indian Relationships." In
*Tacachale: Essays on the Indians of Florida and Southeastern Georgia during the
Historic Period,* ed. Jerald T. Milanich and Samuel Proctor. Gainesville: University Presses of Florida.

Spaulding, Phinizy. 1977. *Oglethorpe in America.* Chicago: University of Chicago
Press.

Spoehr, Alexander. 1941. "Camp, Clan and Kin among the Cow Creek Seminoles
of Florida." *Field Museum of Natural History Anthropological Series* 33: 1–27.

Sprague, John T. 1964 [1848]. *The Origin, Progress and Conclusion of the Florida
War.* Reprint, Gainesville: University of Florida Press.

Sturtevant, William C. 1954. "The Medicine Bundles and Busks of the Florida
Seminoles." *Florida Anthropologist* 7: 31–70.

———, ed. 1956. "R. H. Pratt's Report on the Seminole in 1879." *Florida Anthropologist* 9: 1–24.

———. 1967. "Seminole Men's Clothing." In *Essays on the Verbal and Visual Arts:
Proceedings of the 1966 Annual Spring Meeting of the American Ethnological Society,*
ed. June Helm, 160–74. Seattle: University of Washington Press.

———. 1970. *The Mikasuki Seminole Medical Beliefs and Practices.* Ann Arbor.
Mich.: University Microfilms.

———. 1971. "Creek into Seminole." In *North American Indians in Historical
Perspective,* ed. Eleanor Burke Leacock and Nancy Lurie. New York: Random
House.

Sugden, John. 1982. "The Southern Indians in the War of 1812: The Closing
Phase." *Florida Historical Quarterly* 60: 273–312.

"A Survey of Prints in the William and Mary Parlor, South Wing." n.d. Winterthur,
Del.: Winterthur Museum.

Swan, Caleb. 1795. "Position and State of Manners and Arts in the Creek or
Muskogee Nation in 1791." In *Information Respecting the History, Condition, and*

Prospects of the Indian Tribes of the United States, ed. Henry Rowe Schoolcraft, 5:251–83. Philadelphia: Lippincott and Grambo.

Swanton, John R. 1928. "Social Organization and Social Usages of the Indians of the Creek Confederacy." *Forty-Second Annual Report of the Bureau of American Ethnology Annual Report* 23–472. Washington, D.C.: Government Printing Office.

———. 1929. "Myths and Tales of the Southeastern Indians." *Smithsonian Institution Bureau of American Ethnology,* Bulletin no. 88. Washington, D.C.: Smithsonian Institution.

Thompson, Robert Farris. 1984. *Flash of the Spirit.* New York: Vintage Books.

"Totem Pole from Florida." 1933. *Scientific American* 148: 292–93.

True, David O., ed. 1973. *Memoir of Don d'Escalente Fontaneda: Written in Spain, about the year 1575.* Miami: Historical Association of Southern Florida Reprint and Facsimile Series.

Tsosie, Michael Philip. 1992. "Historic Mohave Bead Collars." *American Indian Art Magazine* 18: 36–59.

Turner, Alta R. 1973. *Finger Weaving: Indian Braiding.* Cherokee, N.C.: Cherokee Publications.

Urlsperger, Samuel. 1968. *Detailed Report on the Salzburger Emigrants Who Settled in America, 1733–34.* Athens: University of Georgia Press.

Viola, Herman J. 1976. *The Indian Legacy of Charles Bird King.* Washington: Smithsonian Institution Press; New York: Doubleday.

Wahlman, Maude Southwell, and John Scully. 1983. "Aesthetic Principles in Afro-American Quilts." In *Afro-American Folk Arts and Crafts,* ed. William Ferris. Boston: G. K. Halland Company.

Waring, Antonio J. 1960. *Laws of the Creek Nation.* Athens: University of Georgia Press.

———. n.d. Unpublished Papers. Collections of the Georgia Historical Society, Savannah, Georgia.

Warren, Cecil. 1934. "Florida's Seminoles." *Miami Daily News.* September 15.

Weiner, Annette B., and Jane Schneider, eds. 1989. *Cloth and Human Experience.* Washington: Smithsonian Institution Press.

Weisman, Brent Richards. 1989. *Like Beads on a String.* Tuscaloosa: University of Alabama Press.

West, Patsy. 1981. "The Miami Indian Tourist Attractions: A History and Analysis of a Transitional Mikasuki Seminole Environment." *Florida Anthropologist* 34: 200–24.

———. 1984. "Glade Cross Mission: An Influence on Seminole Arts and Crafts." *American Indian Art Magazine* 9: 58–67.

Whiteford, Andrew Hunter. 1977. "Fiber Bags of the Great Lakes Indians." *American Indian Art Magazine* 2: 52–64.

Wickman, Patricia R. 1991. *Osceola's Legacy*. Tuscaloosa: University of Alabama Press.

Willey, Gordon R. 1966. *An Introduction to American Archaeology: North and Middle America*. 2 vols. Englewood Cliffs, N.J.: Prentice-Hall.

Willoughby, Hugh H. 1898. *Across the Everglades: A Canoe Journey of Exploration*. Philadelphia: J. B. Lippincott.

Wilson, Lee Ann. 1985. "Southern Cult Images of Composite Human and Animal Figures." *American Indian Art Magazine* 11: 46–57.

Wittmer, Marcilene. 1989a. "African Influence on Florida Indian Patchwork." *Southeastern College Art Conference Review* 11: 269–75.

———. 1989b. "Florida Indian Patchwork and the Question of African Influence." Unpublished manuscript.

Wright, J. Leicht, Jr. 1986. *Creeks and Seminoles*. Lincoln: University of Nebraska Press.

Young, Dianne. 1990. "Through Family Hands." *Southern Living Magazine*. July.

Index